Fabulous Fashion Coloring Book
Glamourous Gowns & High Heels
Inspire intimate moments of mindfulness, calm and creativity

Kids and grown ups will love this classic coloring book that features over 100 pages of beautiful dresses and shoes. A glamorous collection of favorite fashion in gowns and heels.

Kids love to color, and with over 100 pages of coloring fun, this one coloring book will keep them happy through many long road trips, plane rides, sleepovers, rainy days, and more. Coloring is fabulous for fine motor skill development. The intricate patterned designs leave lots of room to explore creative color combinations.

Once colored the dresses and shoes can be cut out to dress up paper dolls, make two-sided ornaments or decorate a bedroom or an office. Use your imagination and have fun!

The zentangles included in the designs make this a perfect coloring book for adults too!

Use this as a calming activity for both mother and daughter. Color the pages as you sit side by side to share some intimate quiet time together that is both fun and creative.

Kids and grown ups unwrapping this fun coloring book on Christmas holidays or birthdays, or any day will be delighted with hours of calm colorful and creative enjoyment.

May your hearts and hands be filled with love.

From my heart to yours.

©PenMeIn

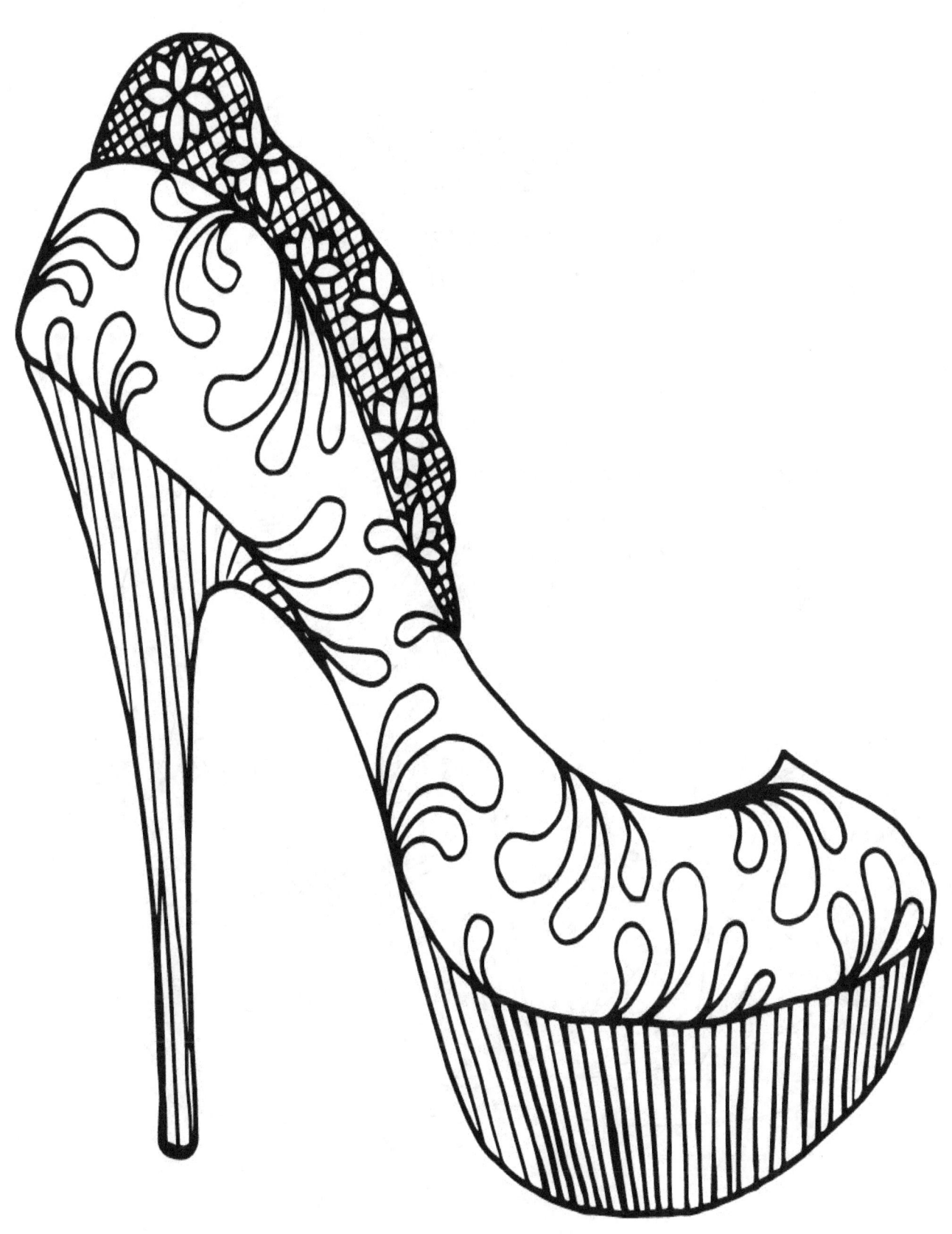

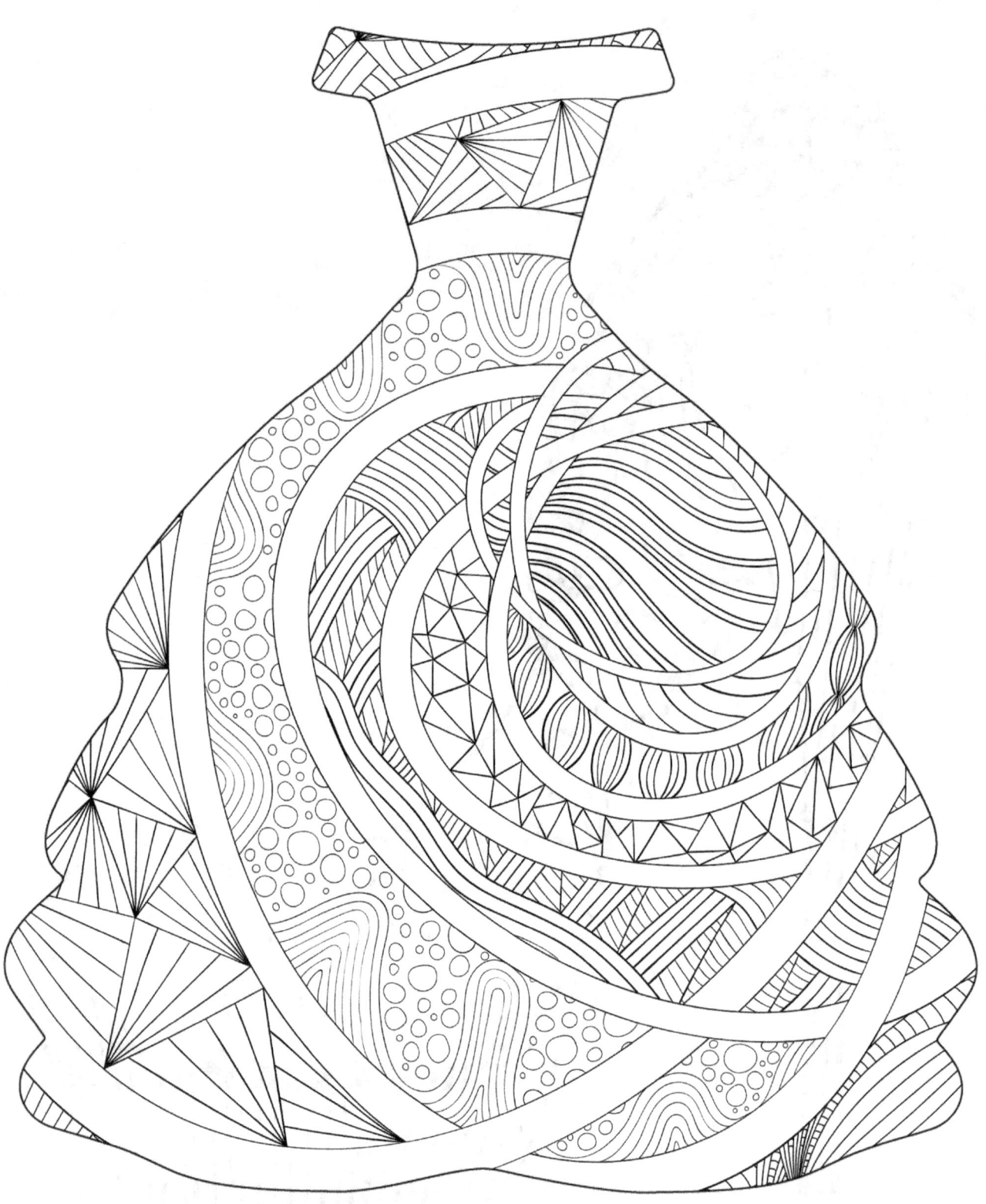

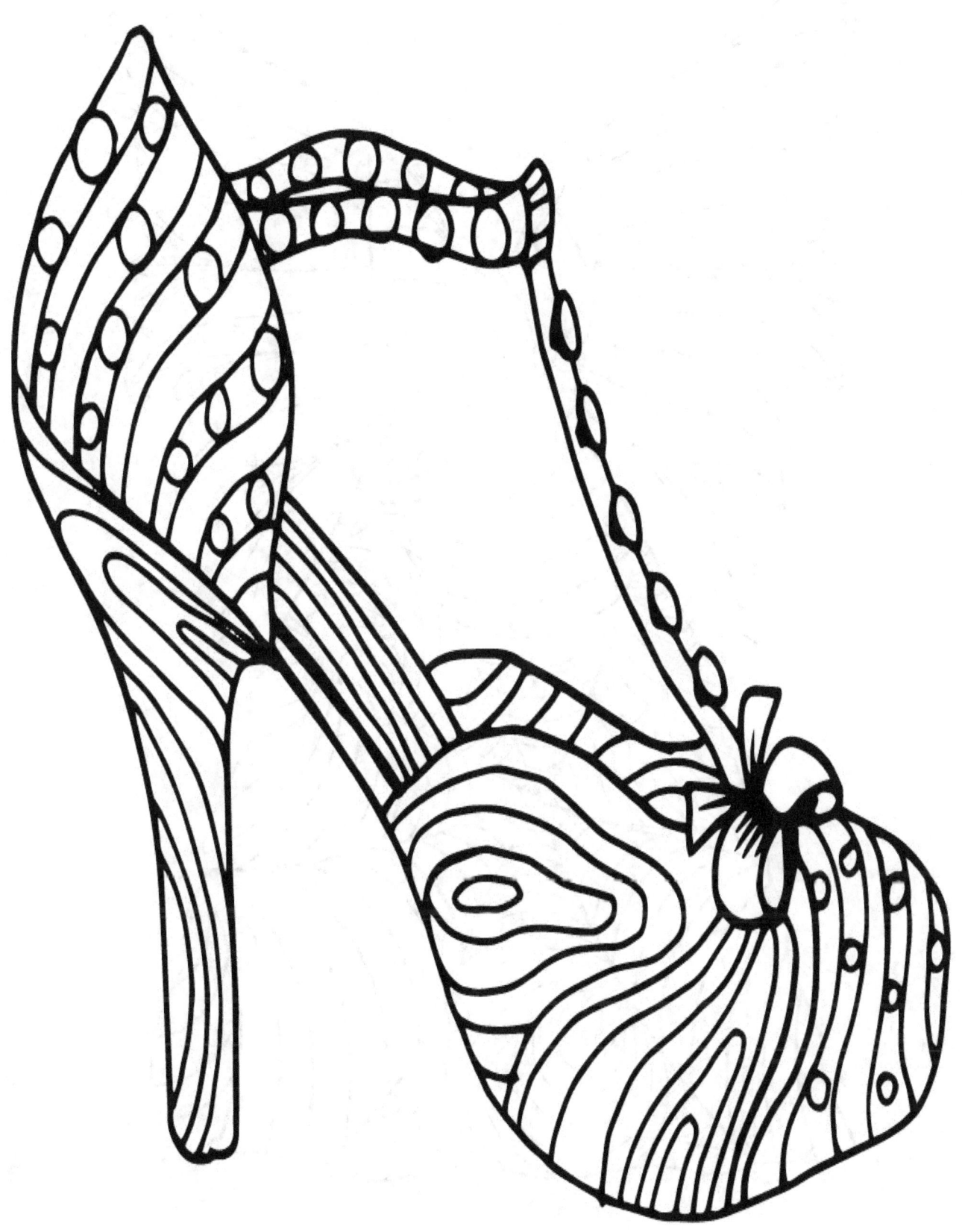

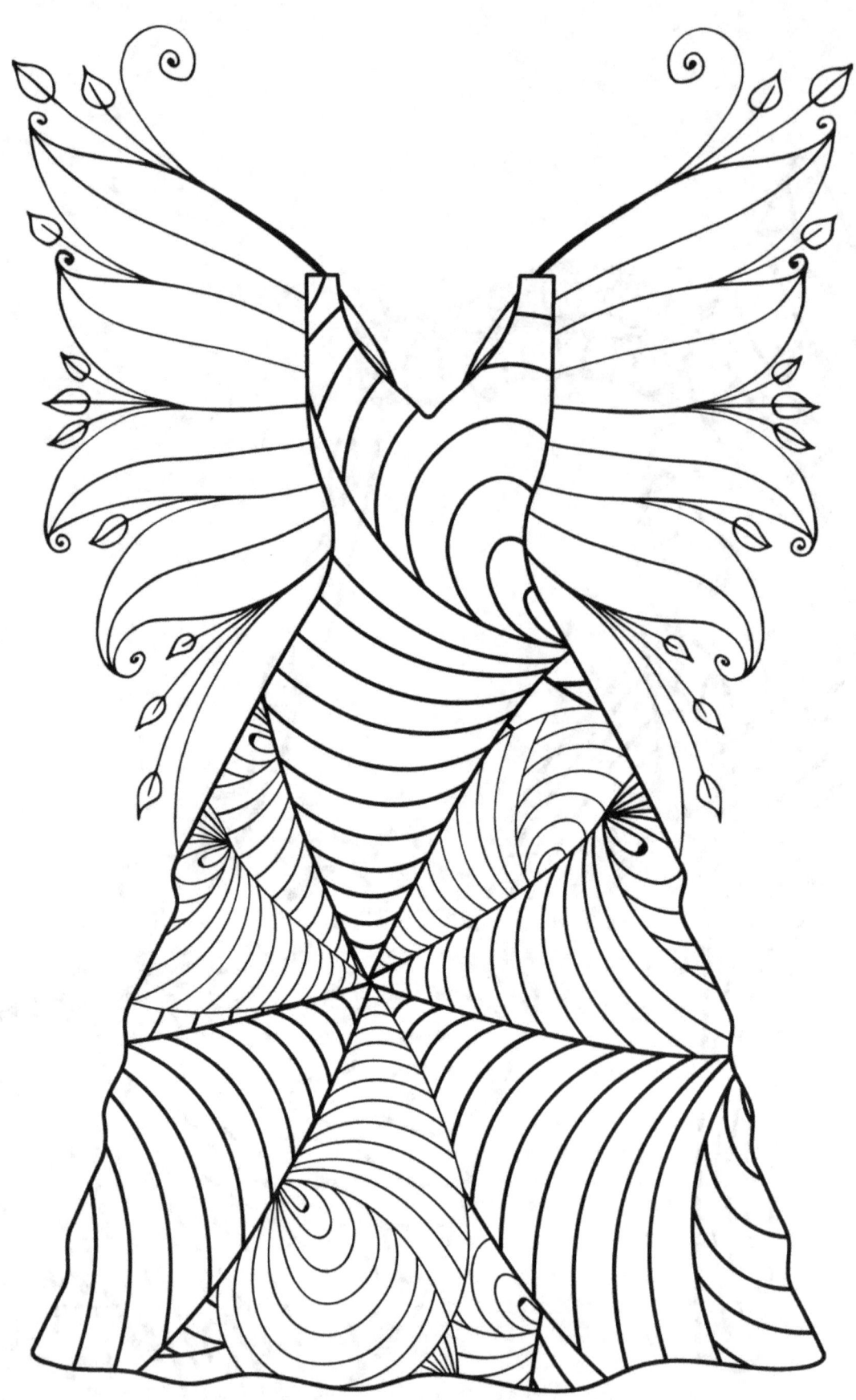

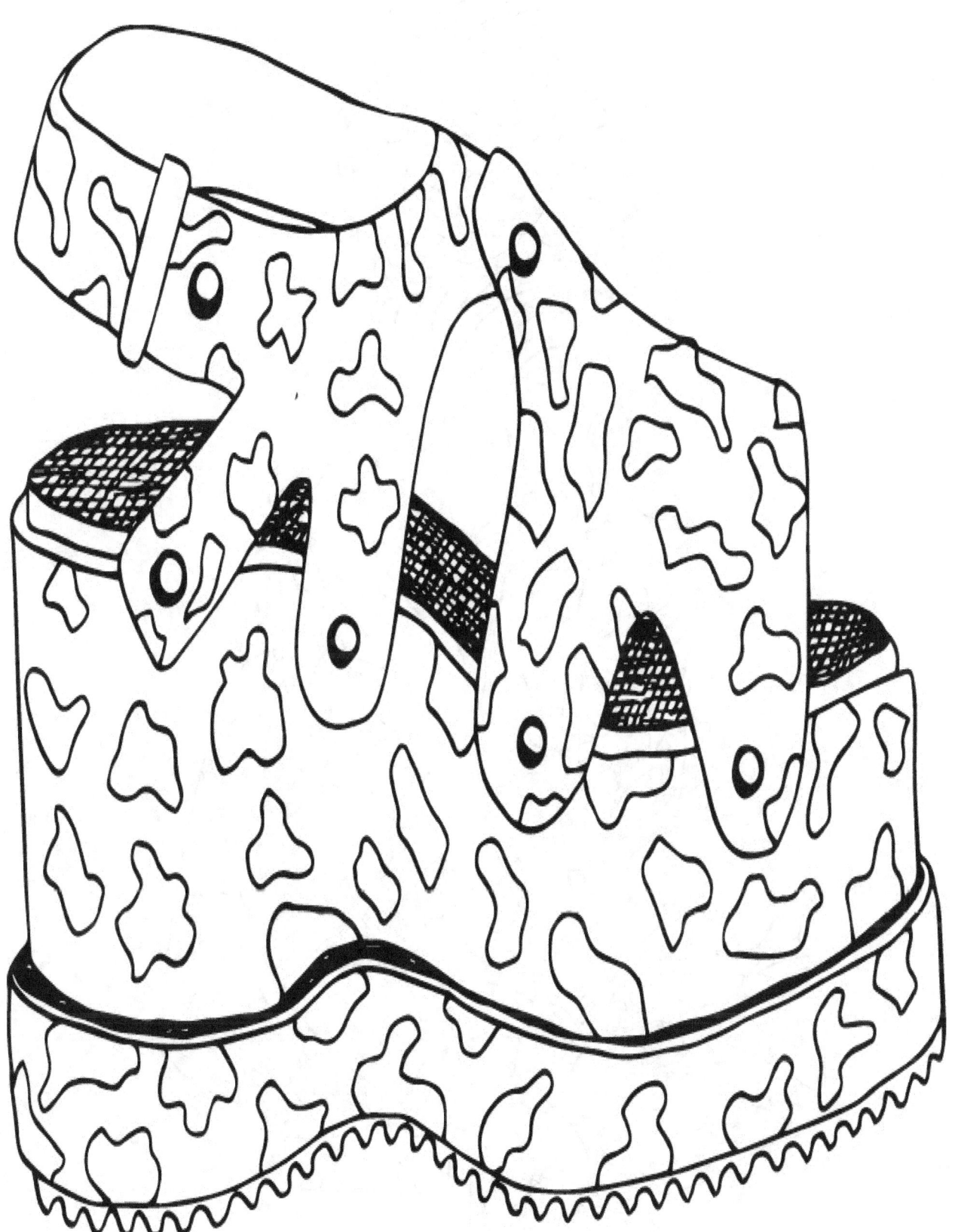

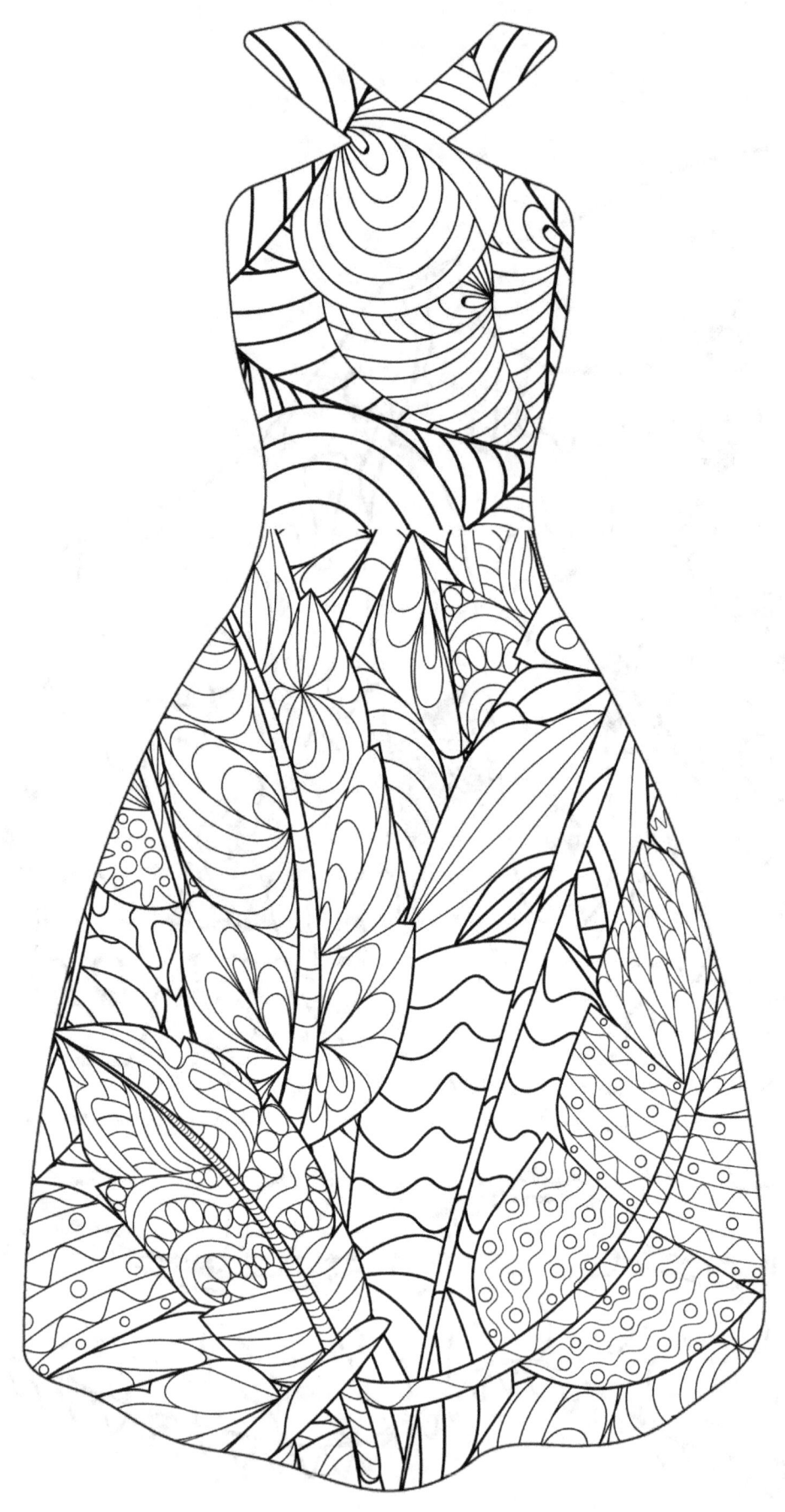

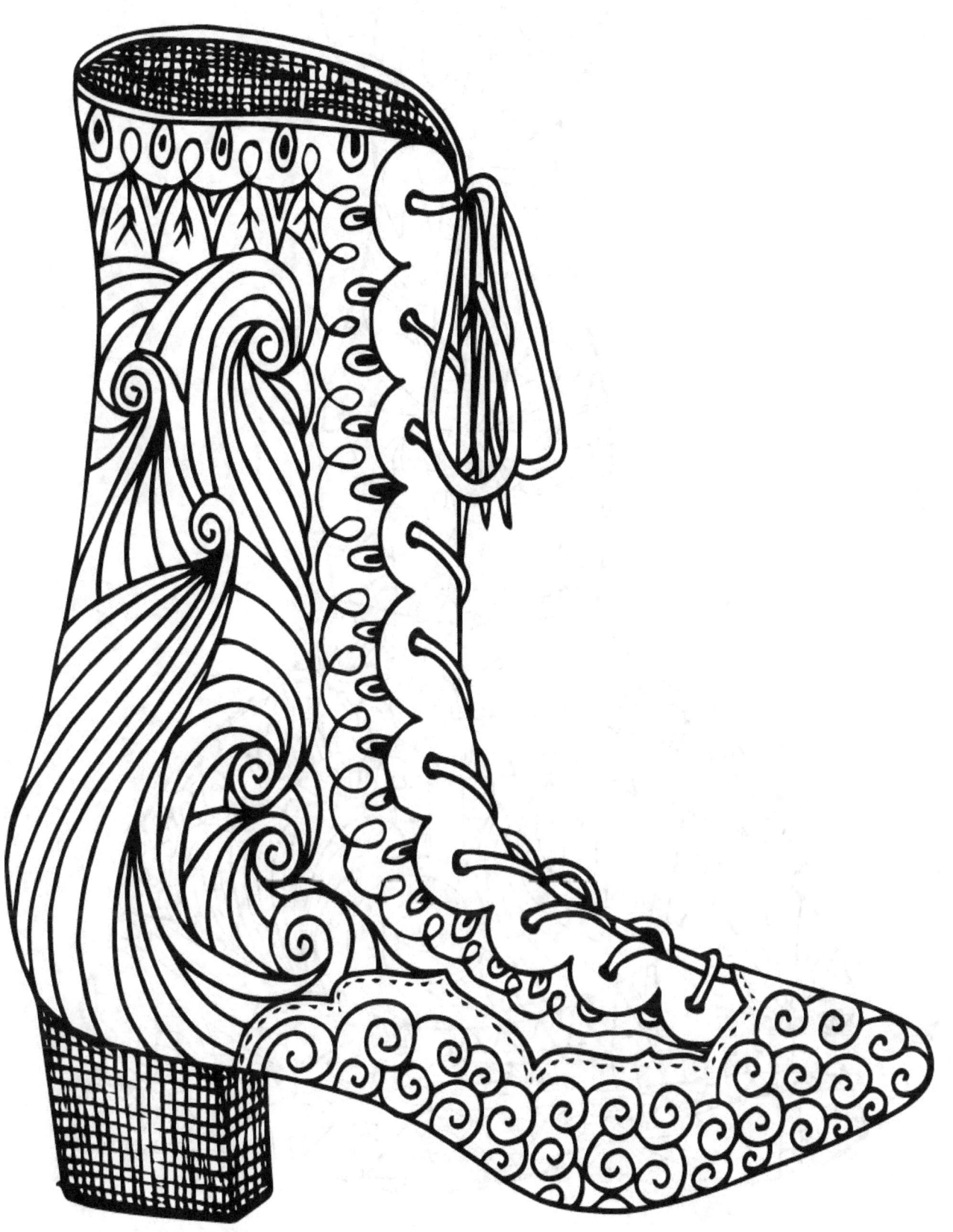

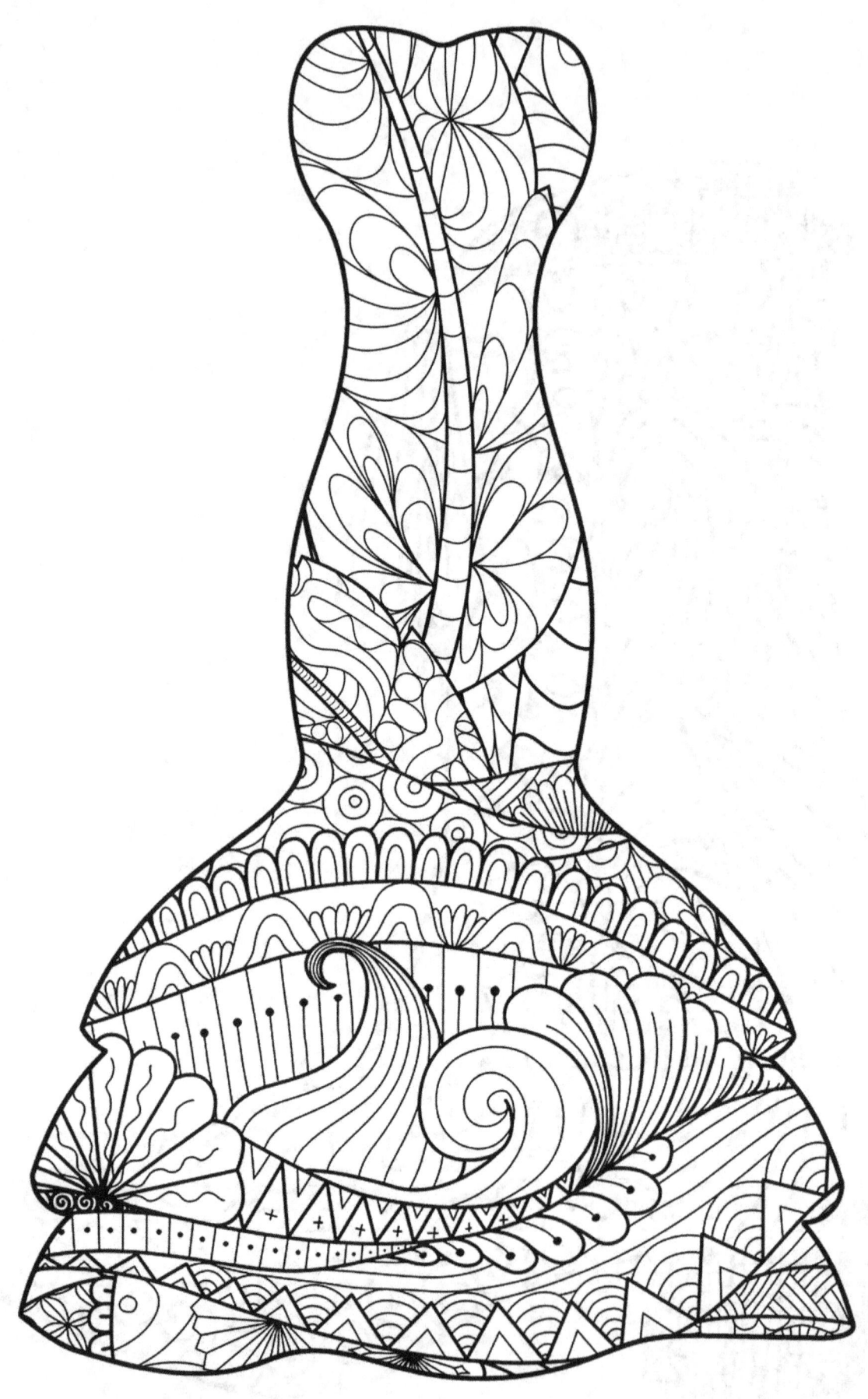

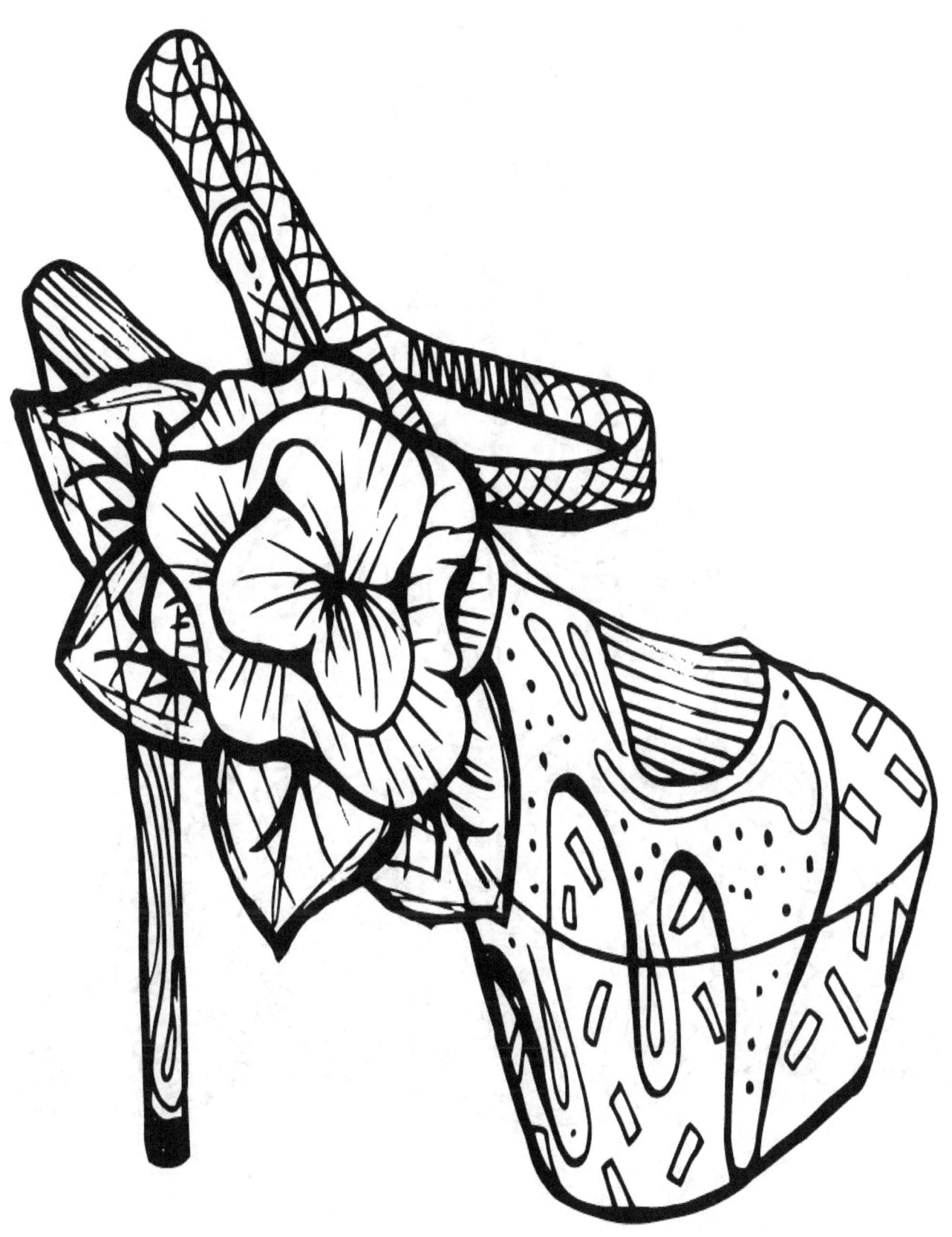

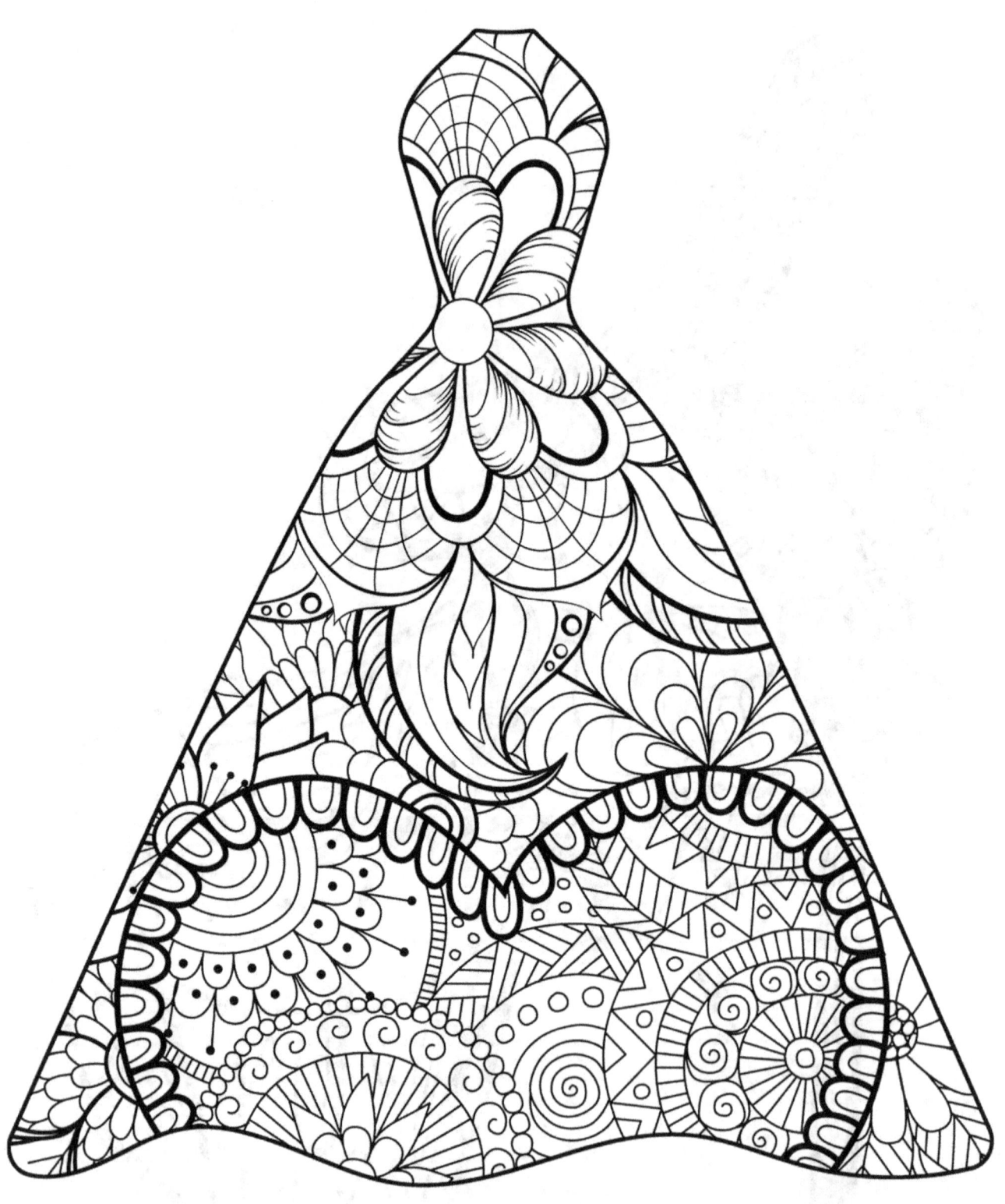

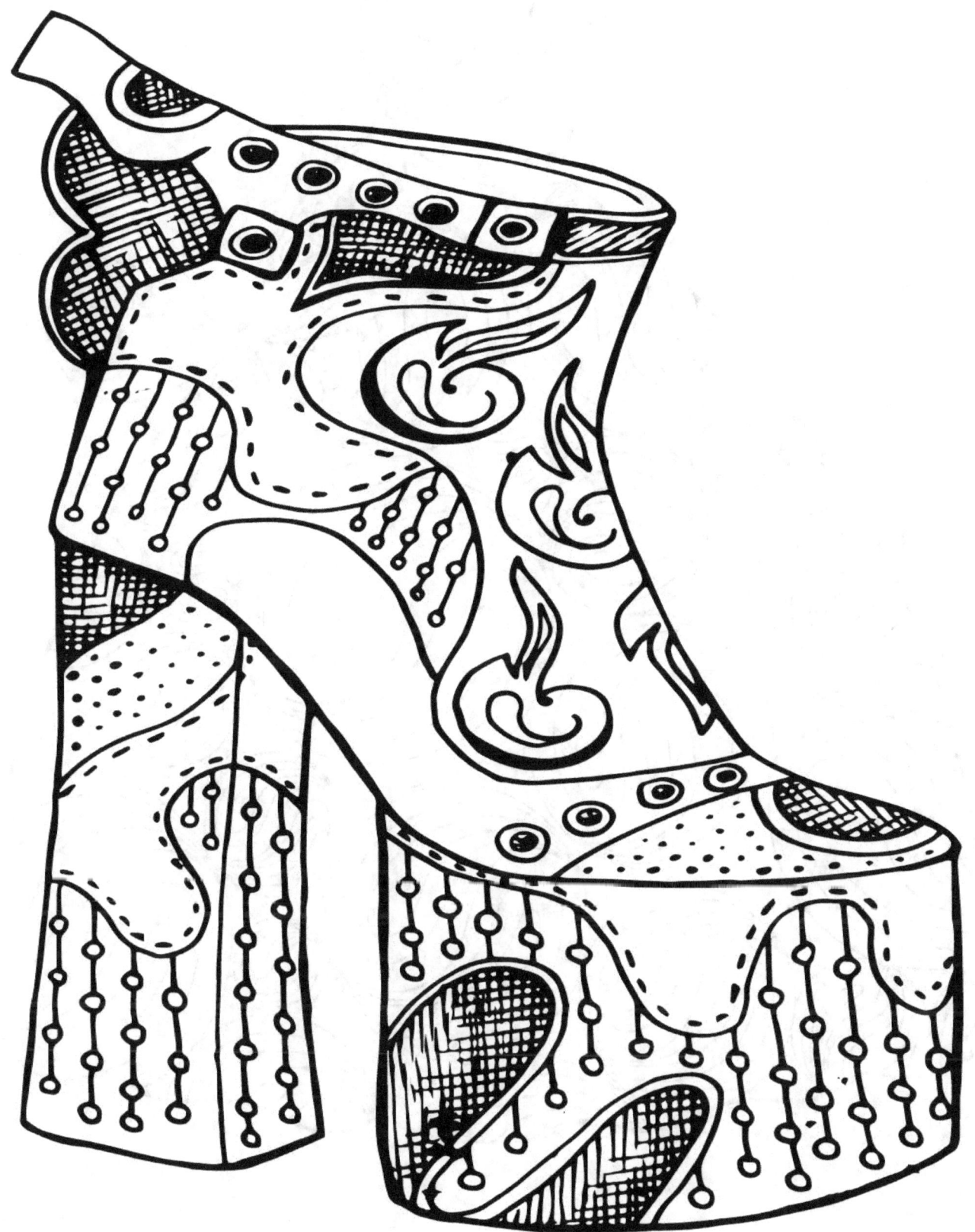

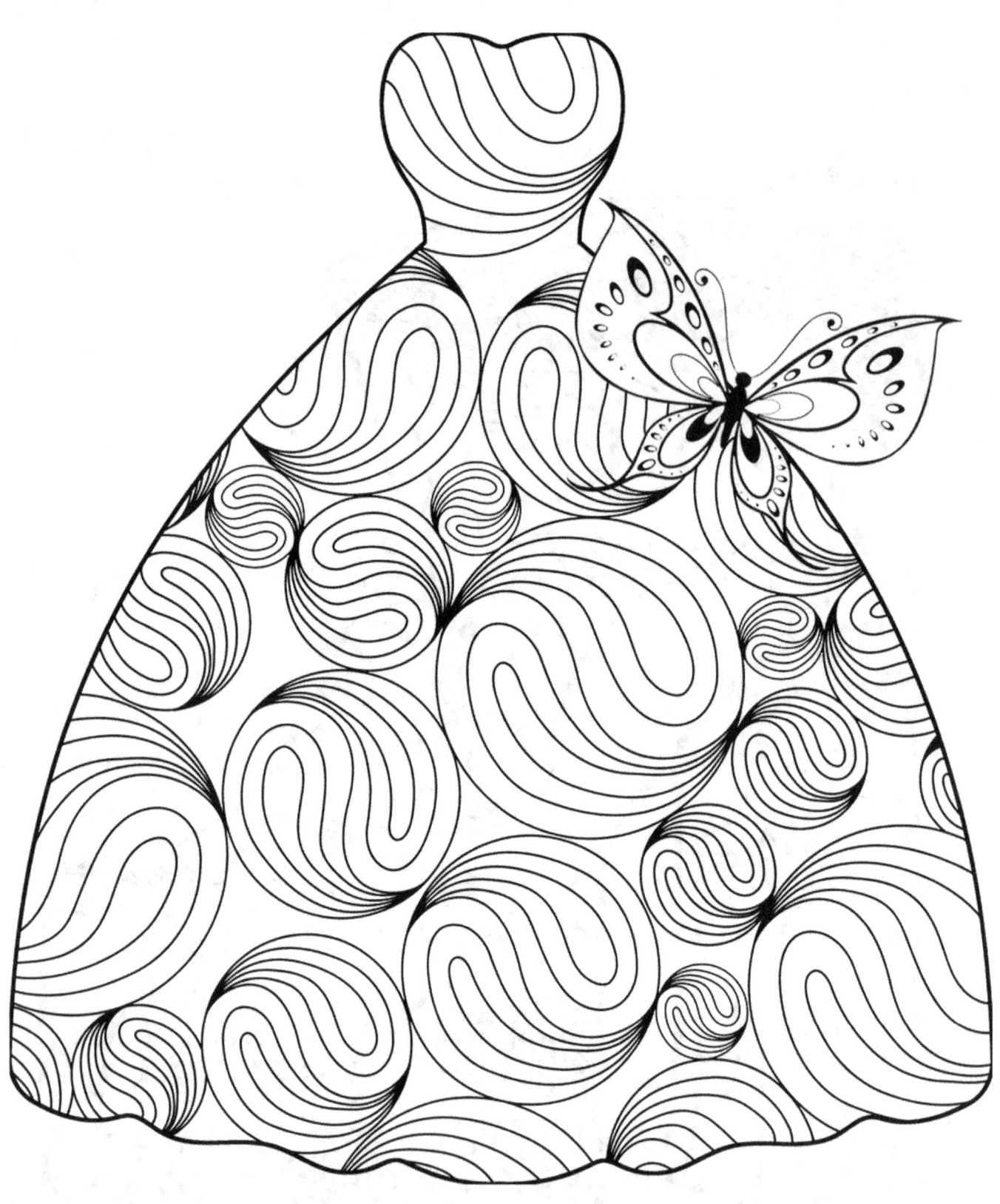

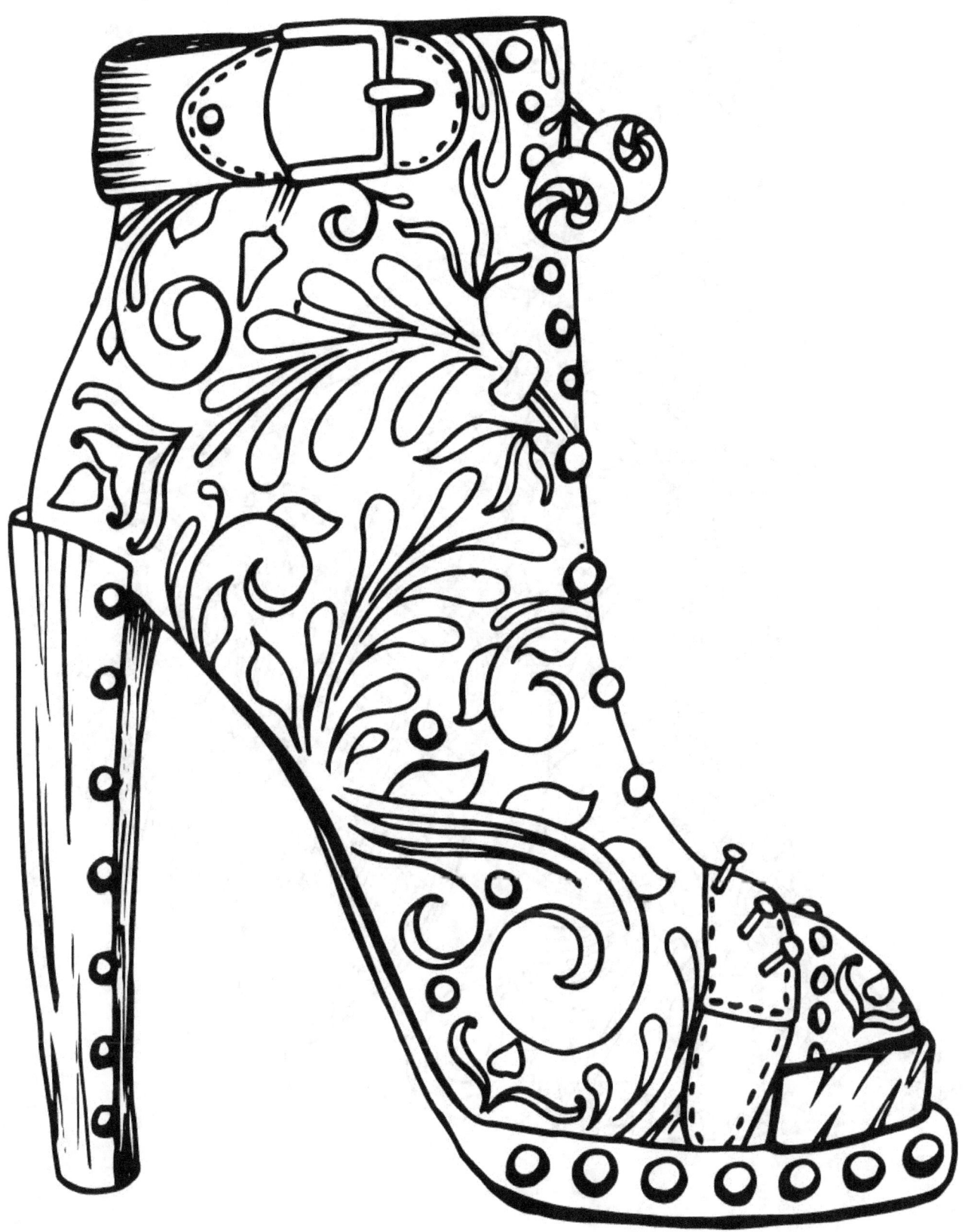

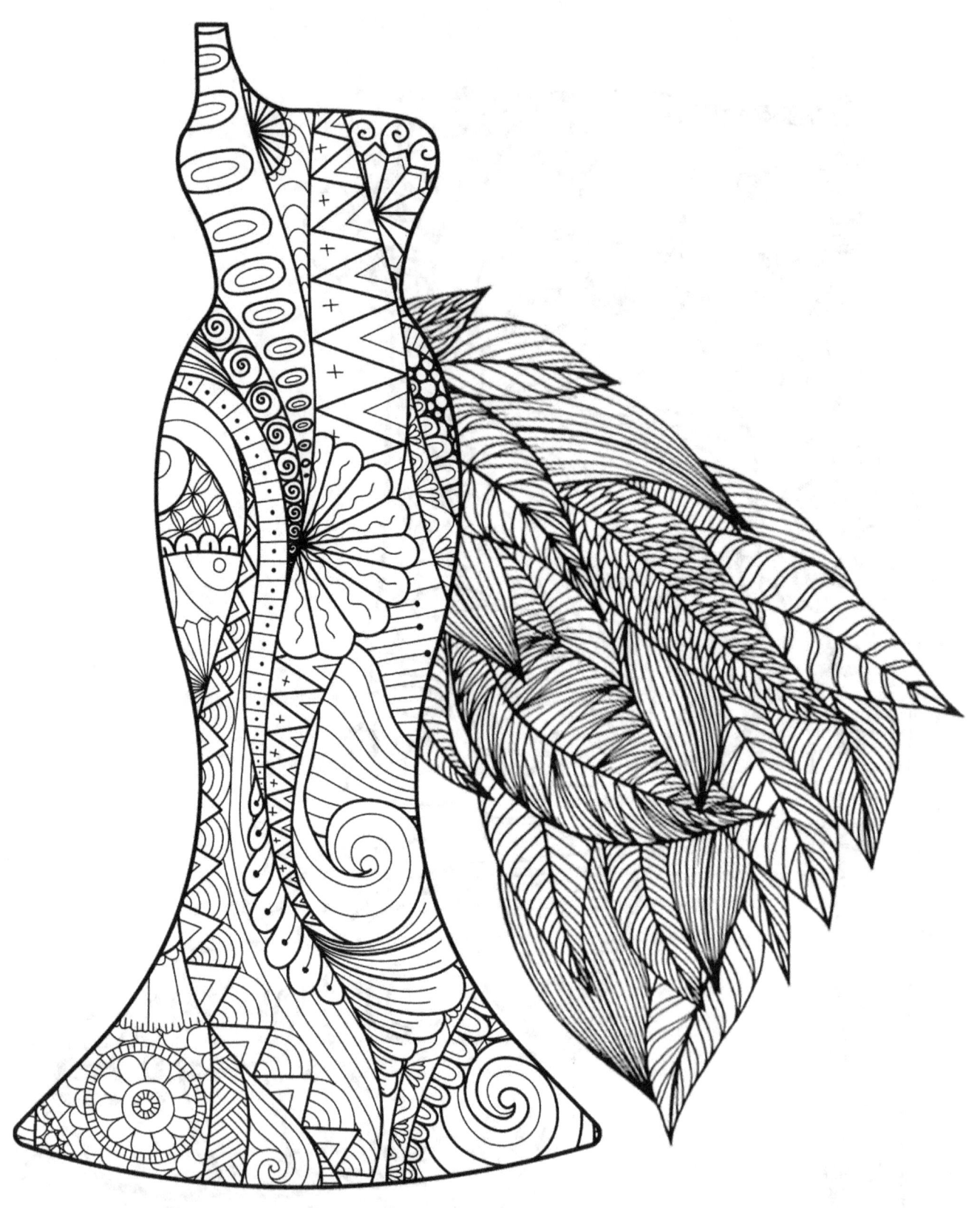

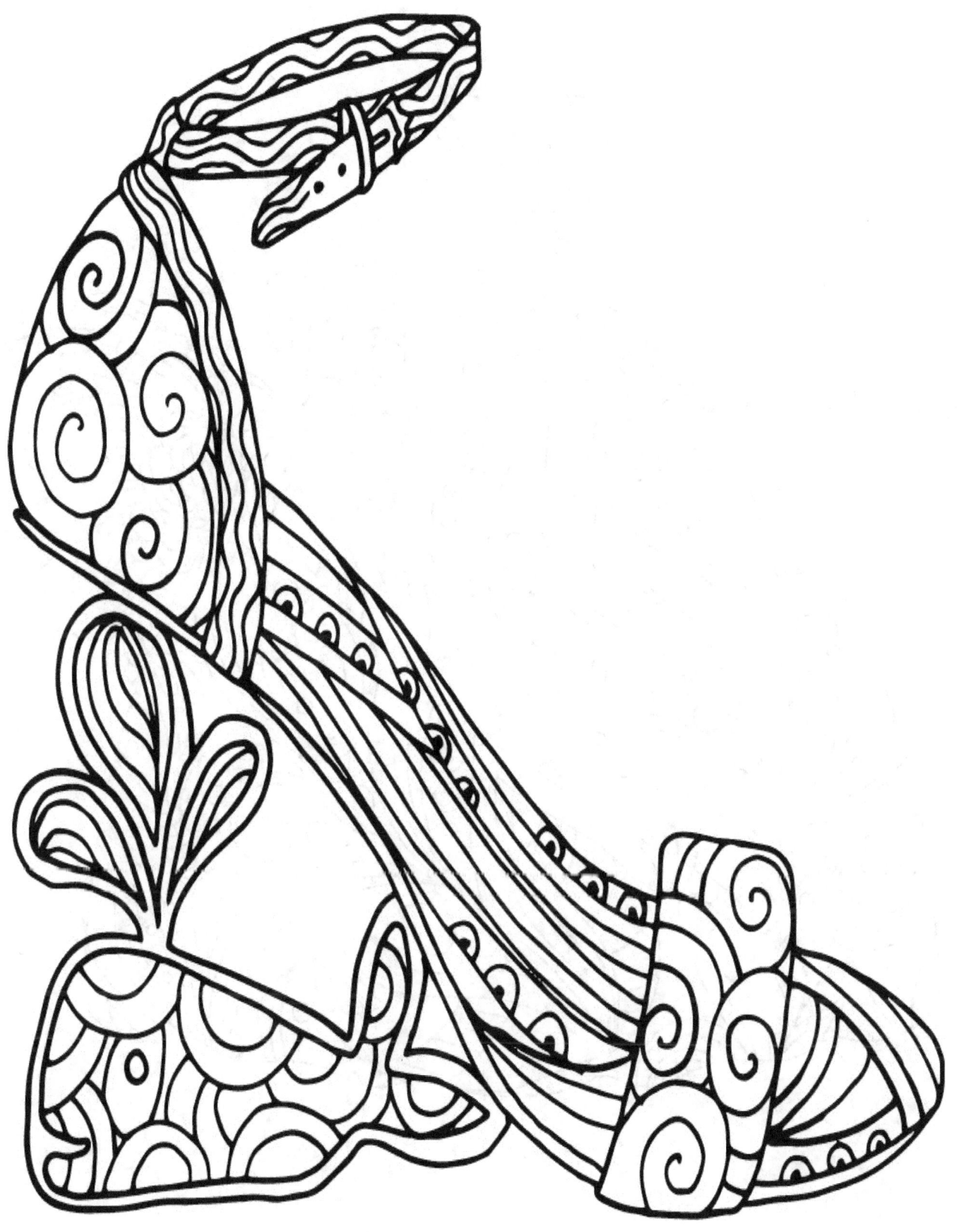

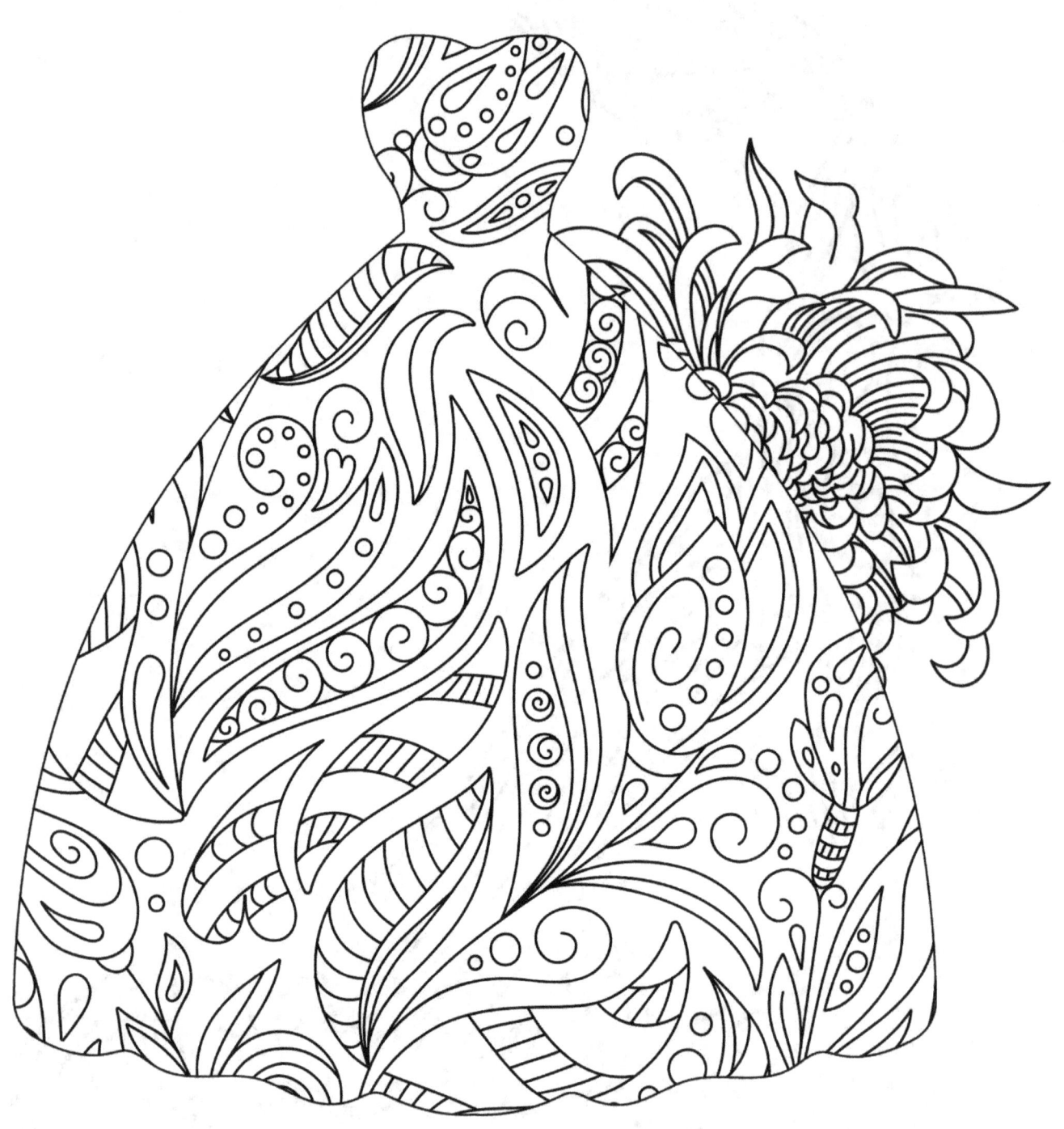

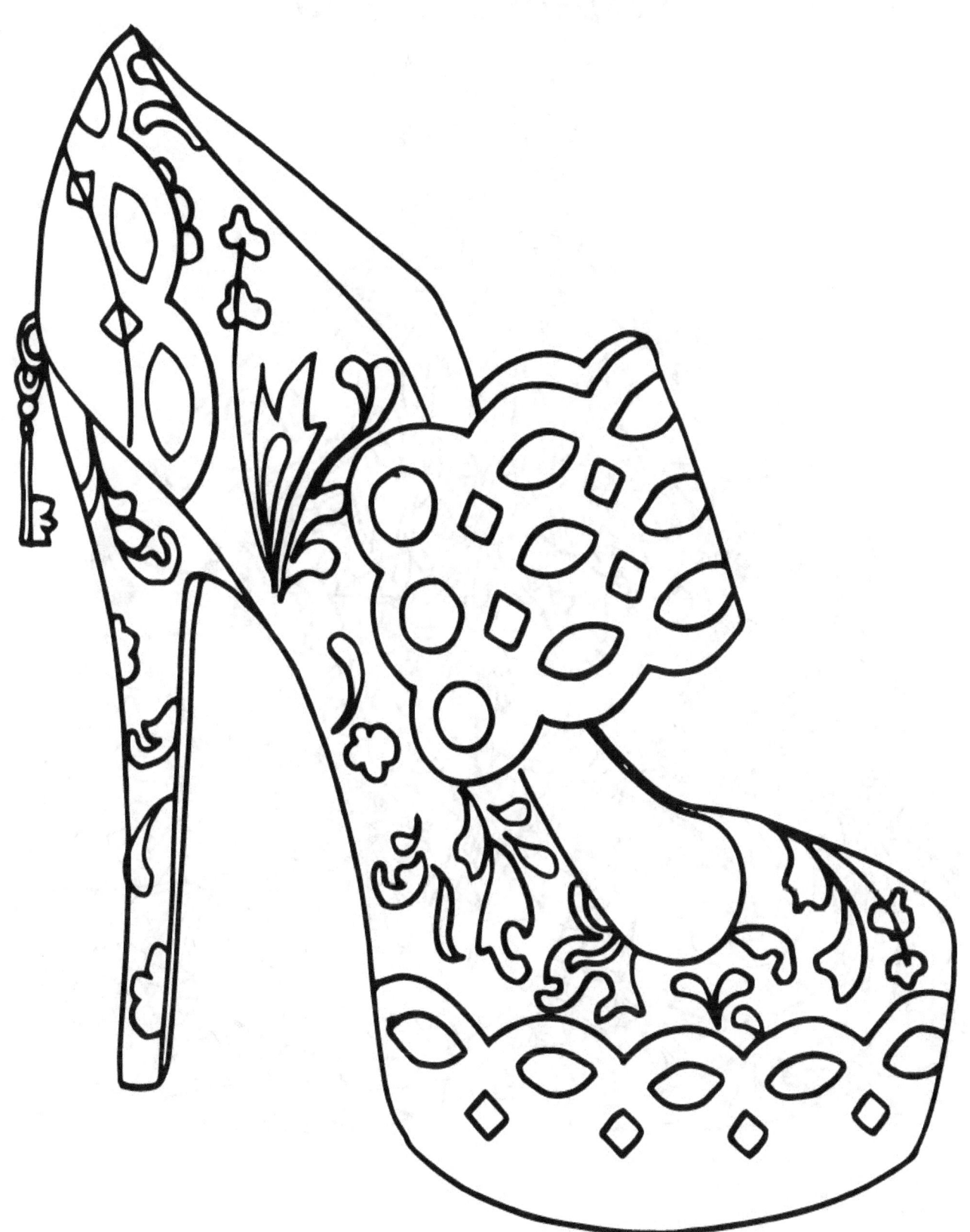

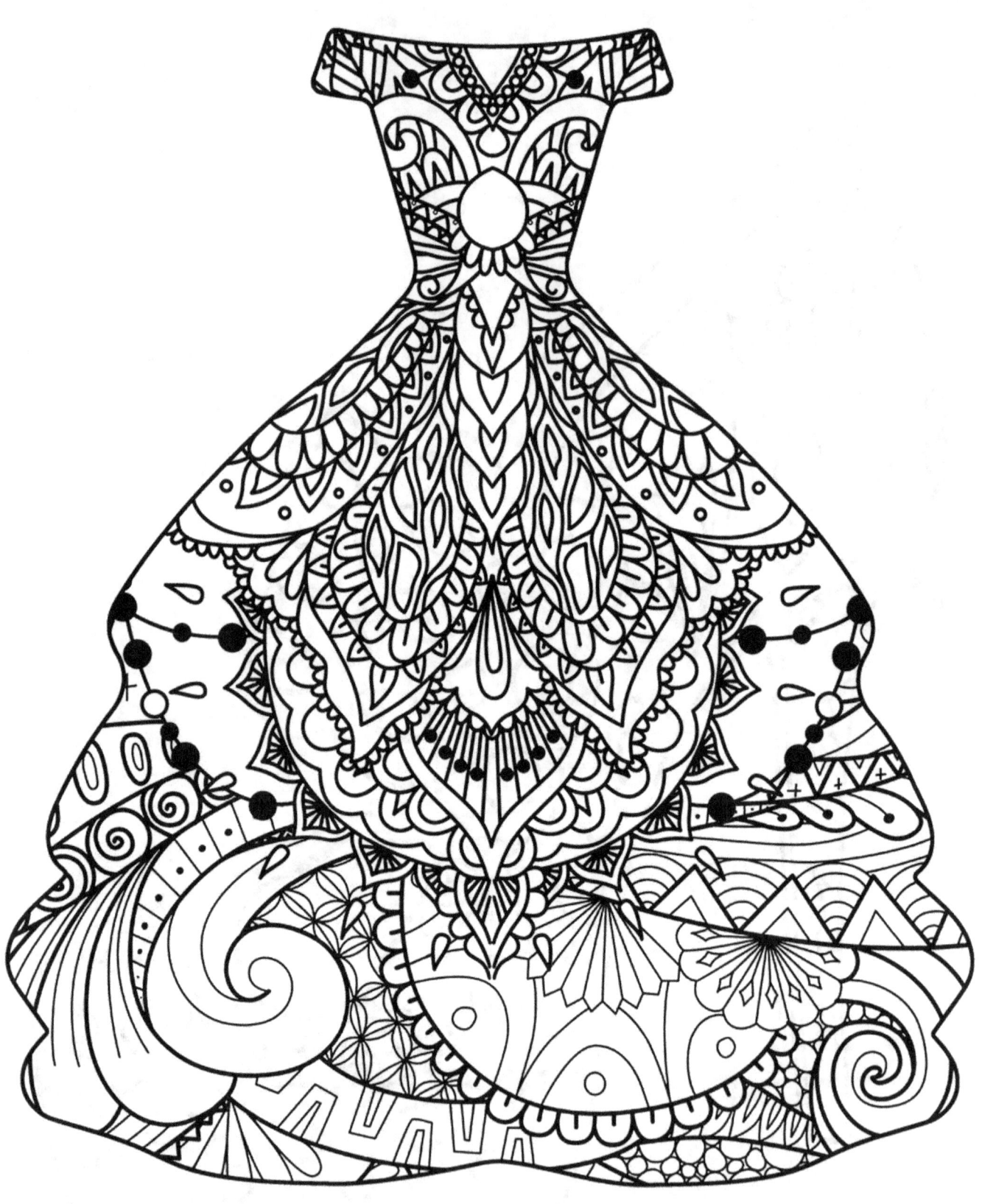

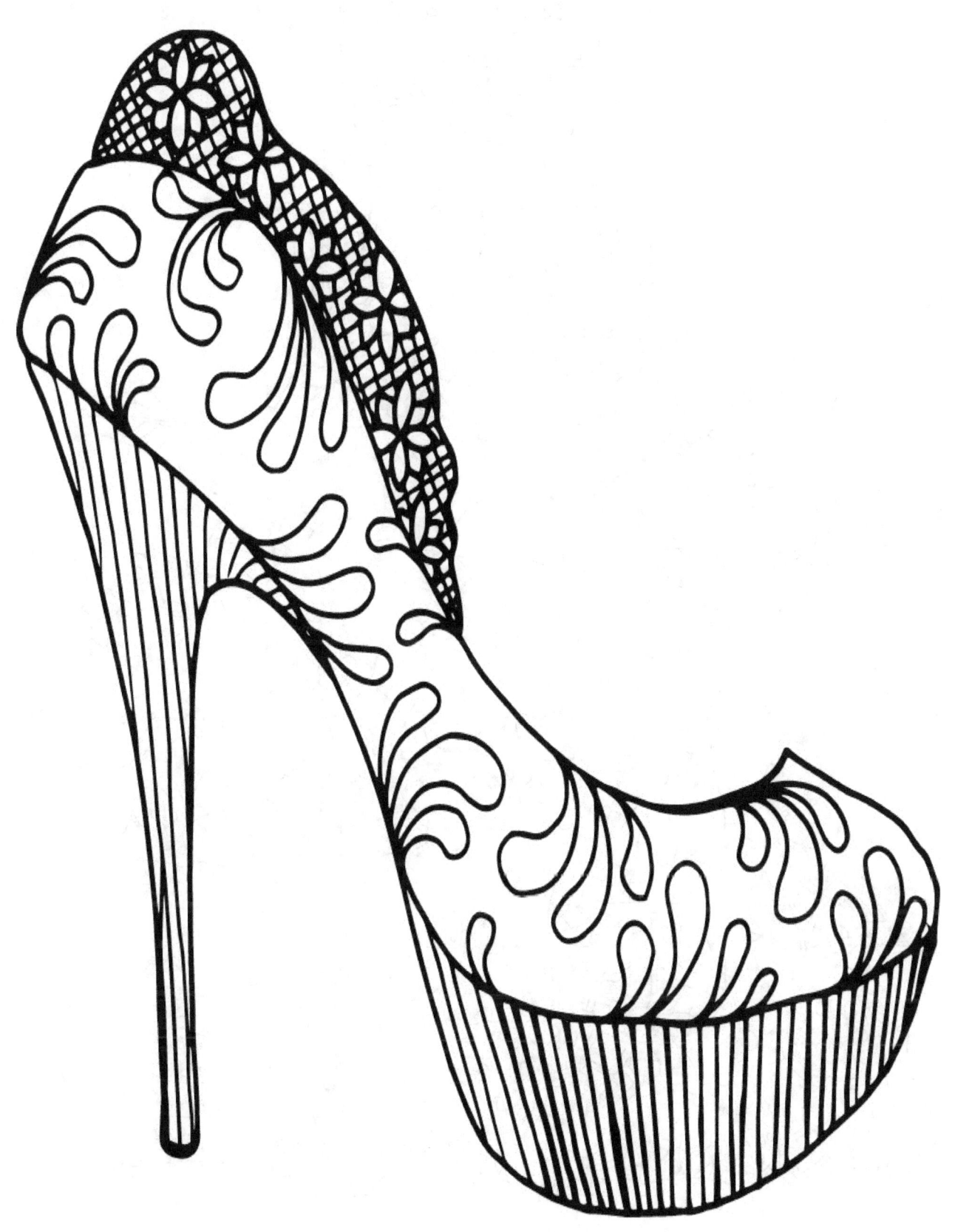

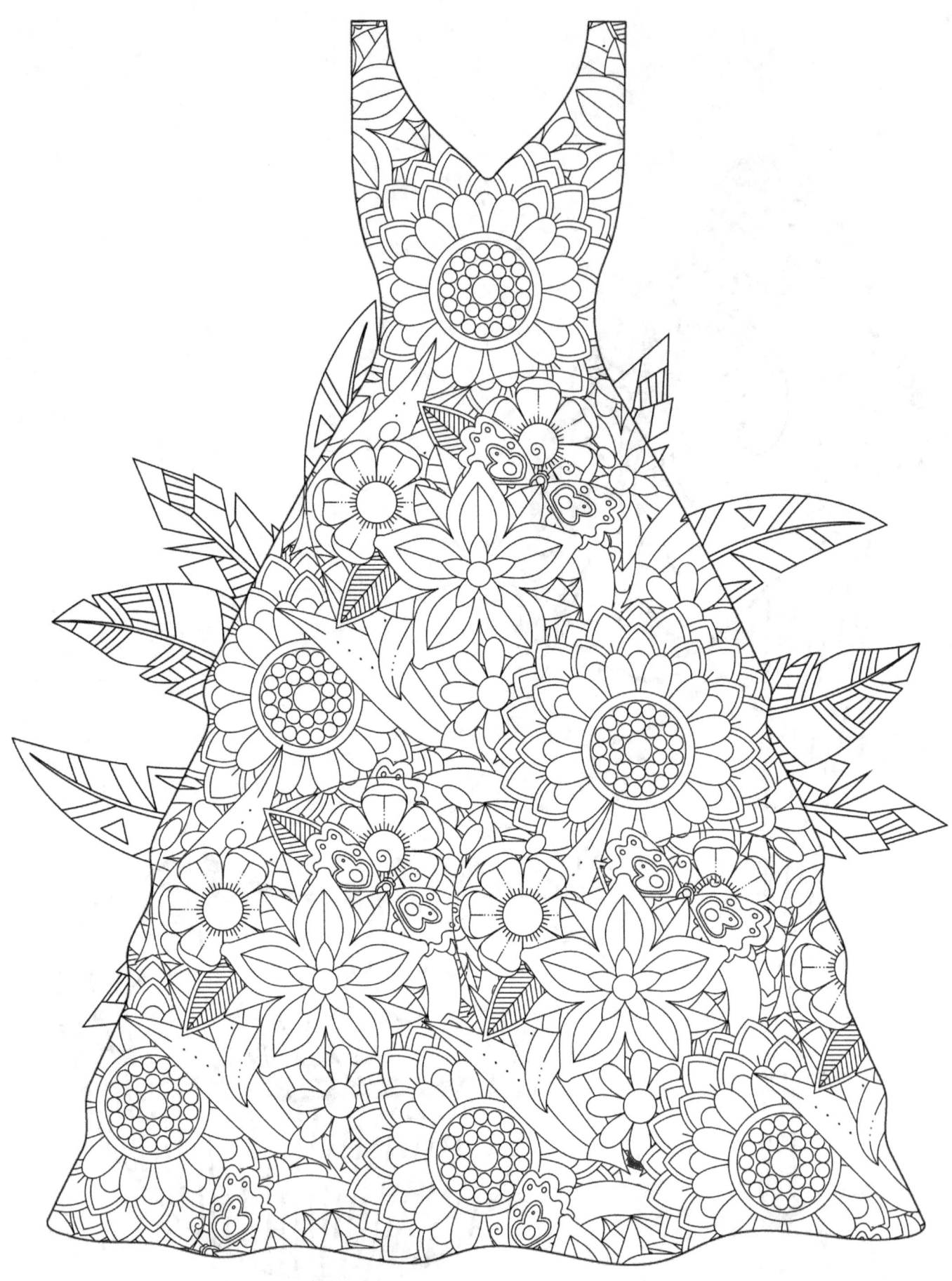

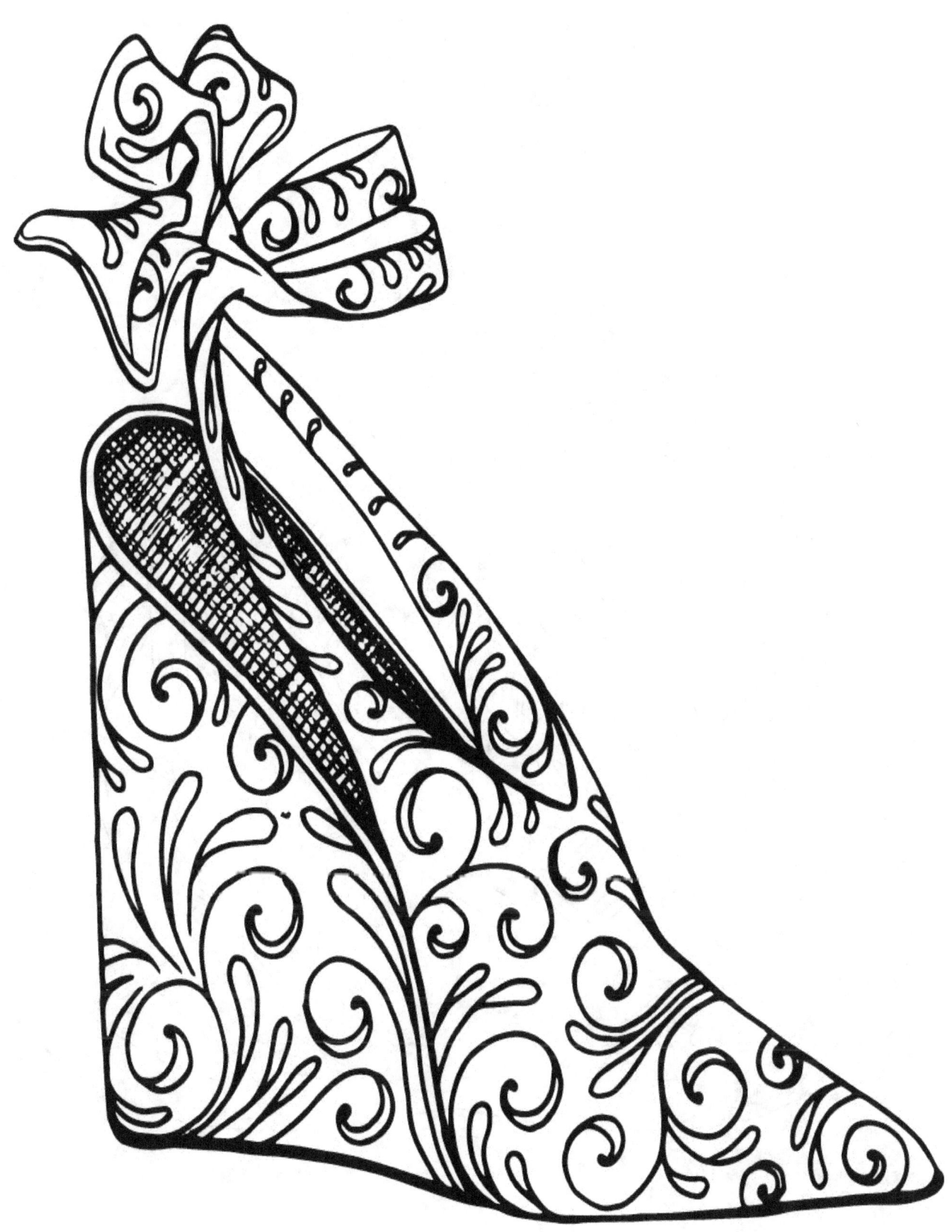

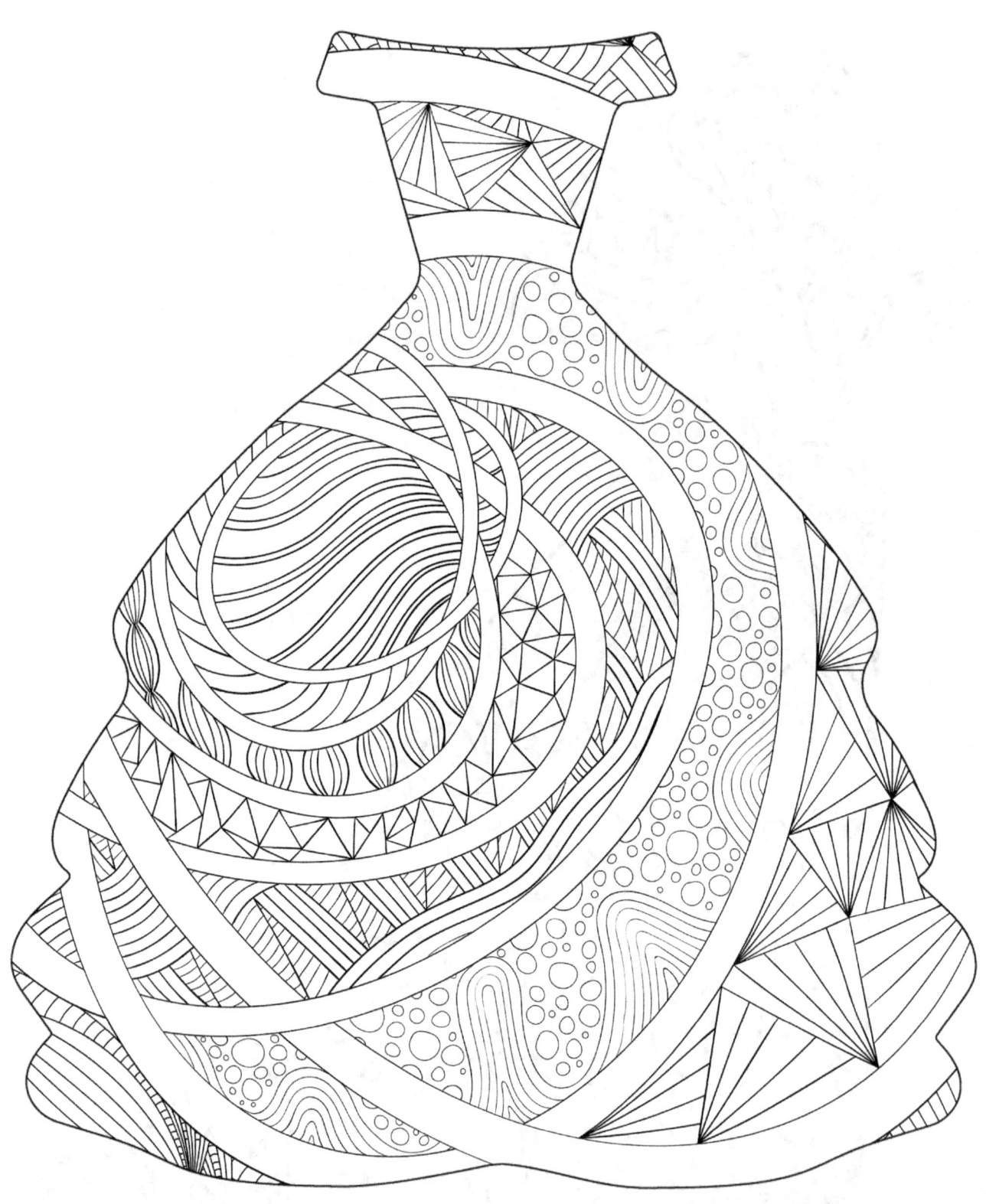

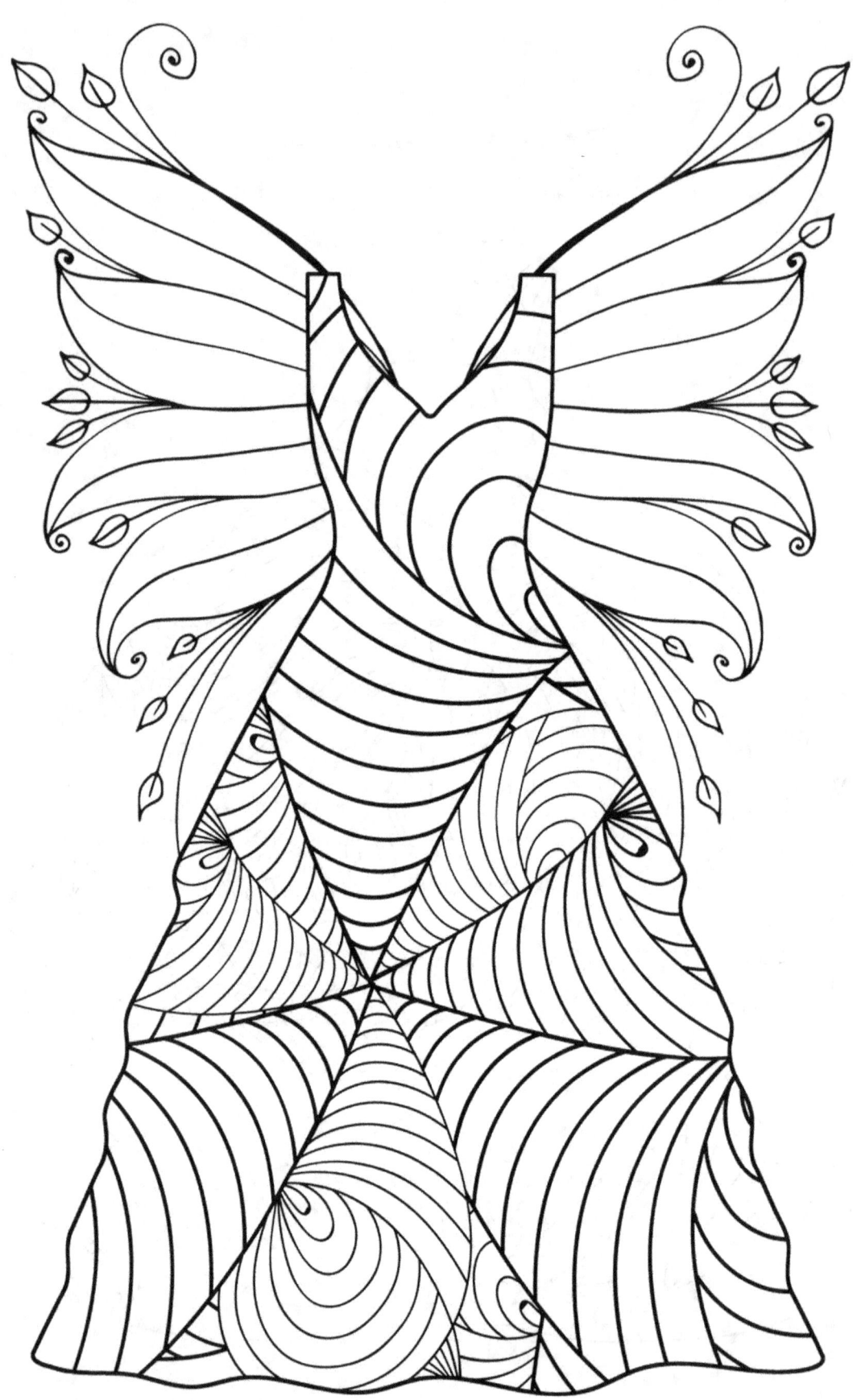

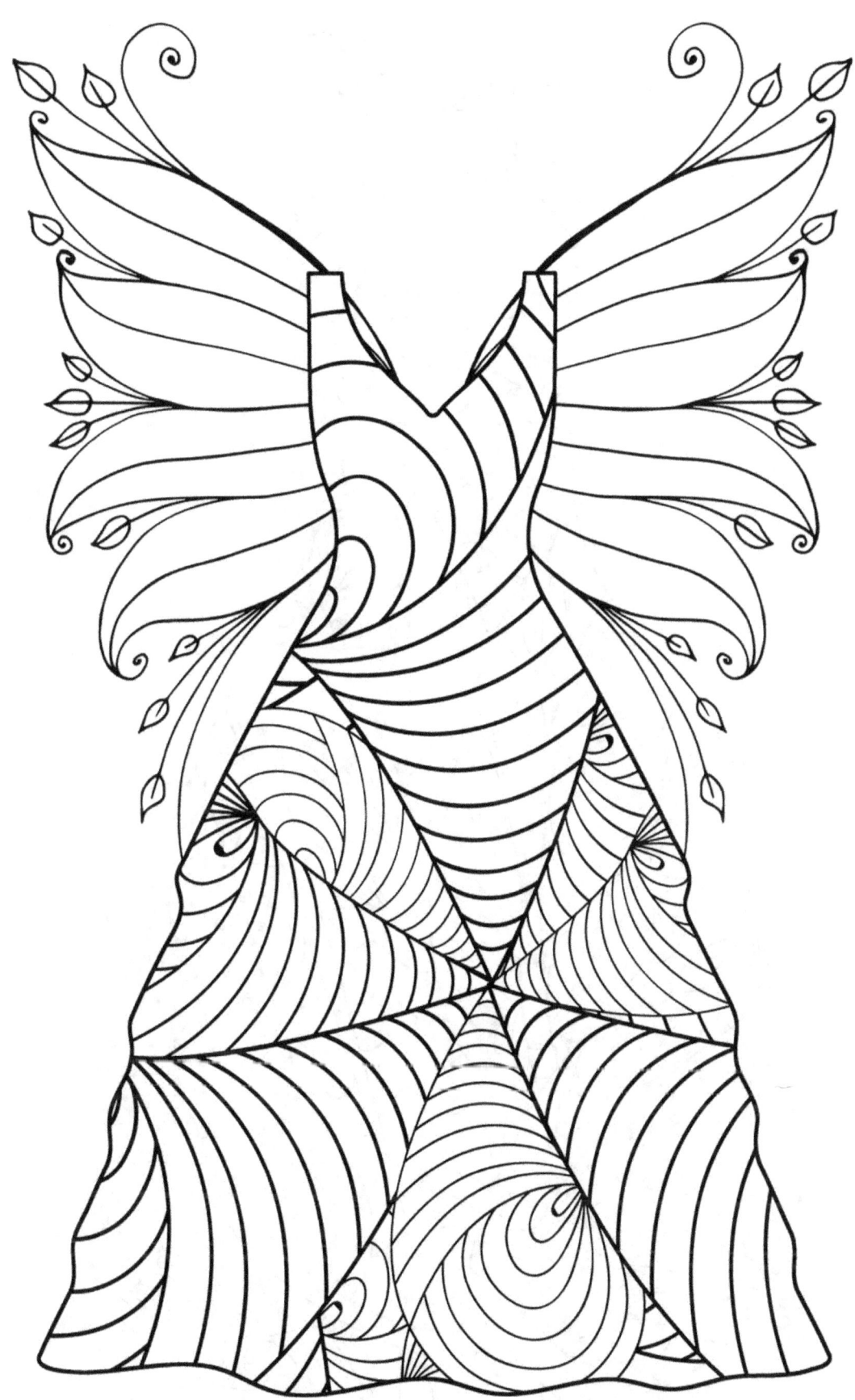

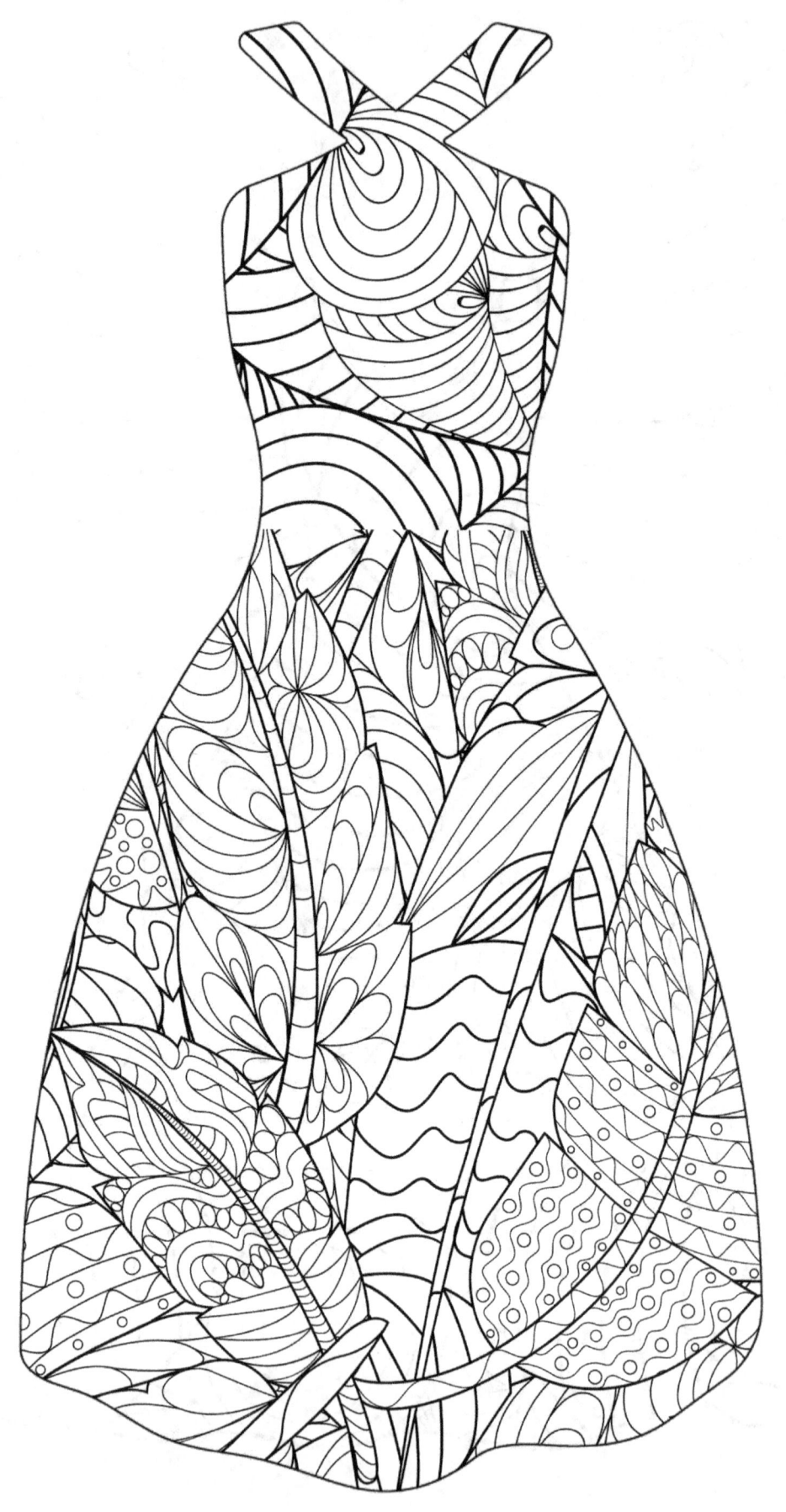

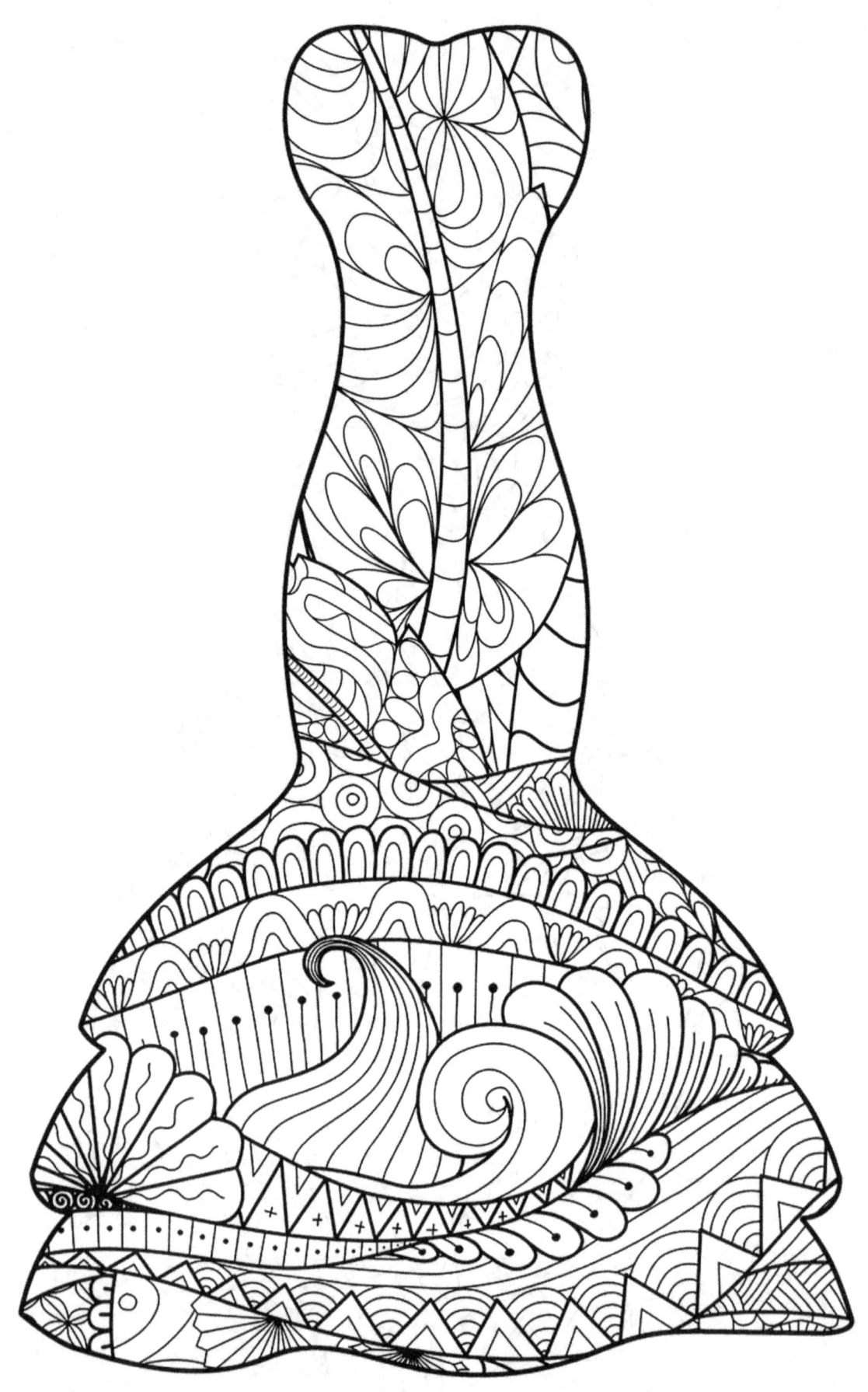

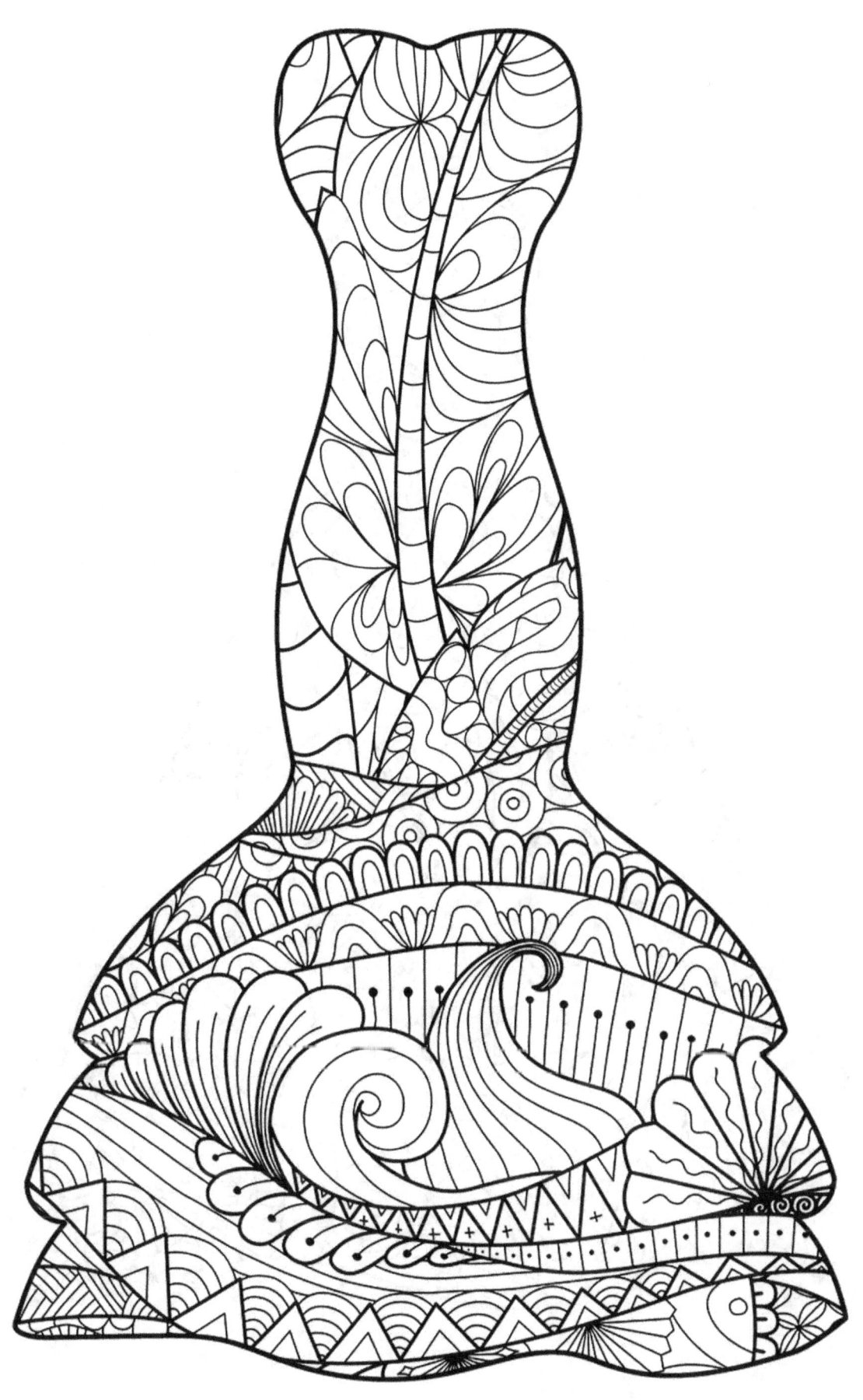

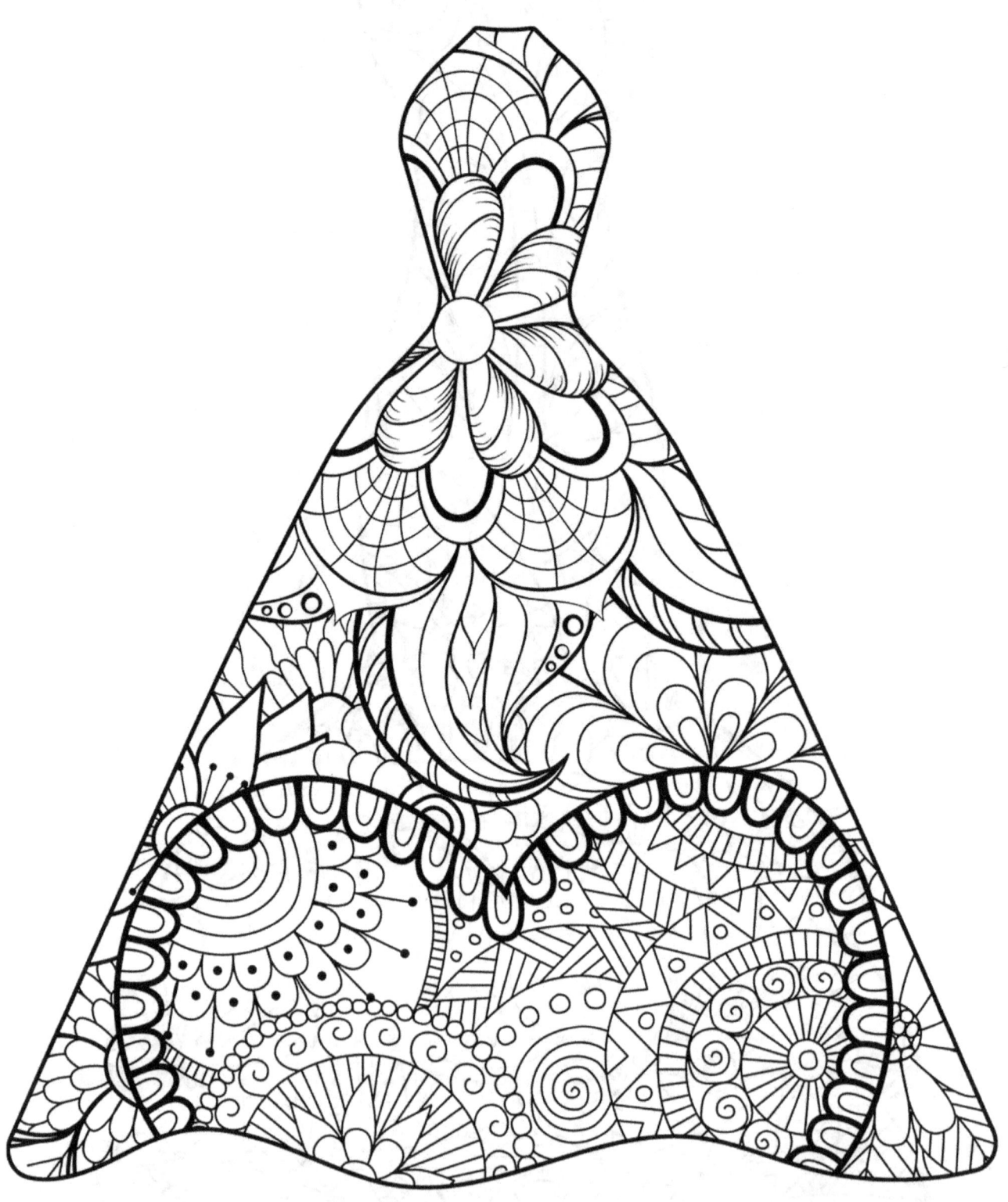

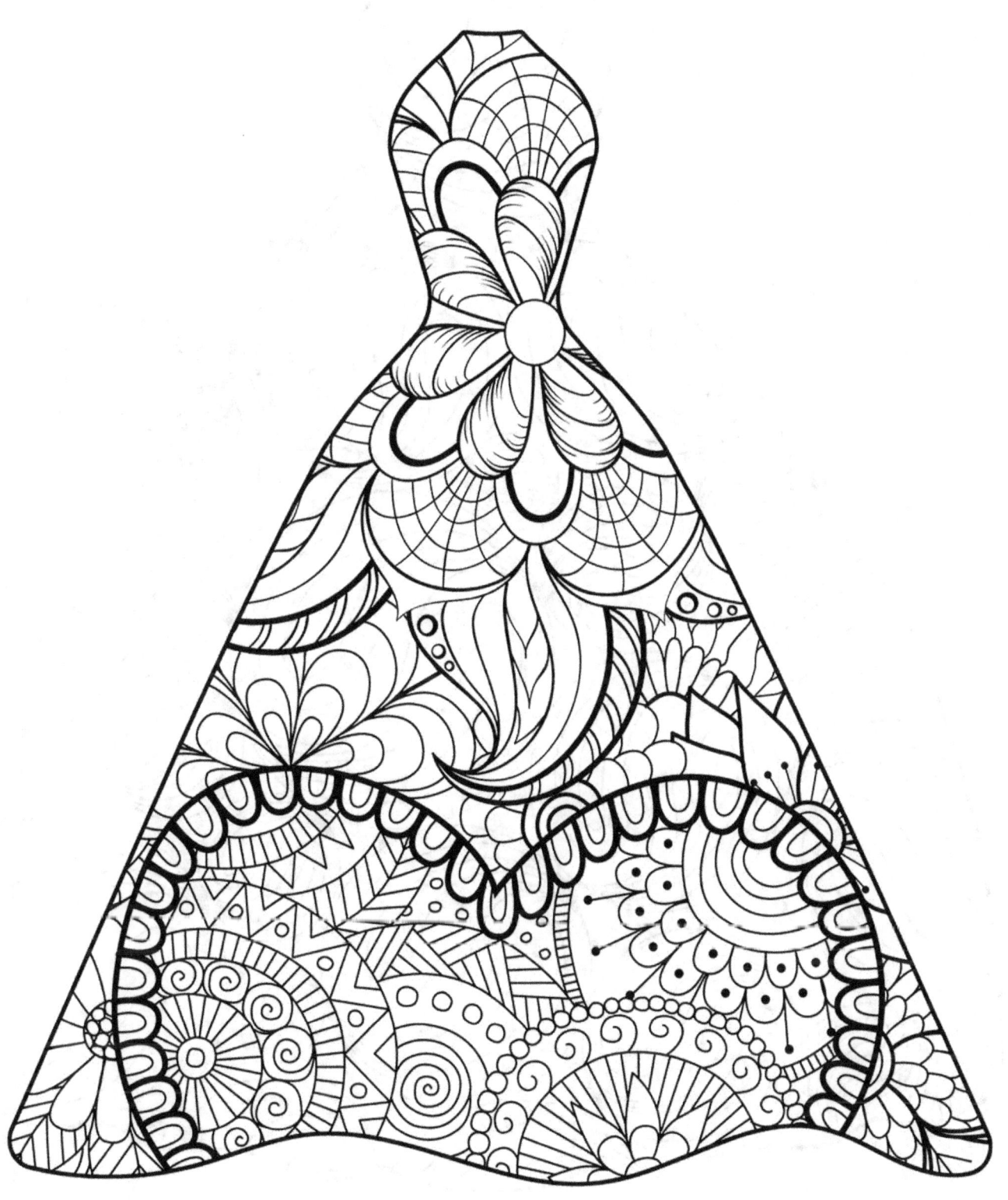

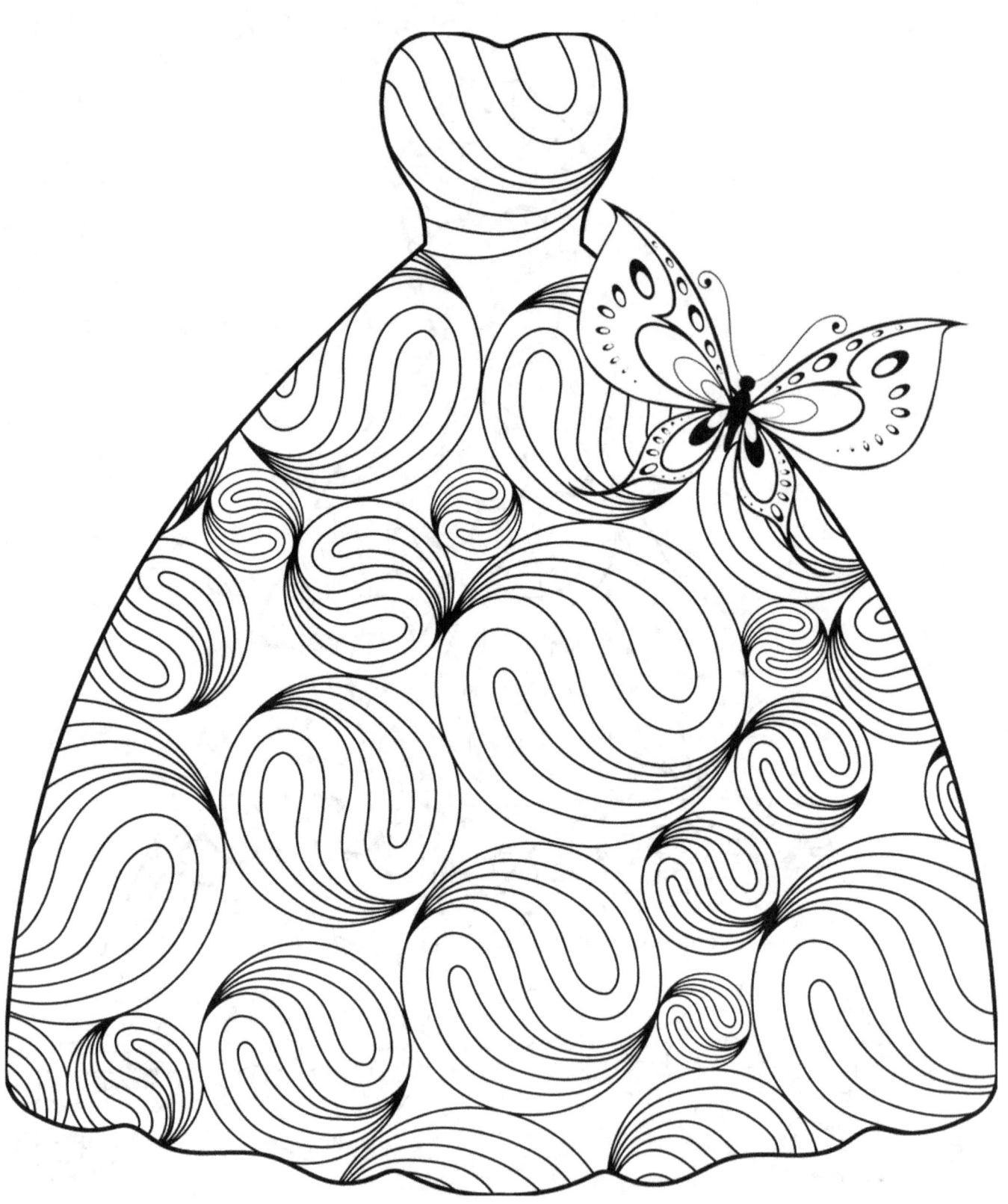

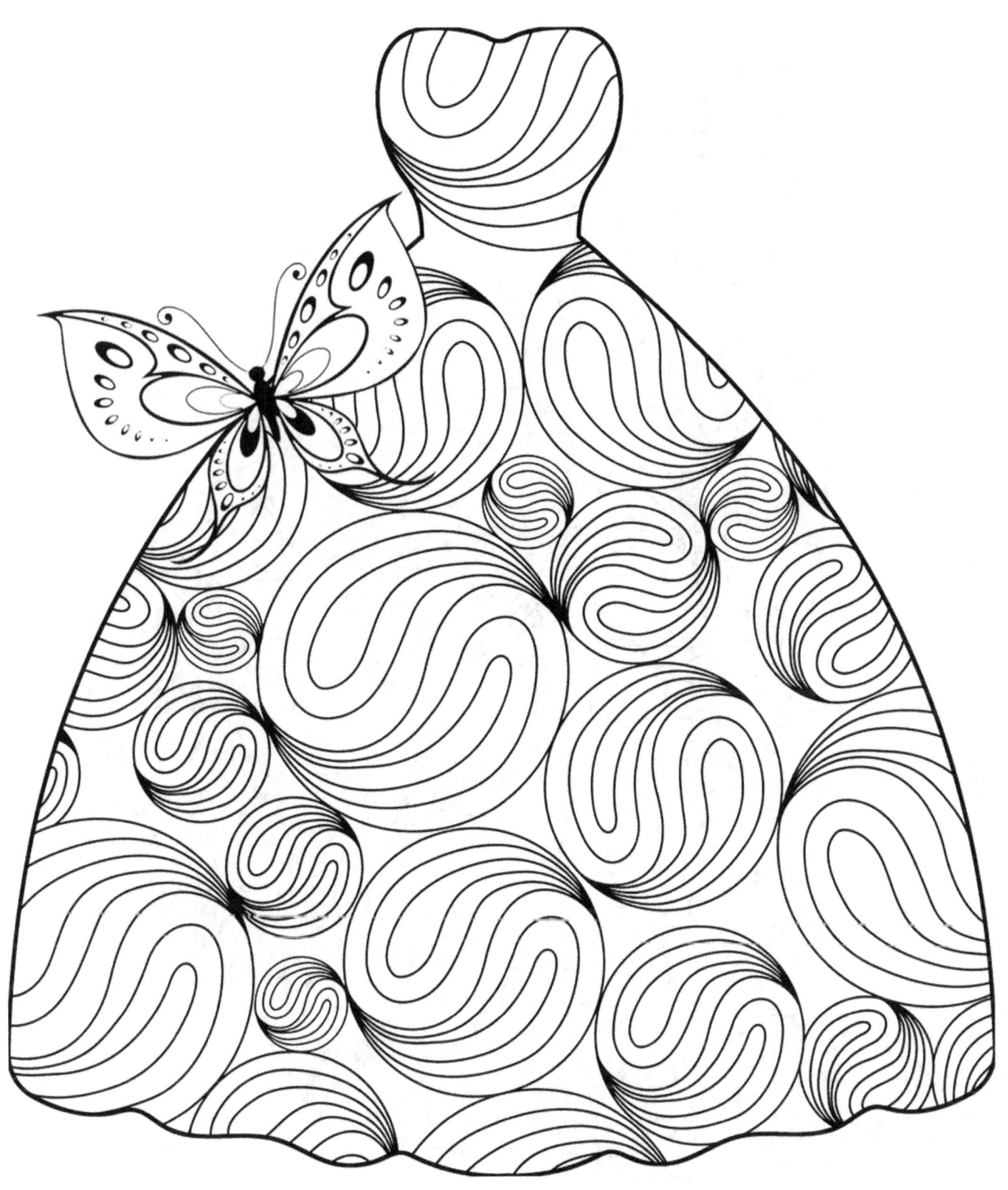

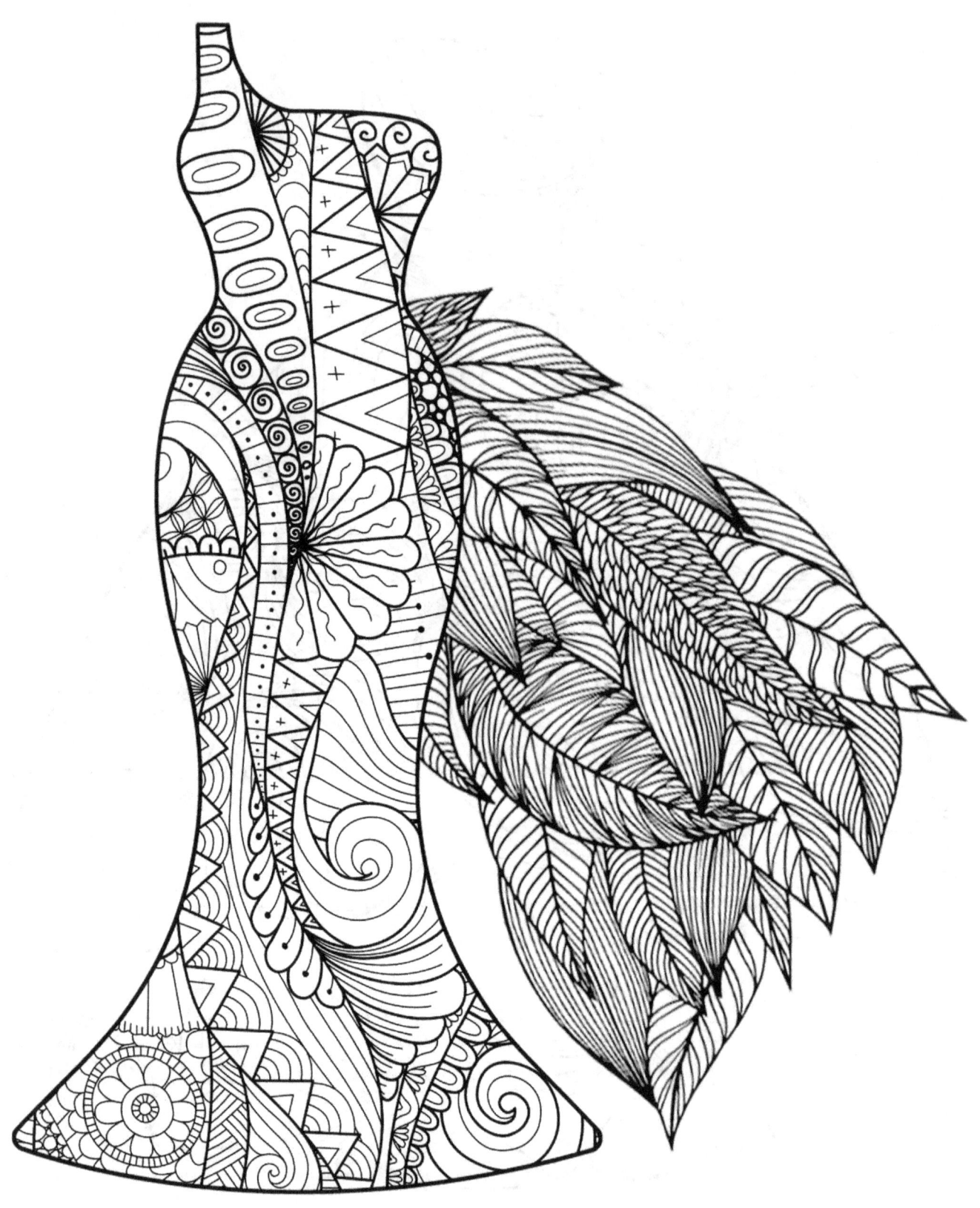

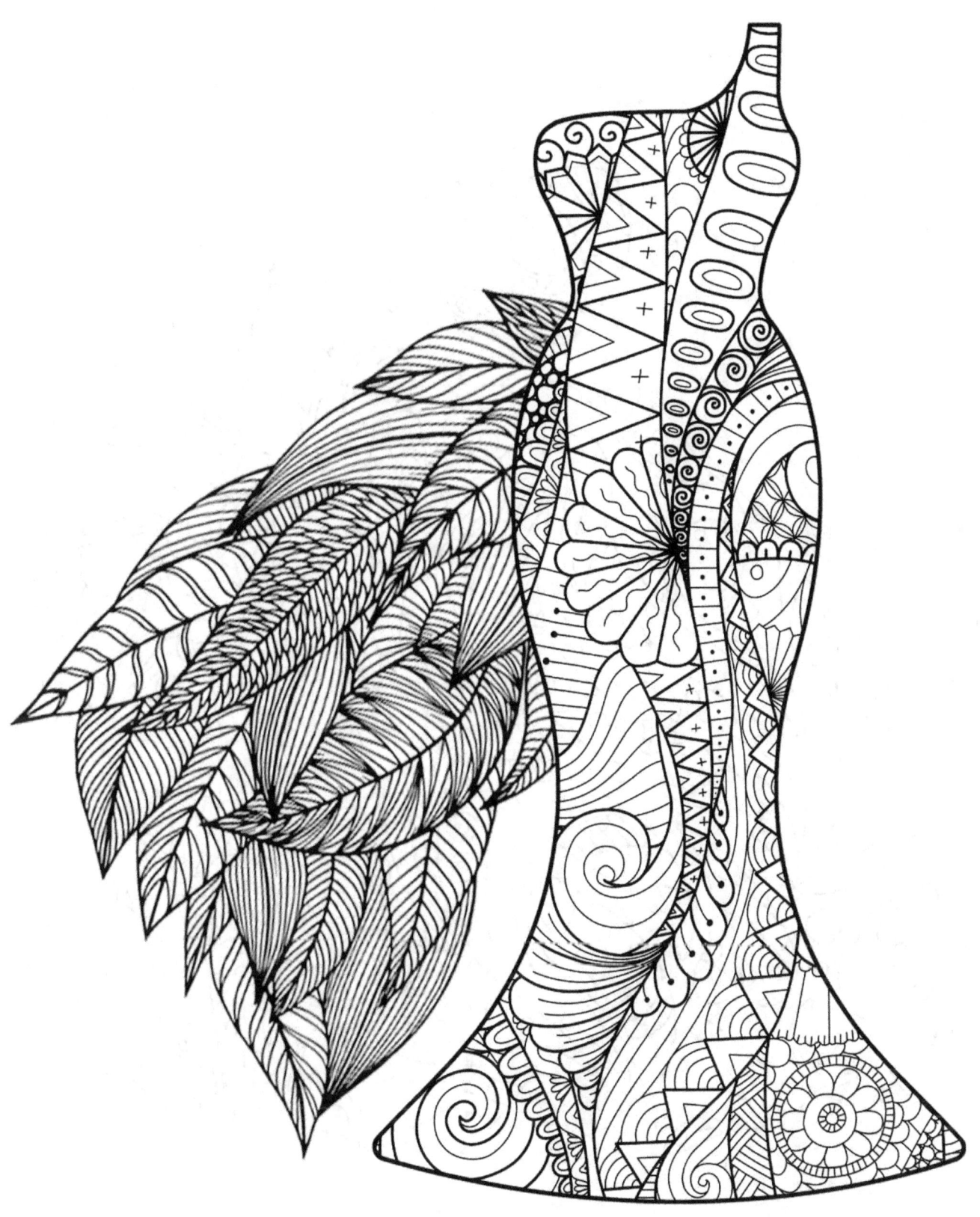

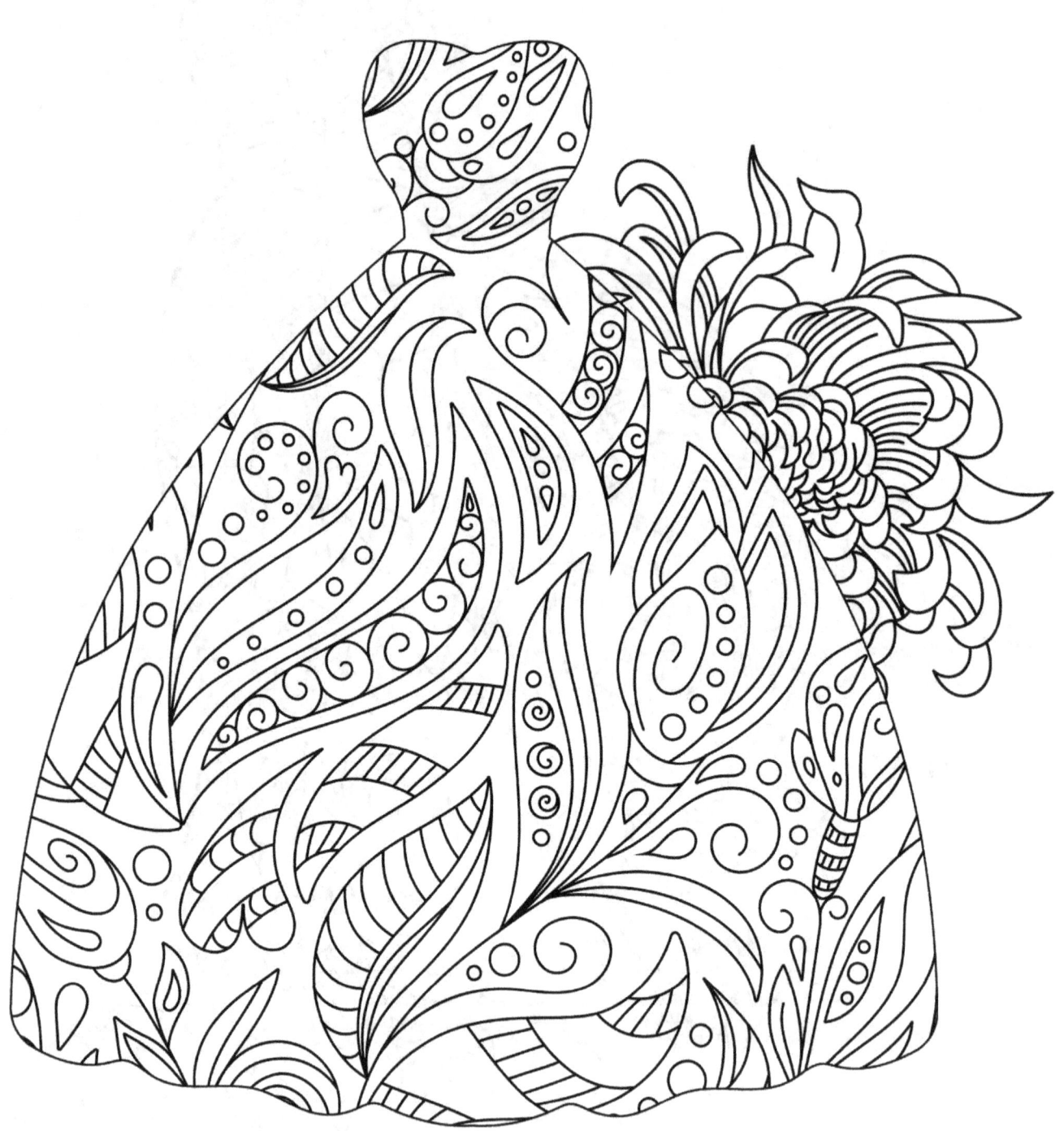

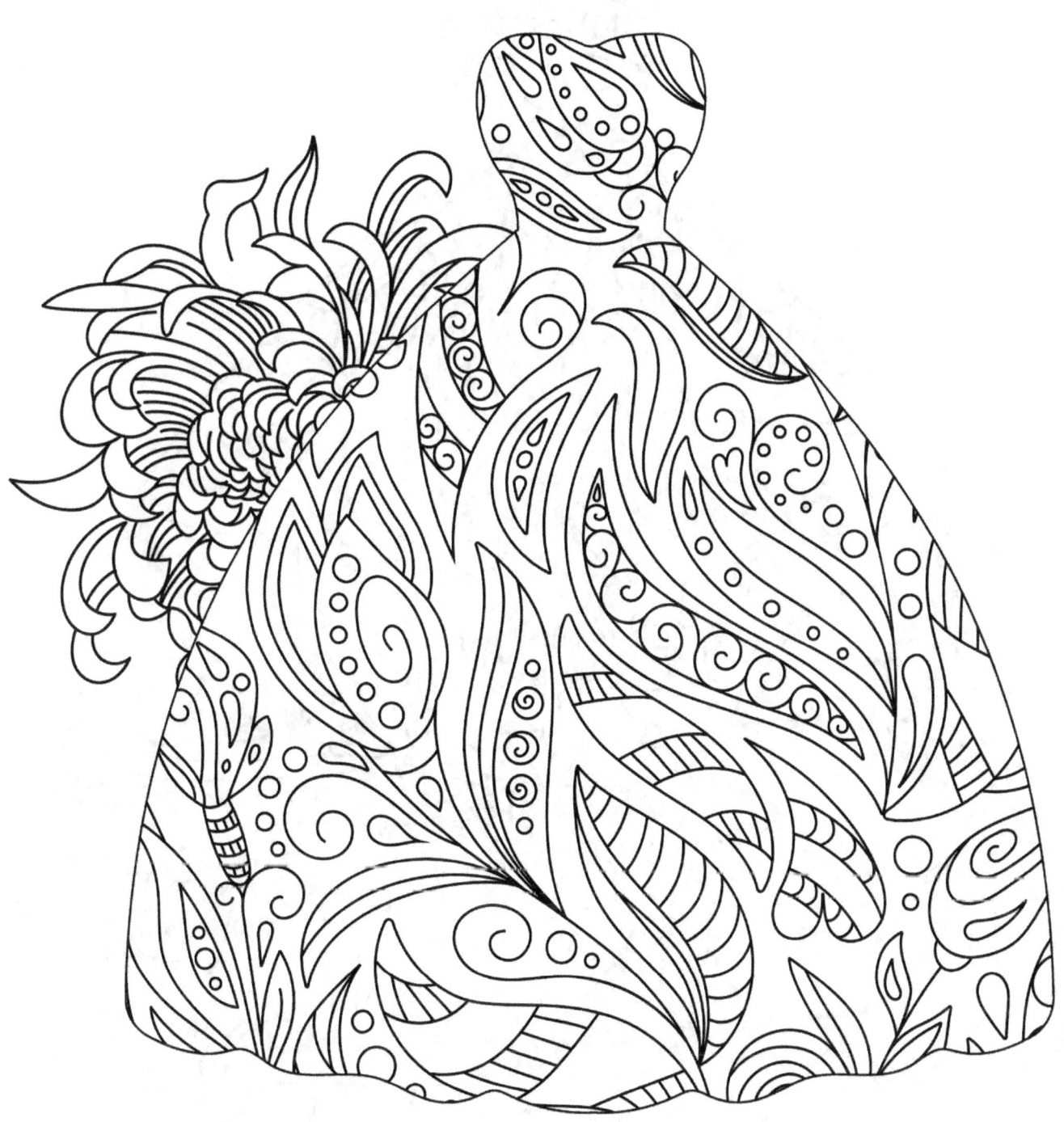

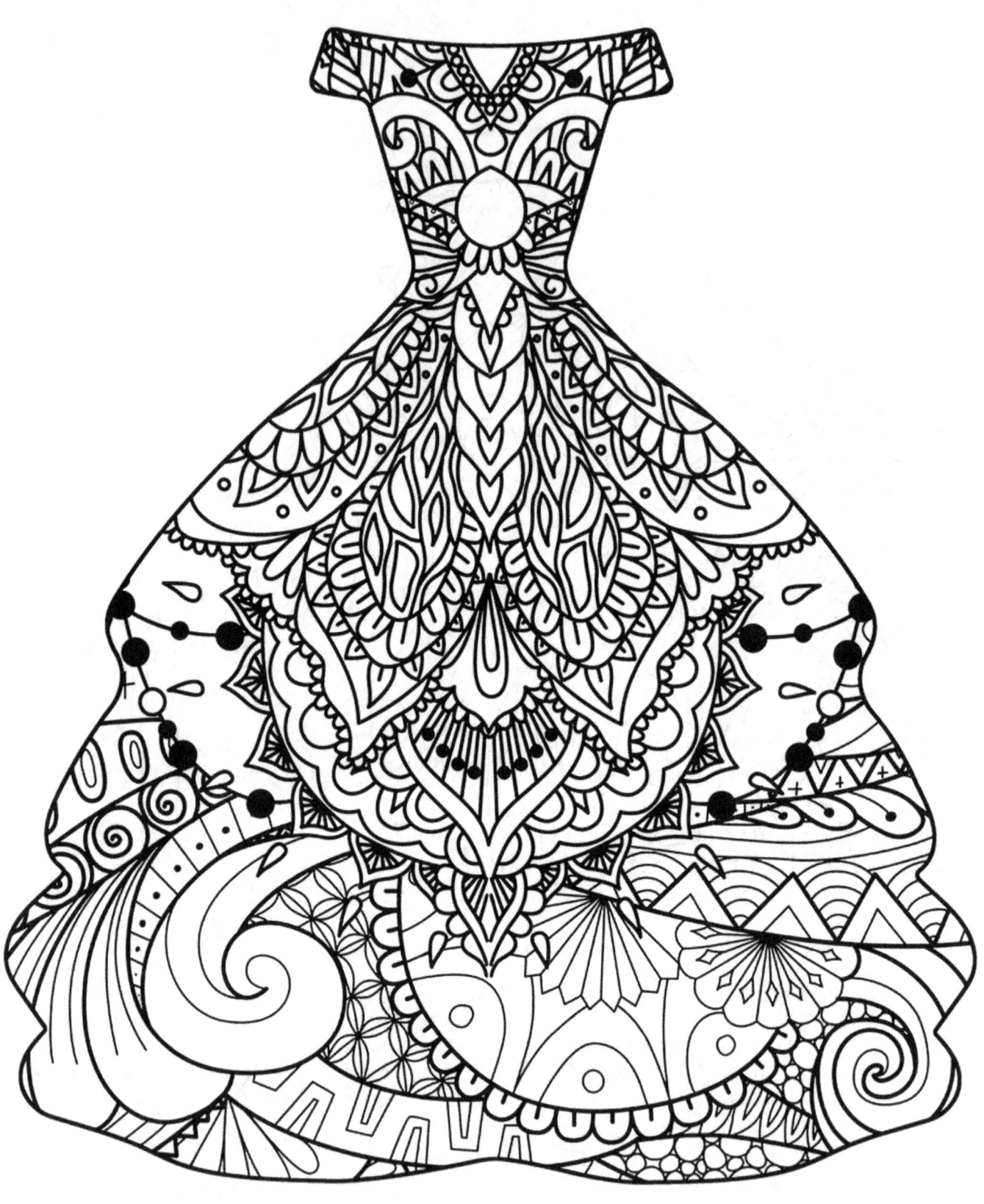

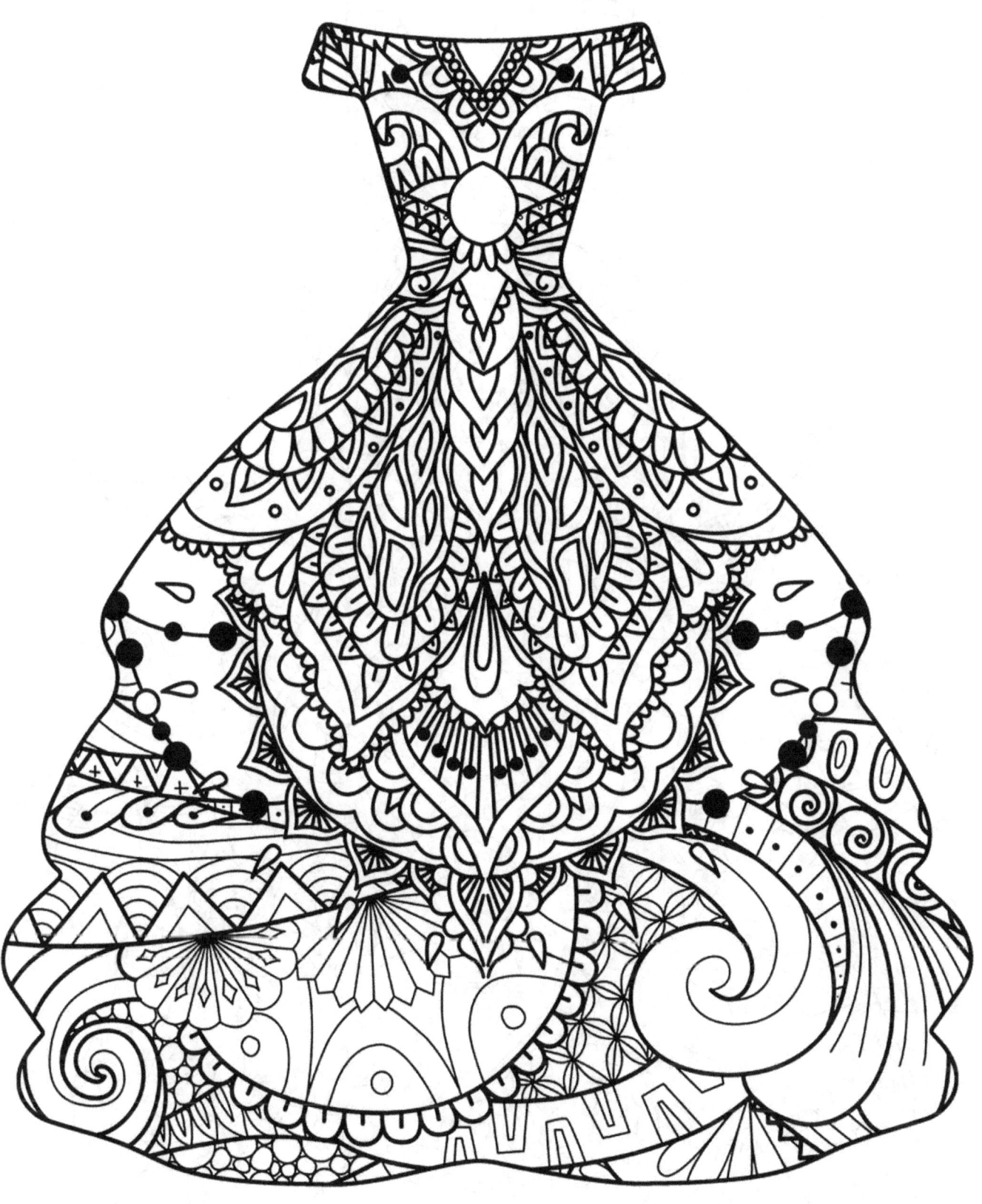

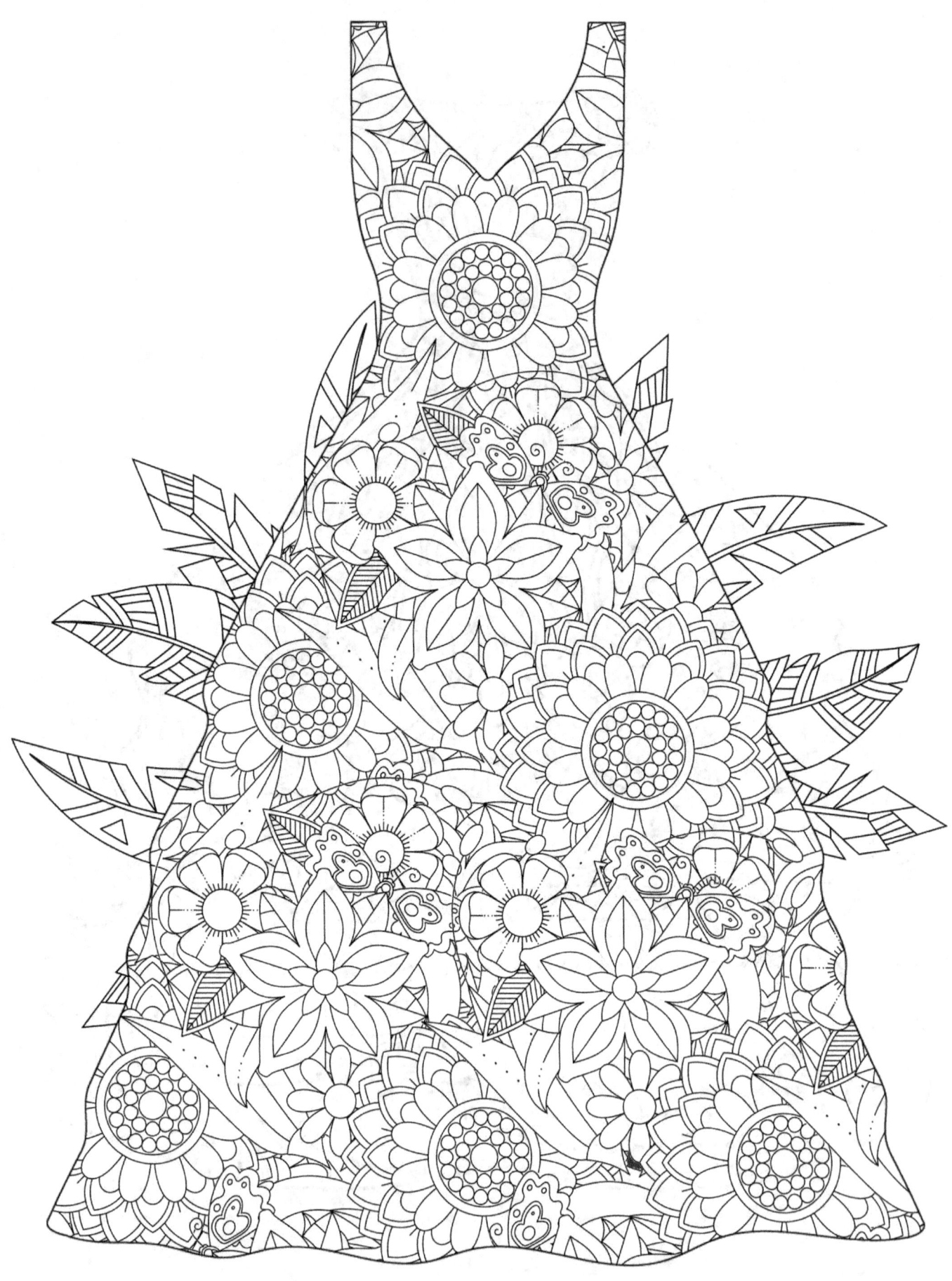

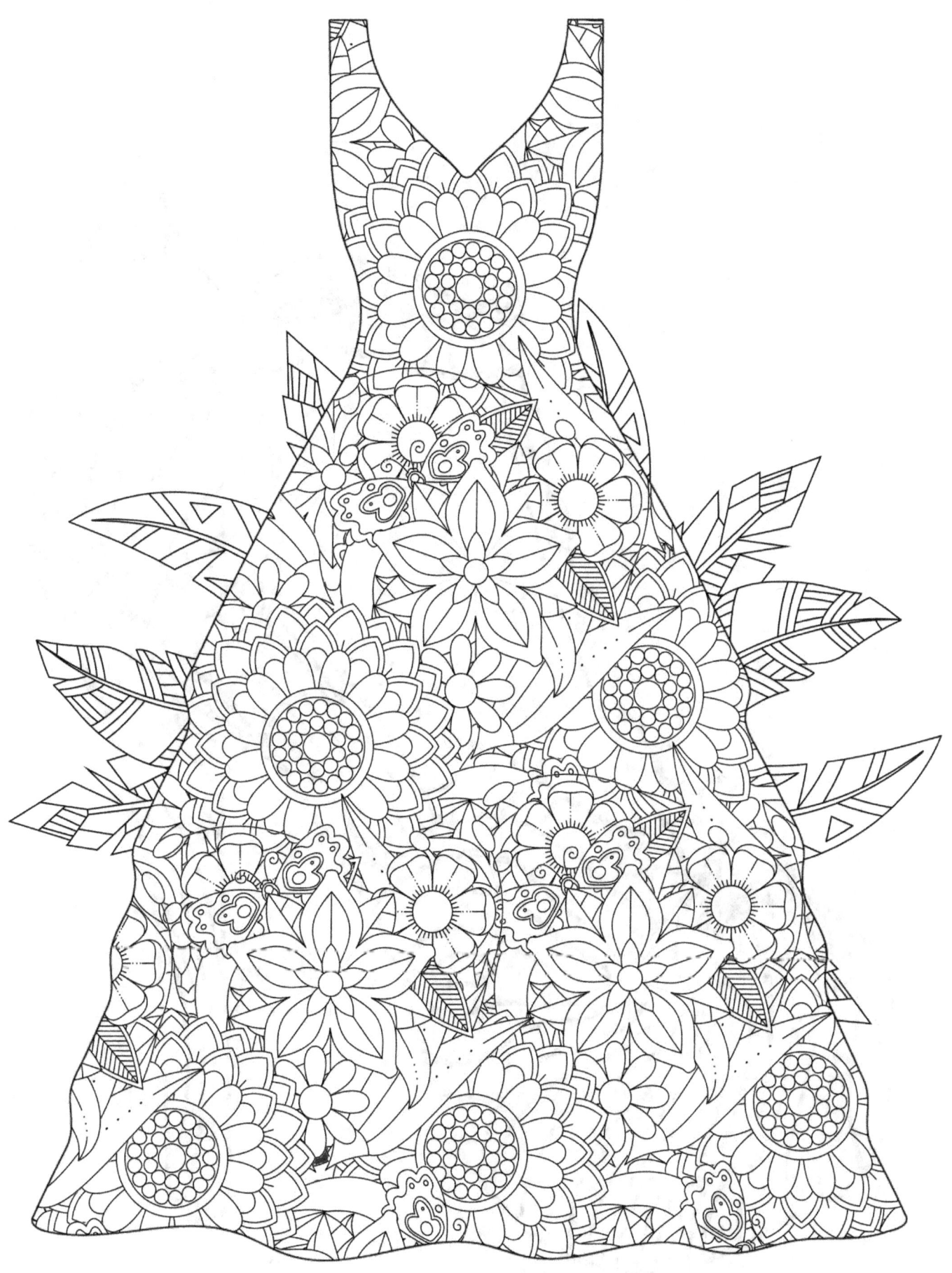

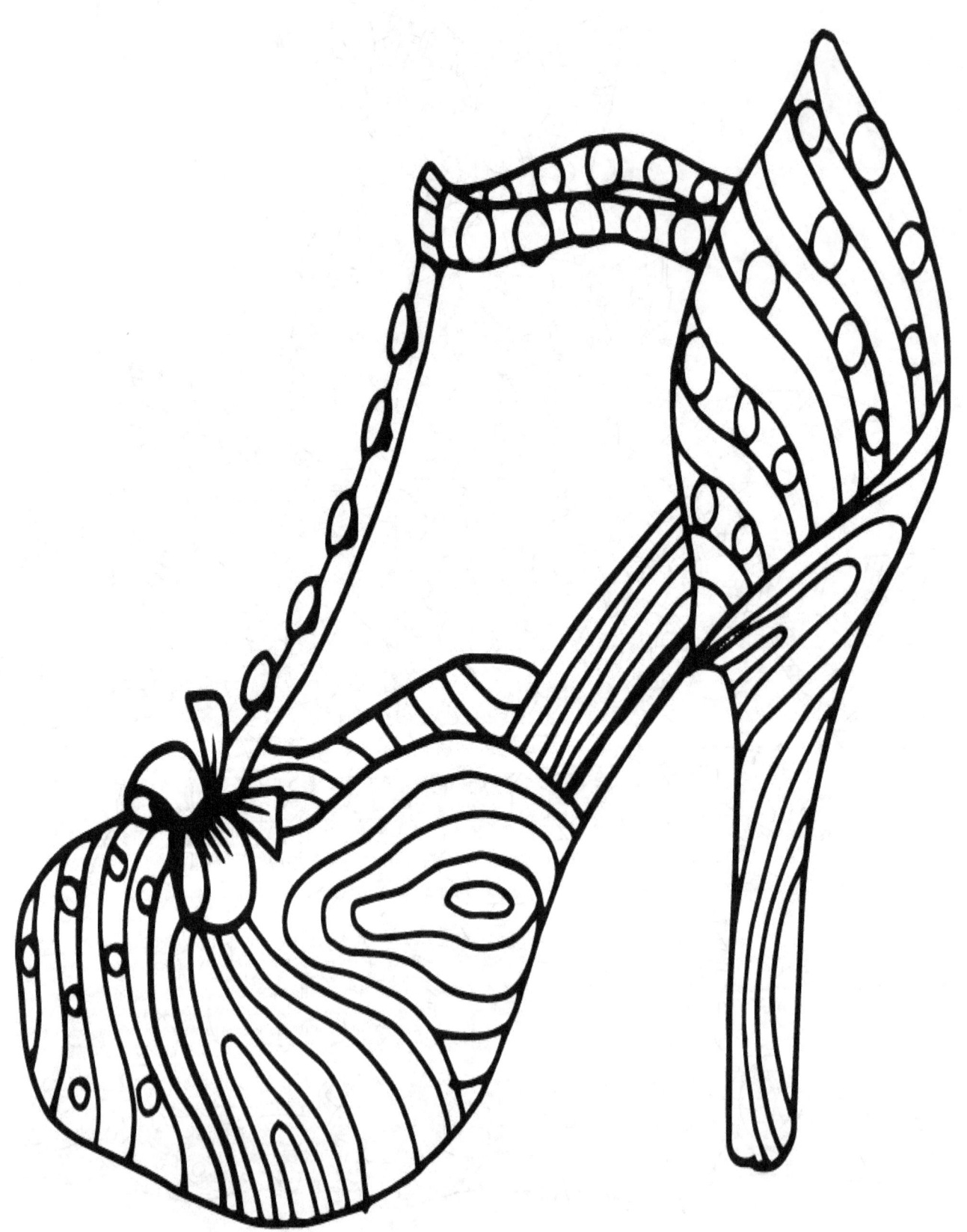

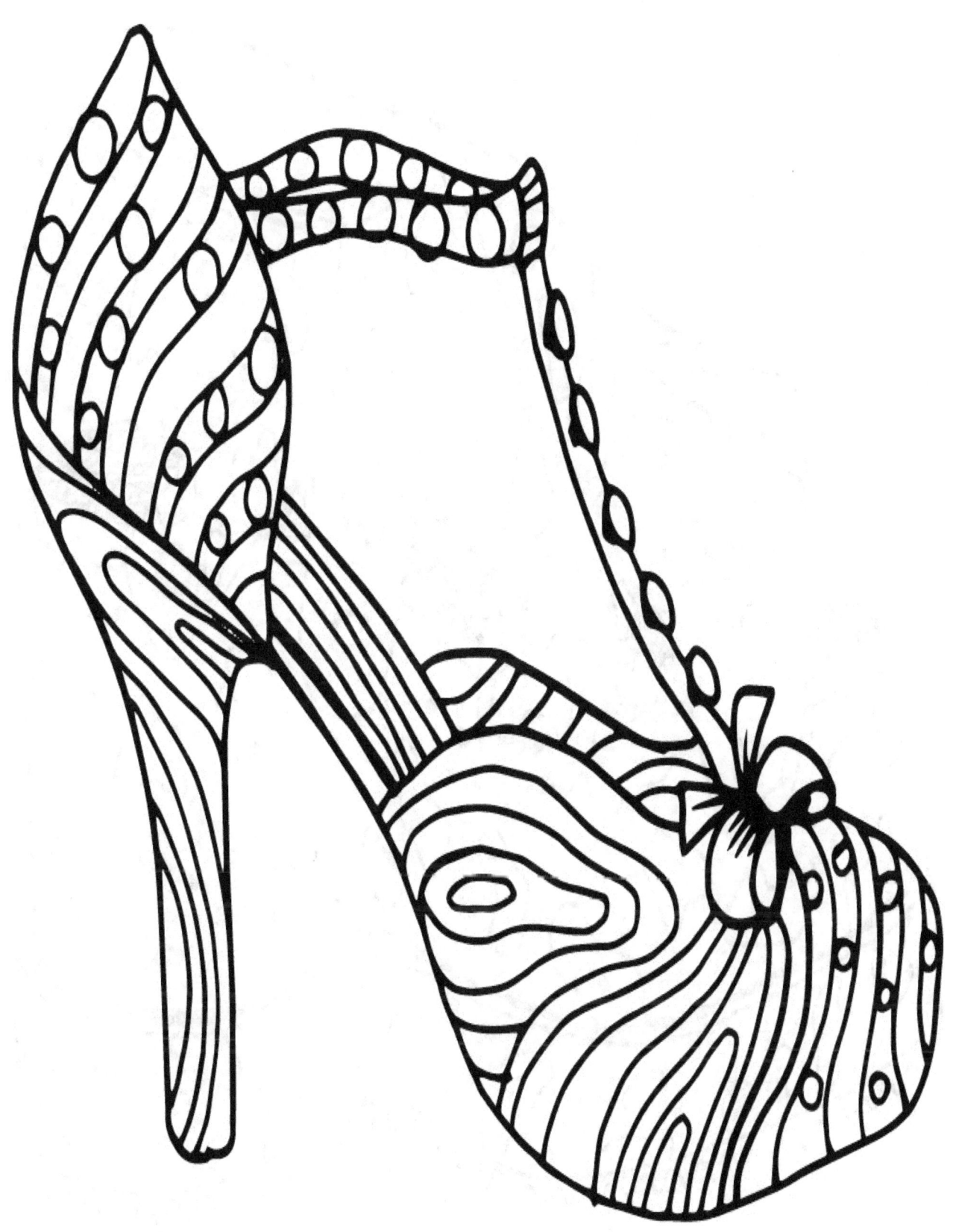

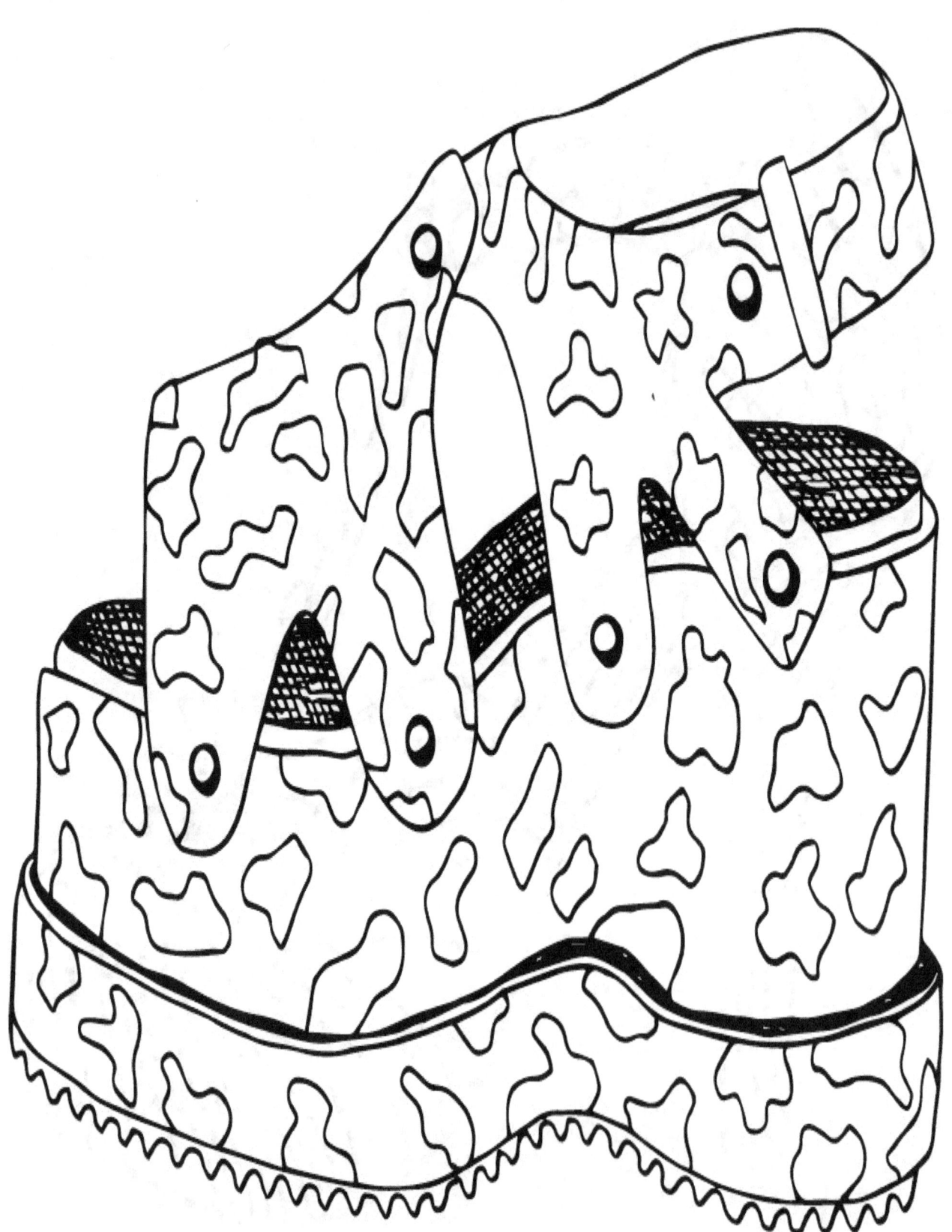

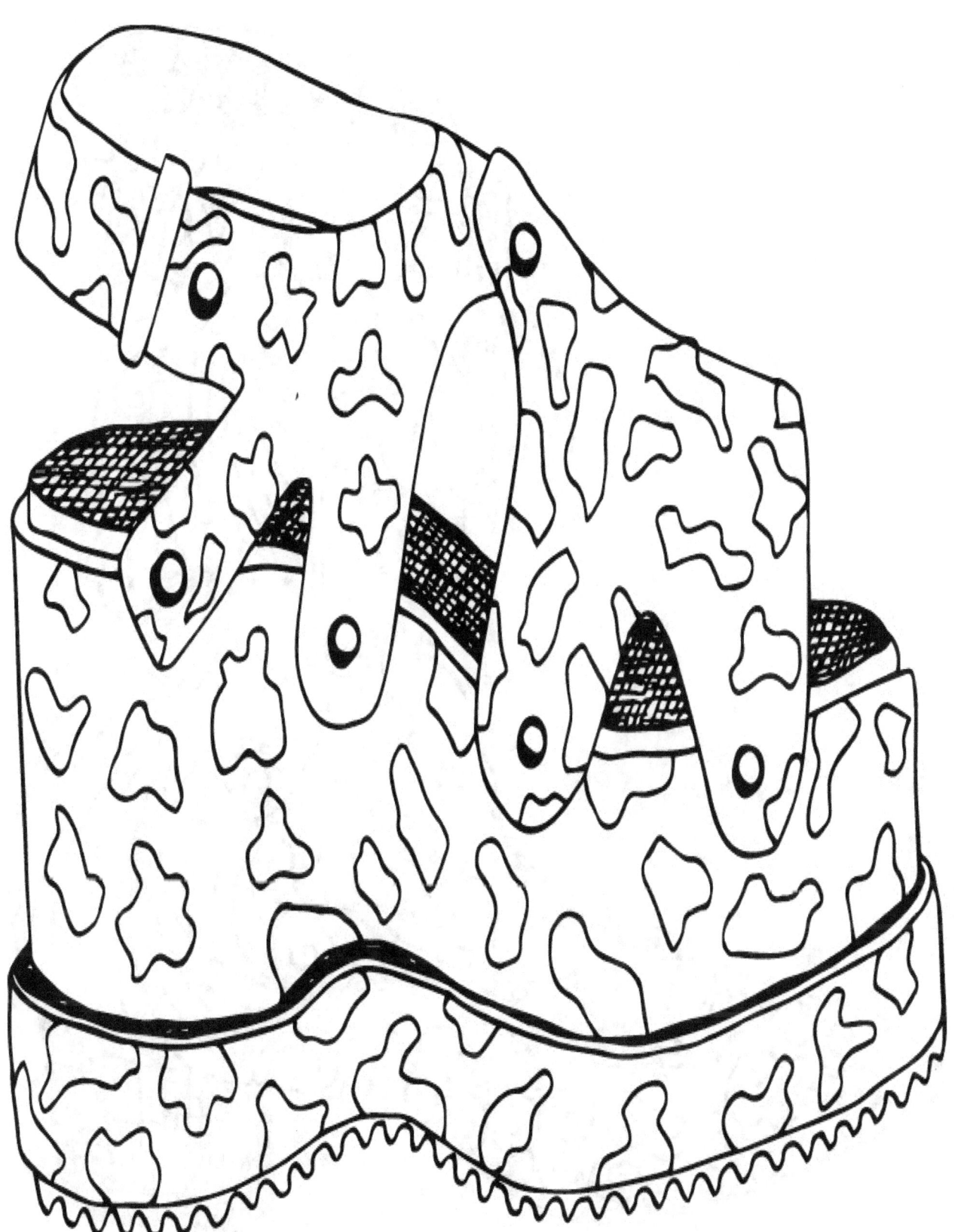

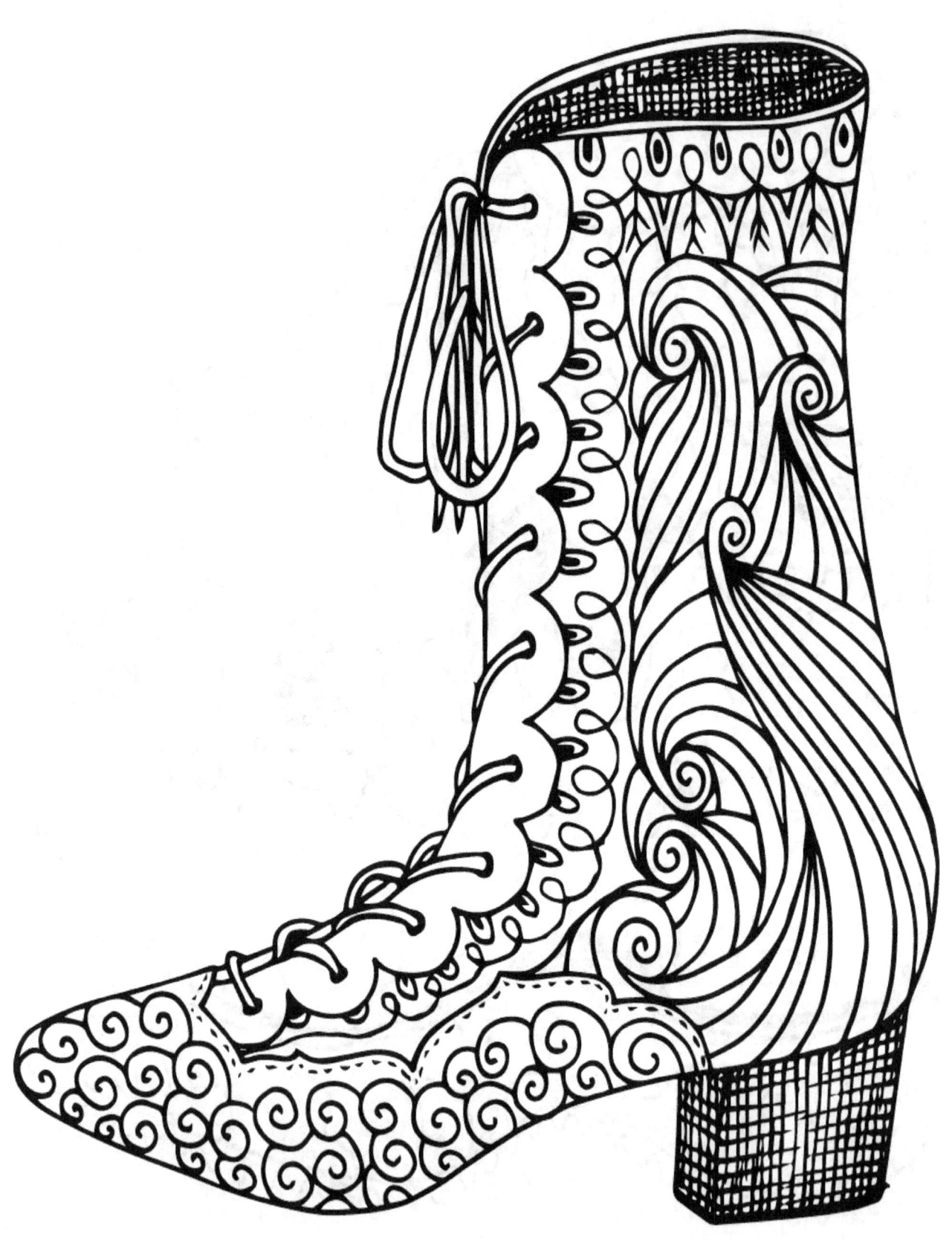

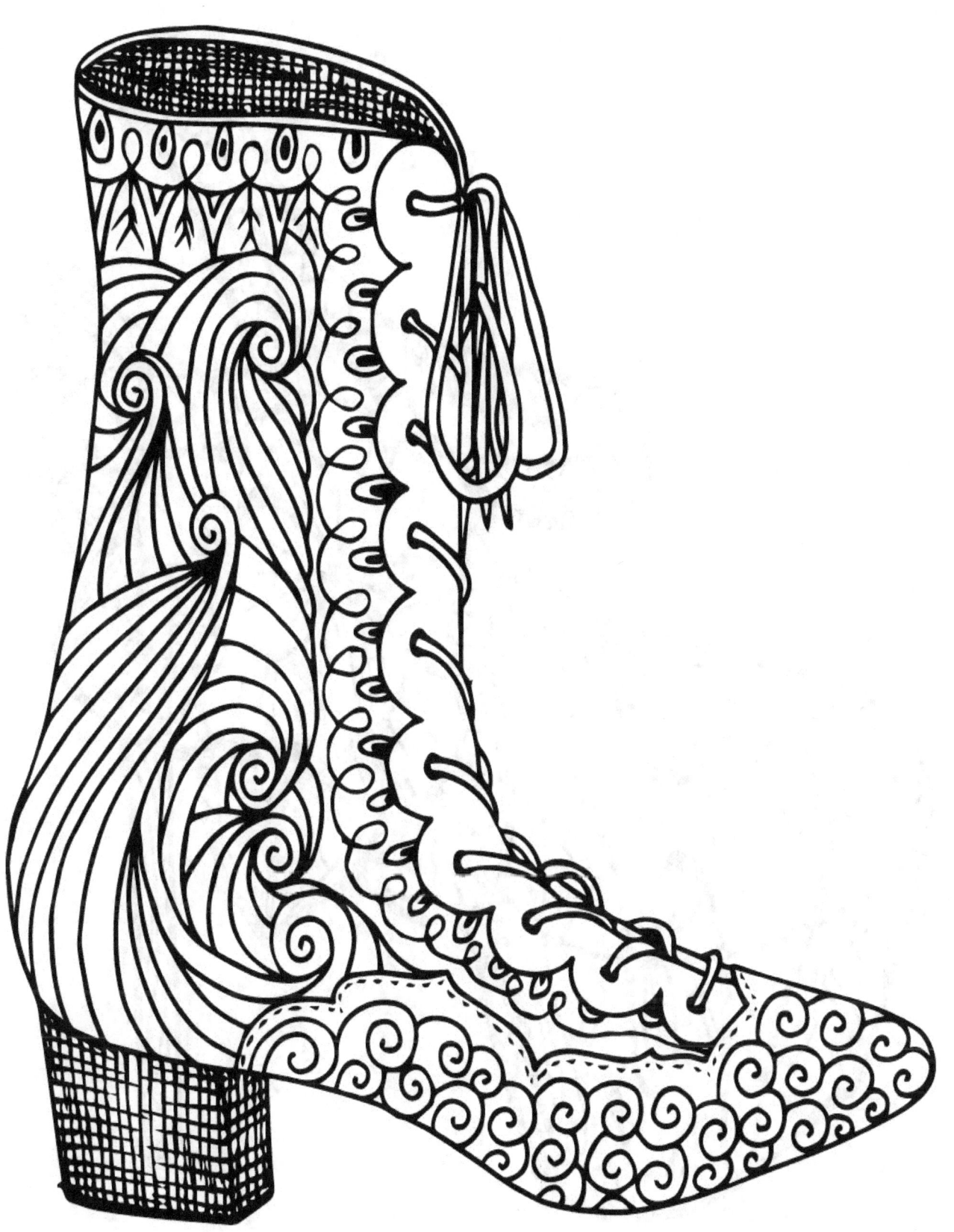

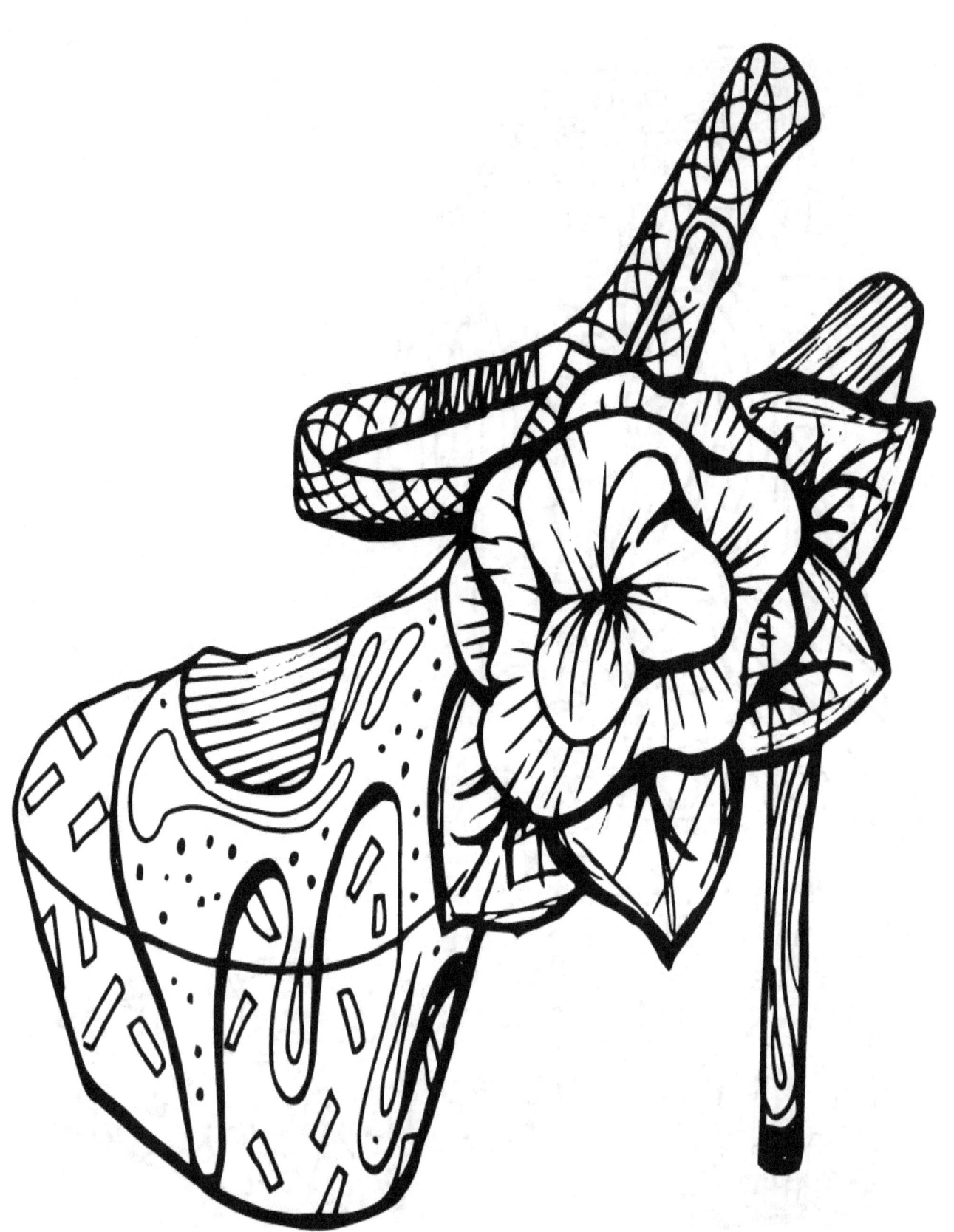

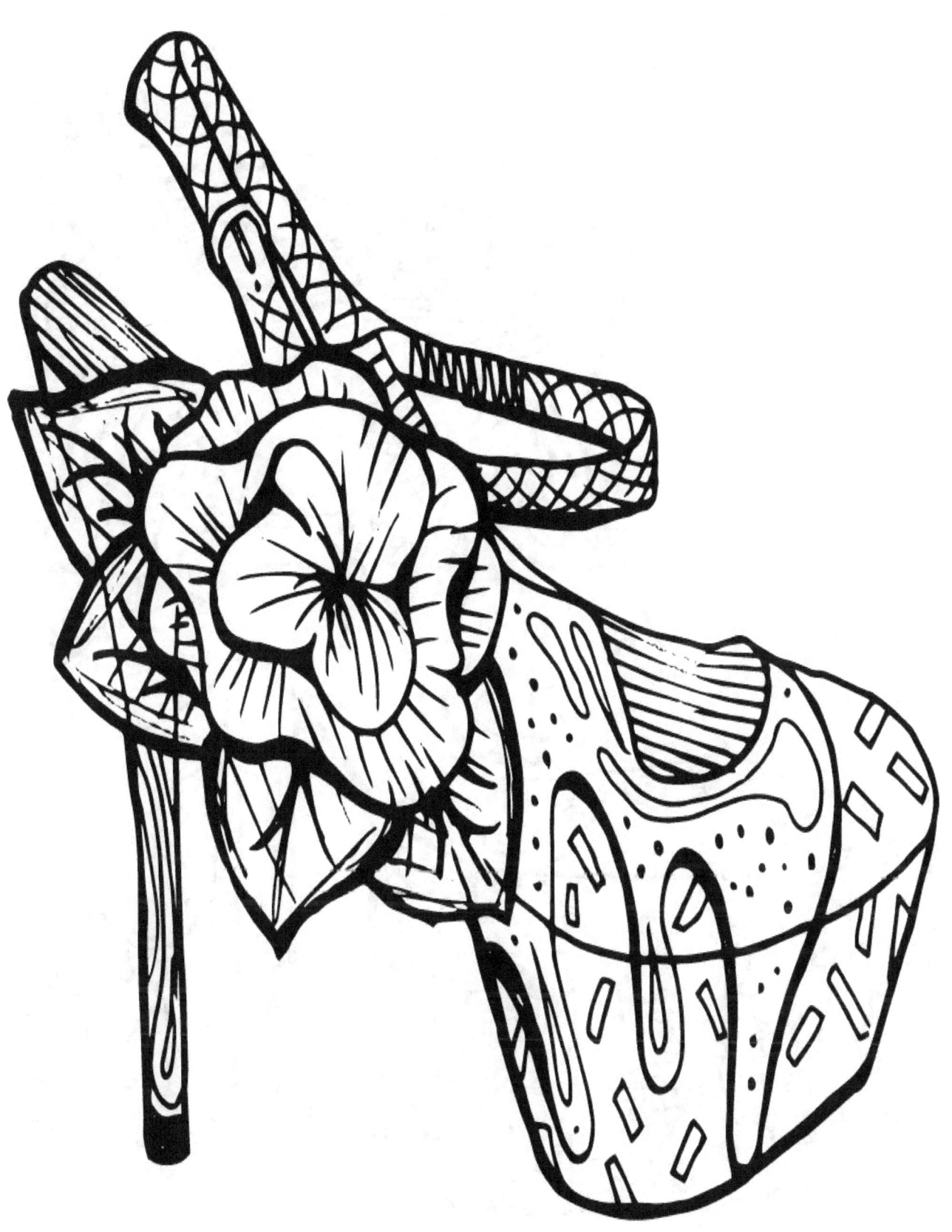

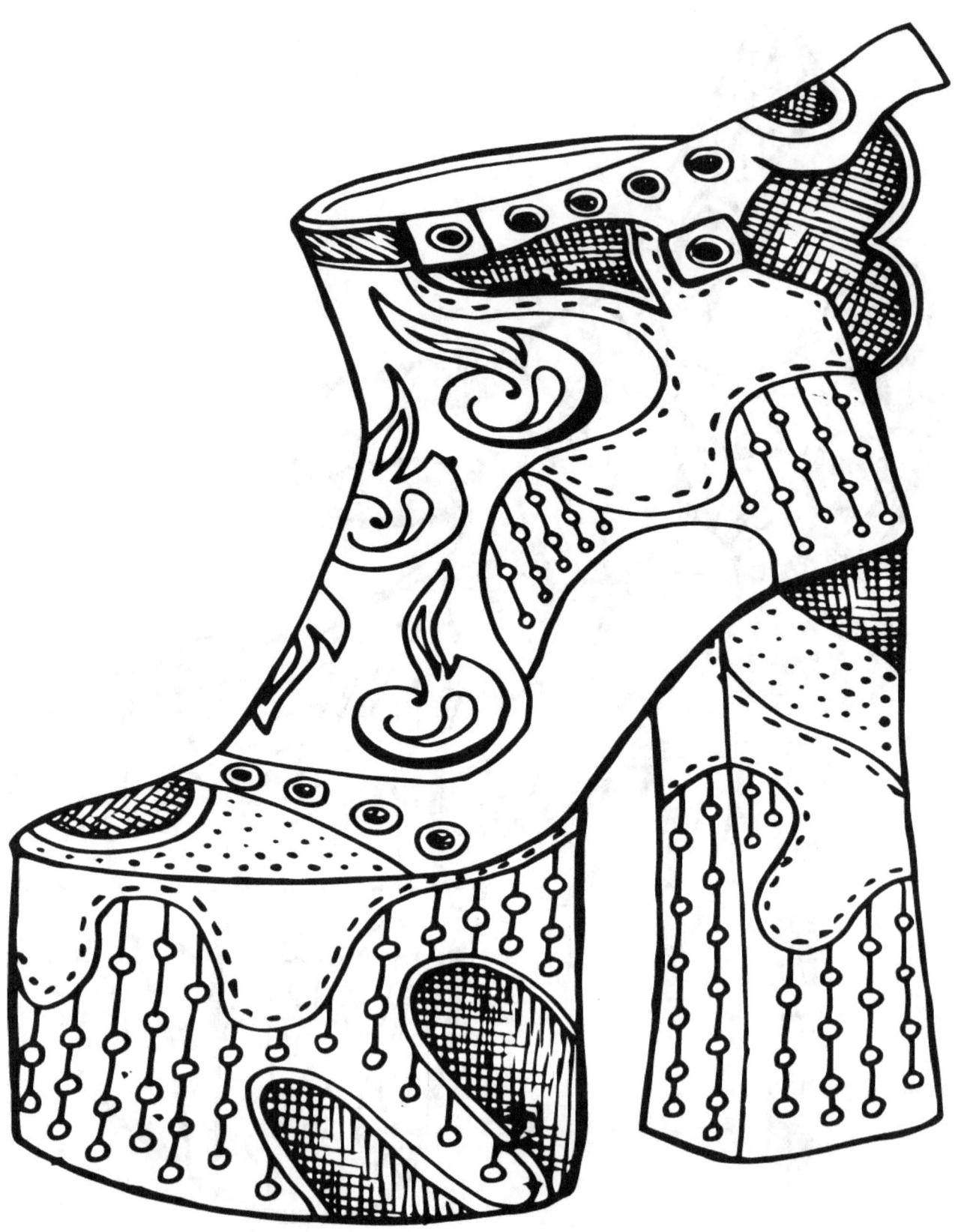

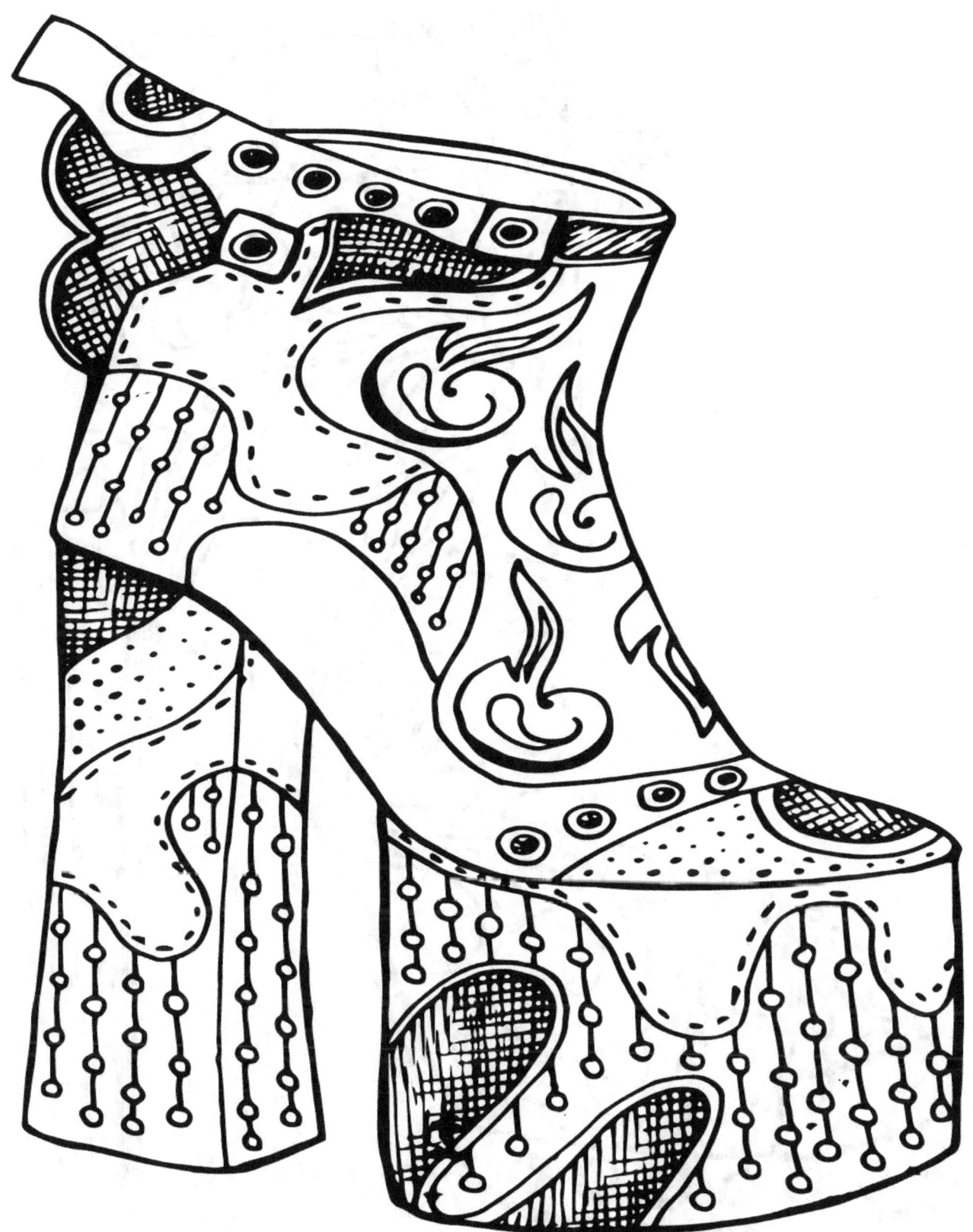

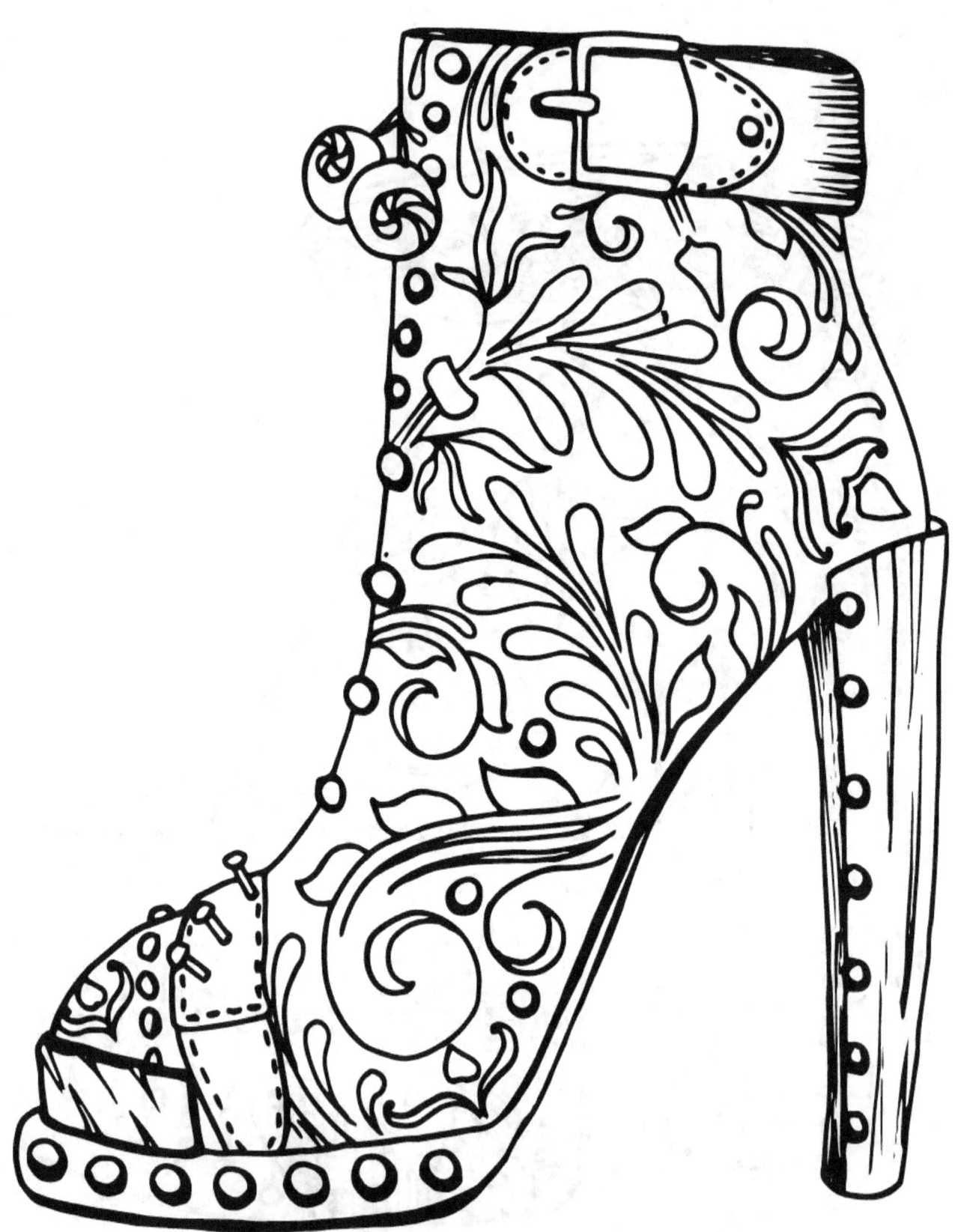

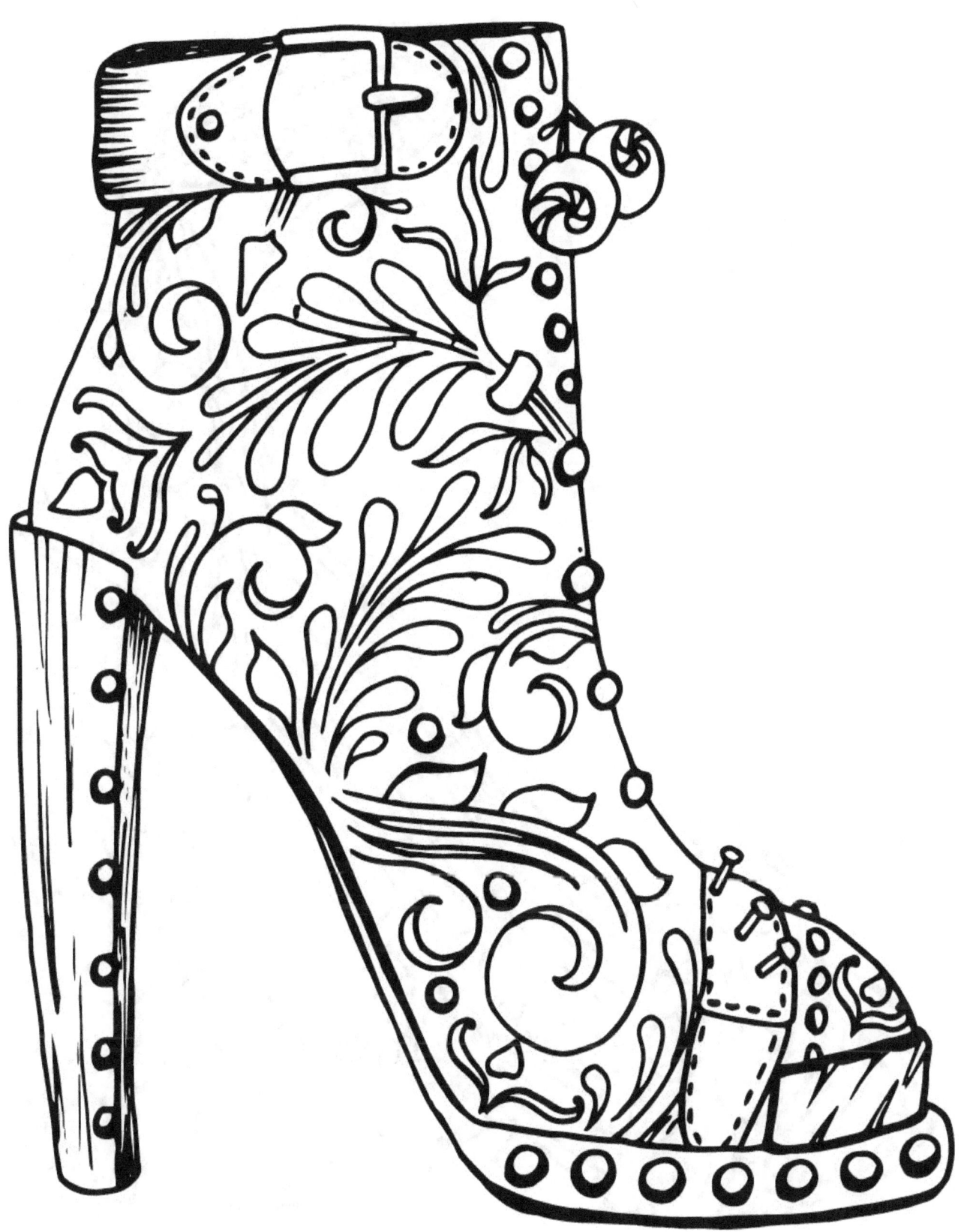

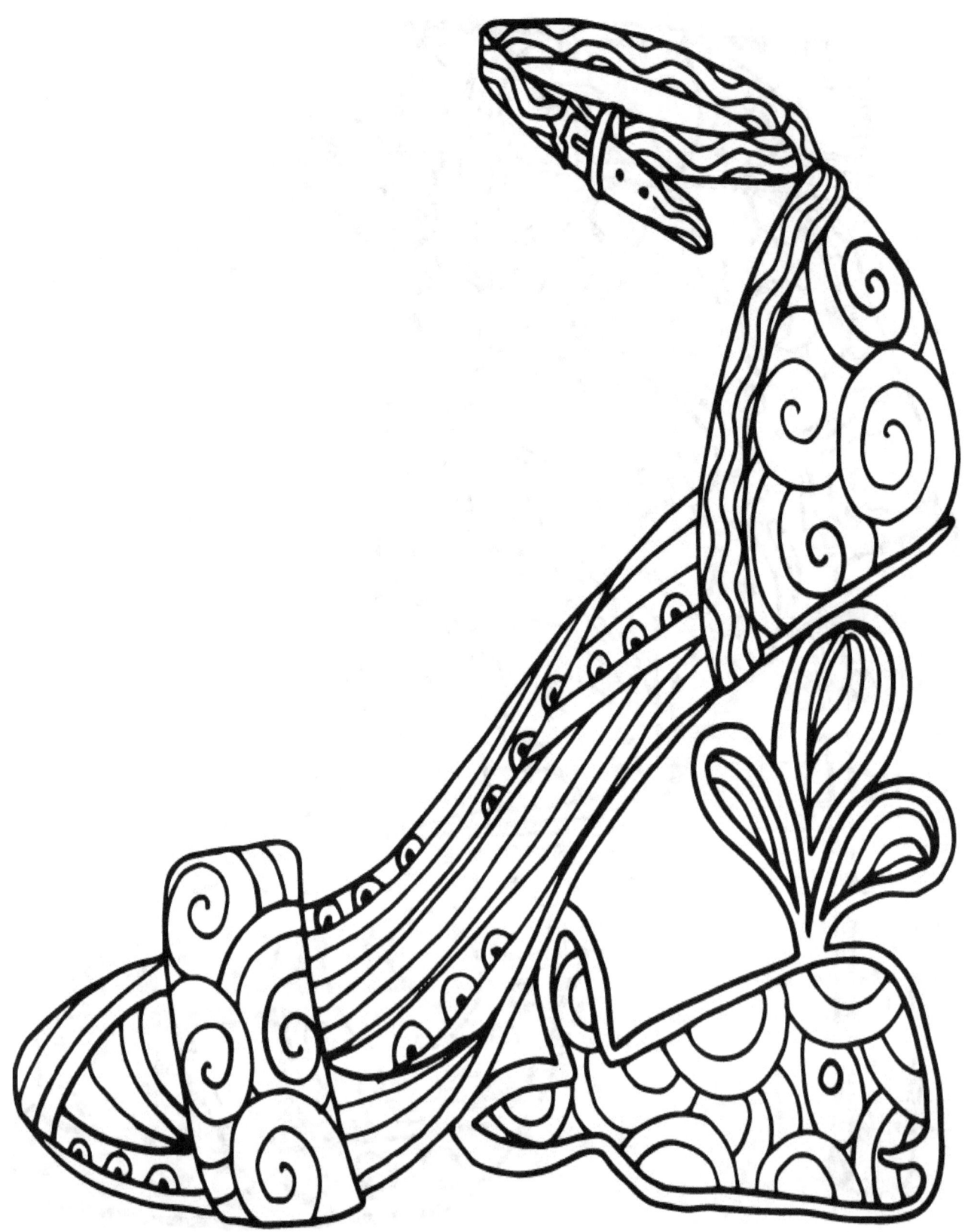

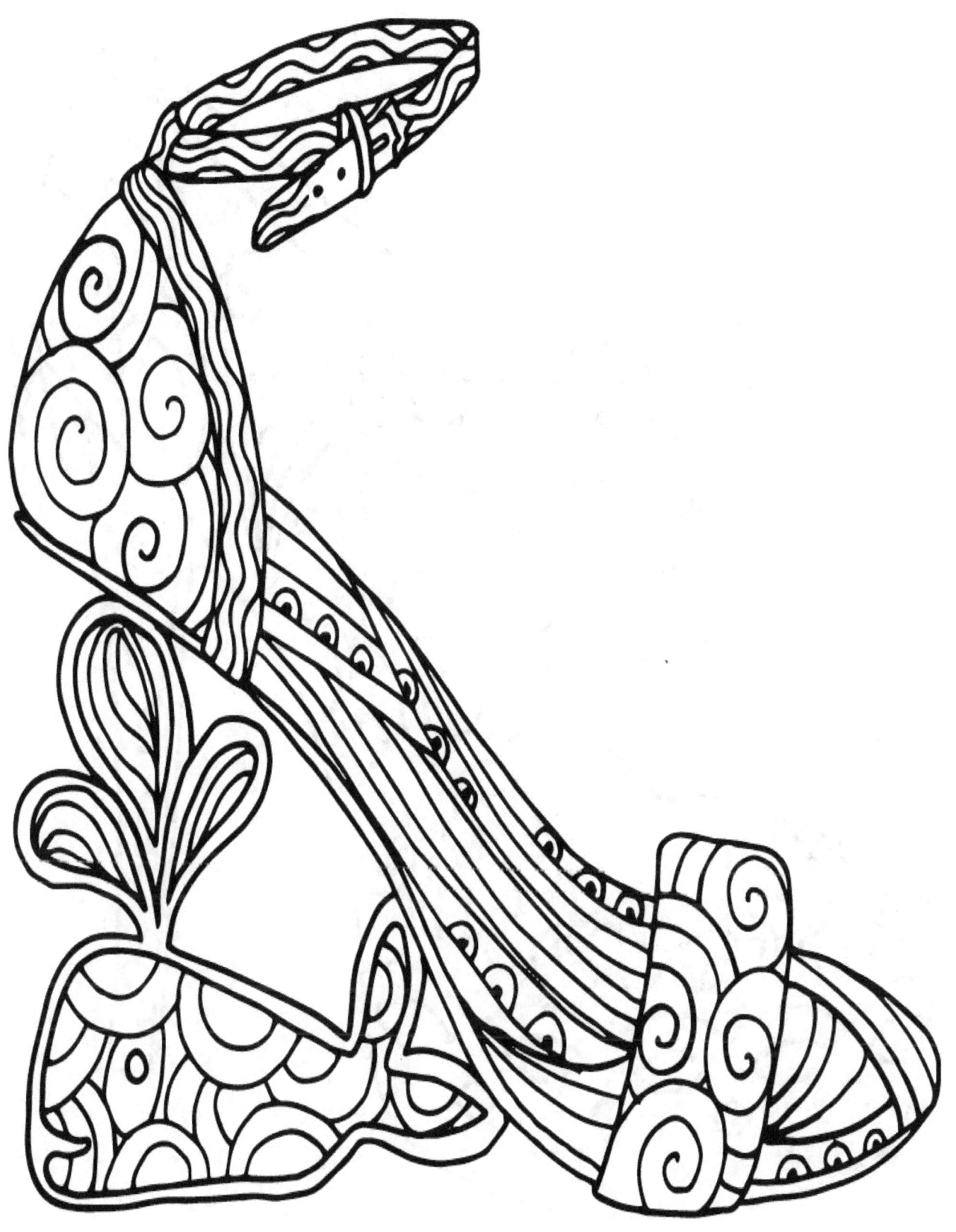

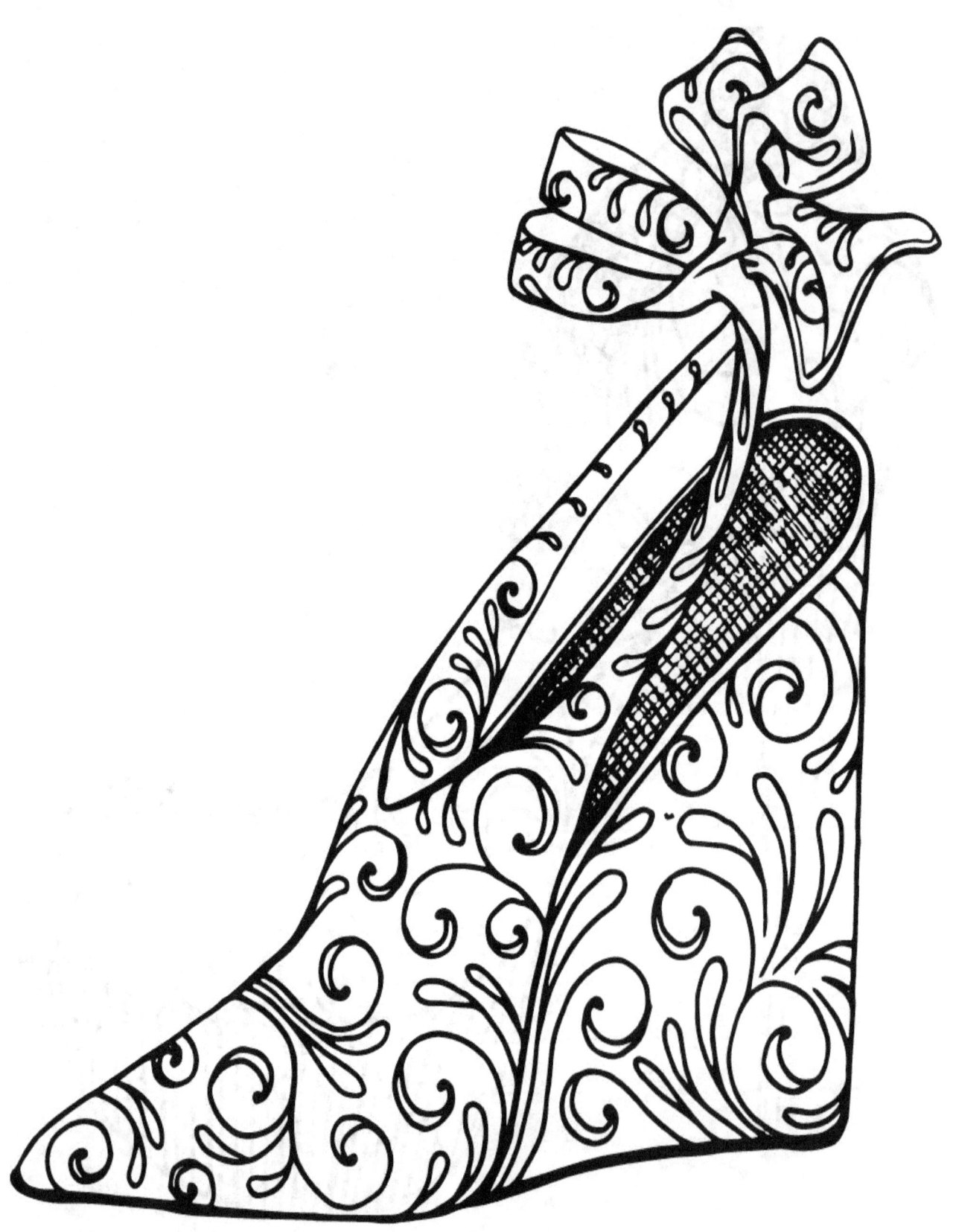

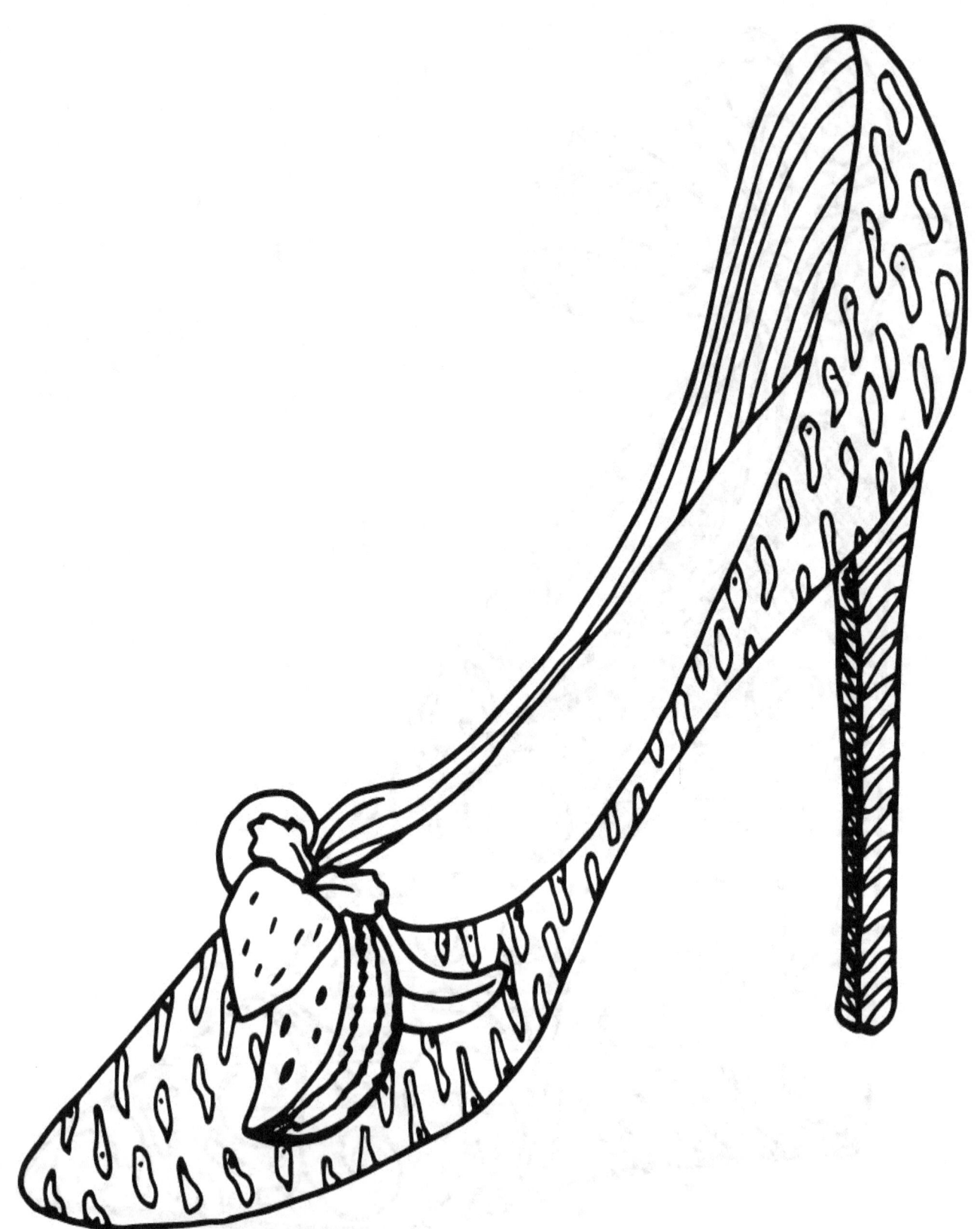

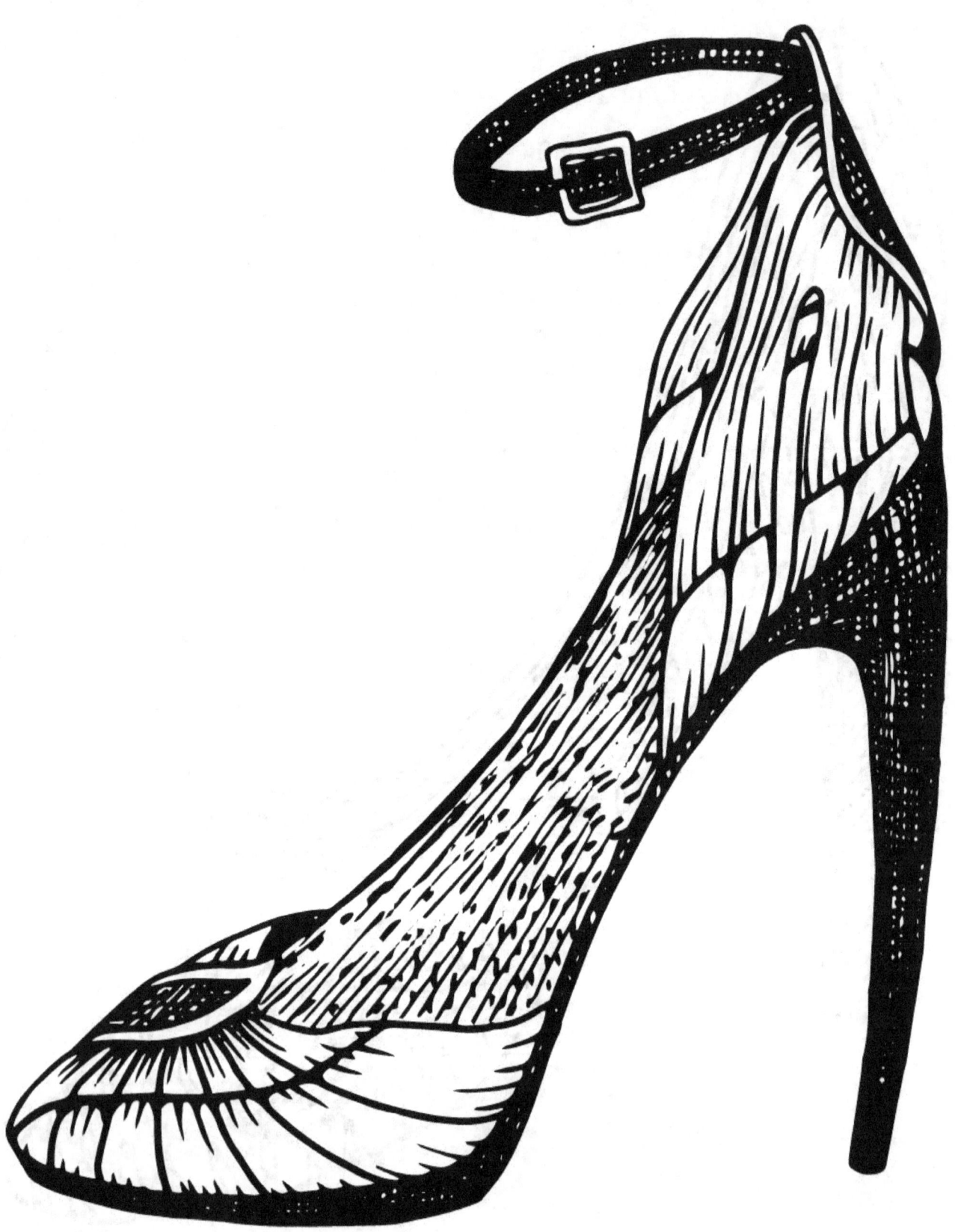

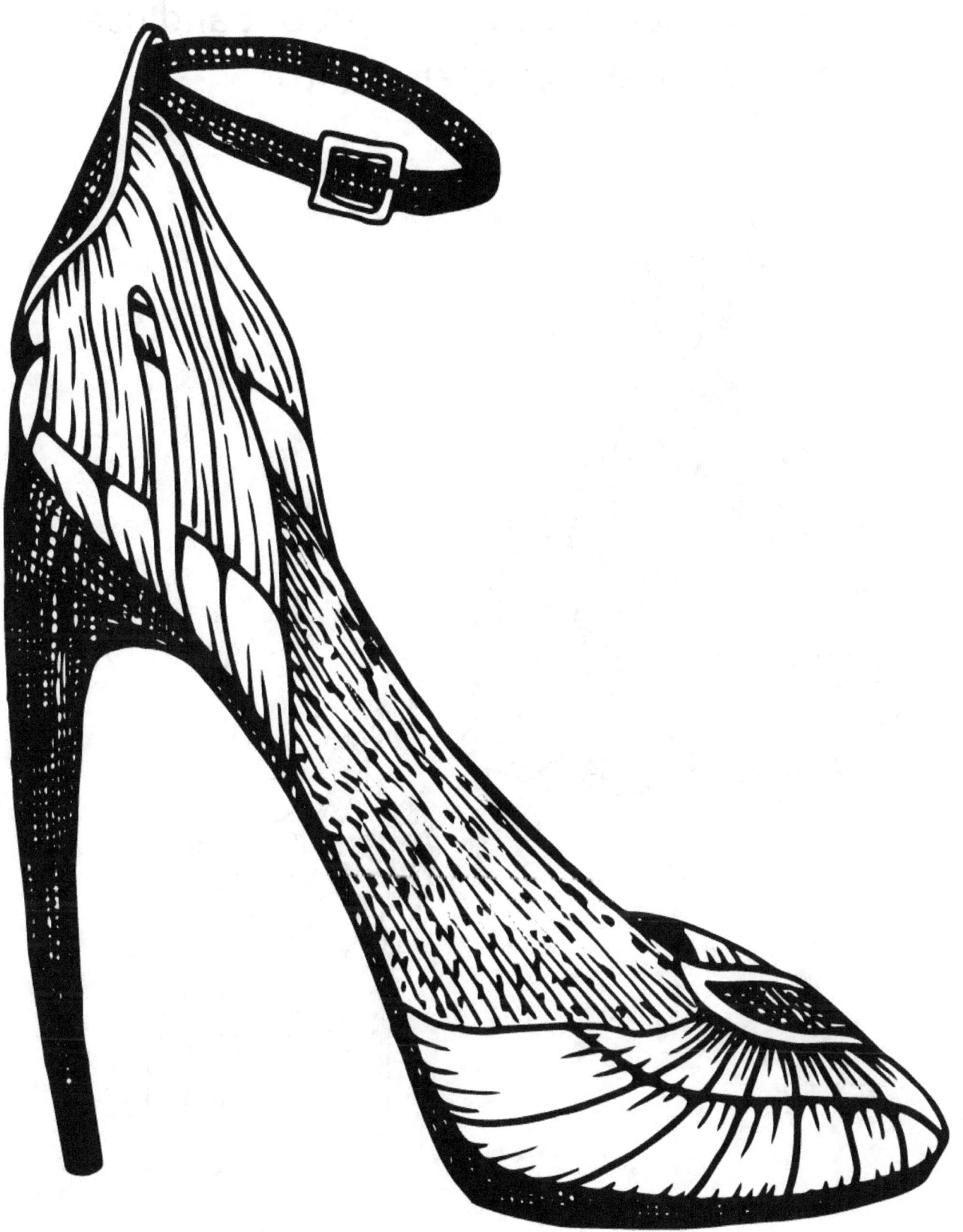

Use these pages to make two sided ornaments that you can cut out and use as decorations all year round.

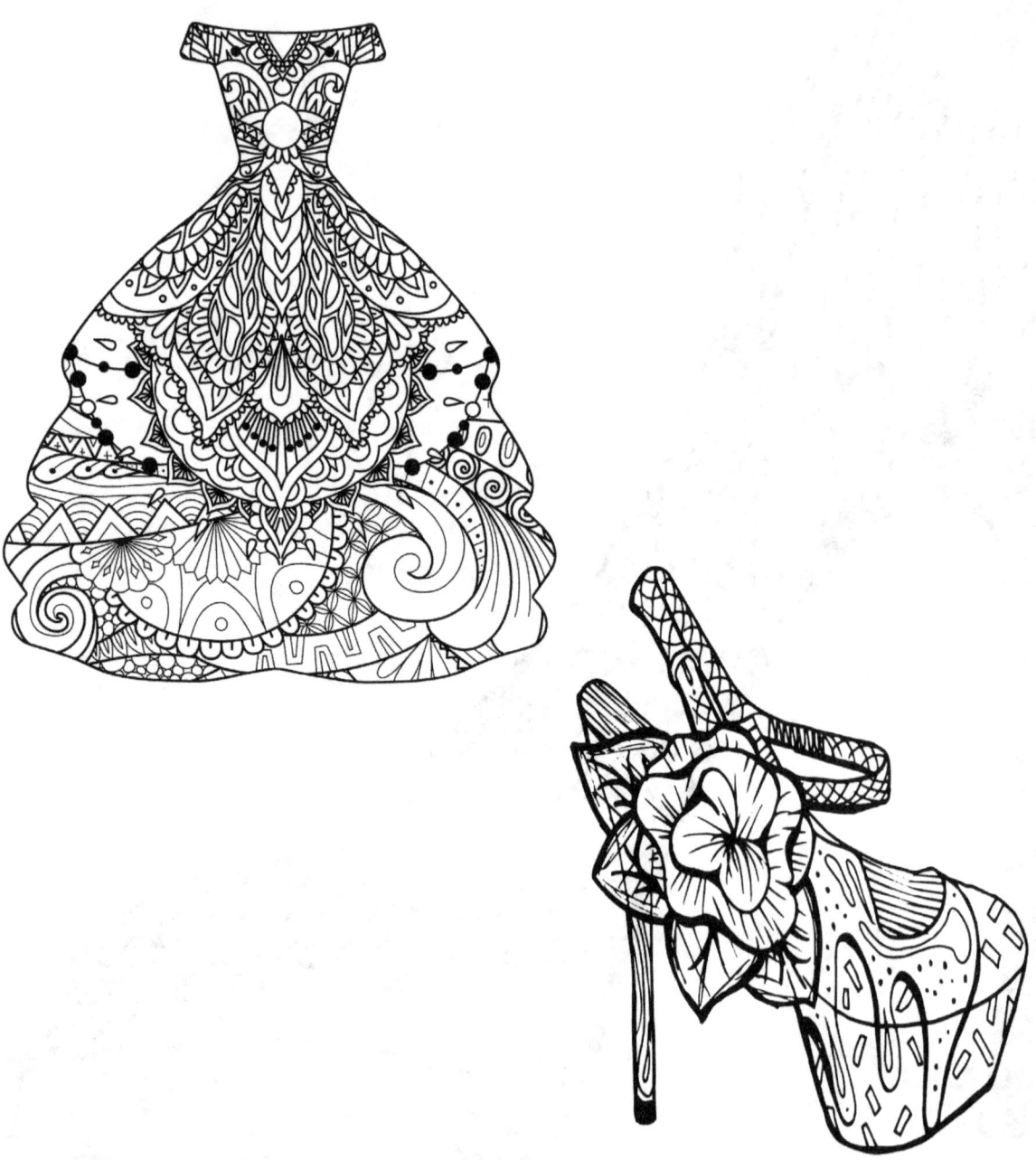

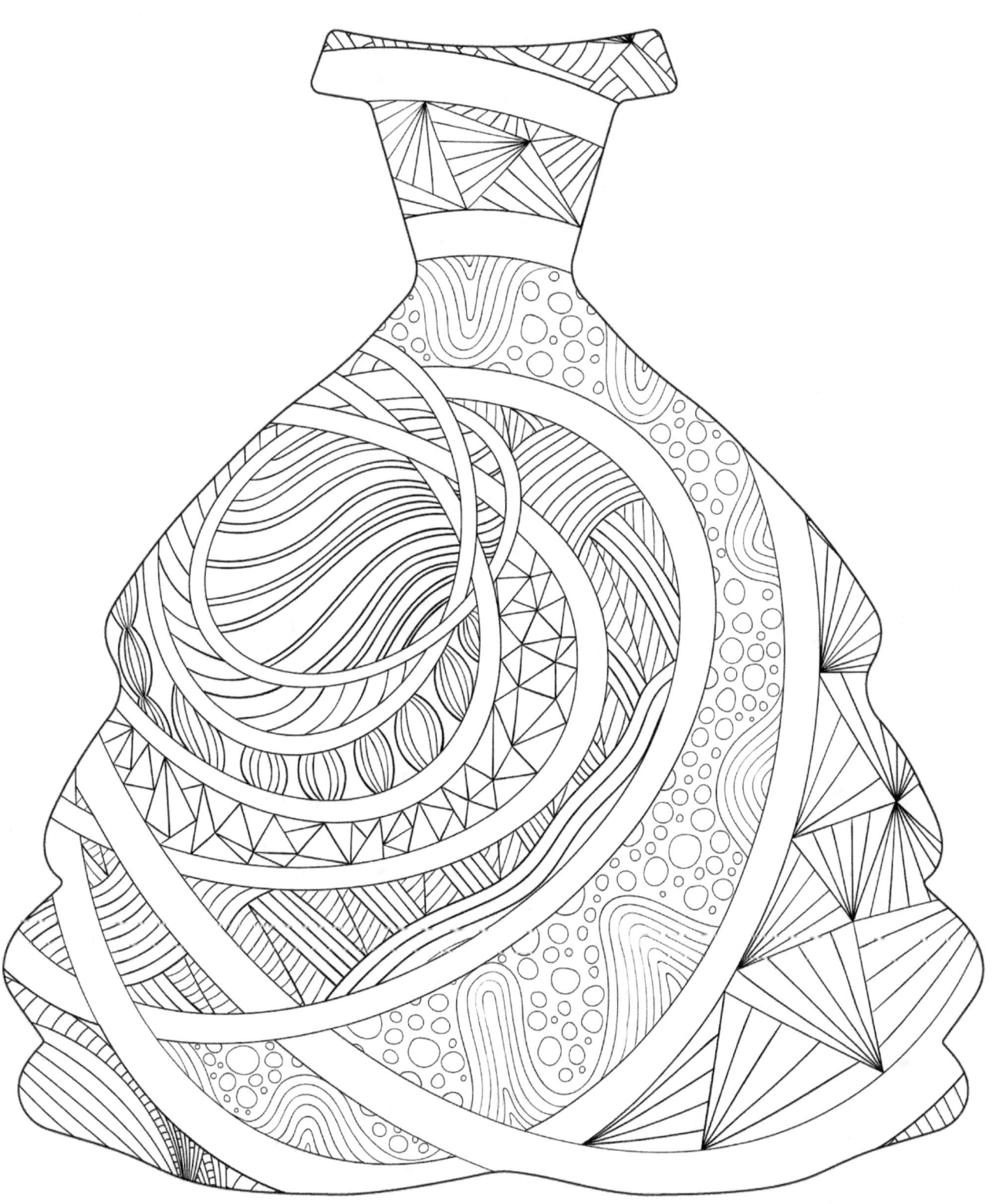

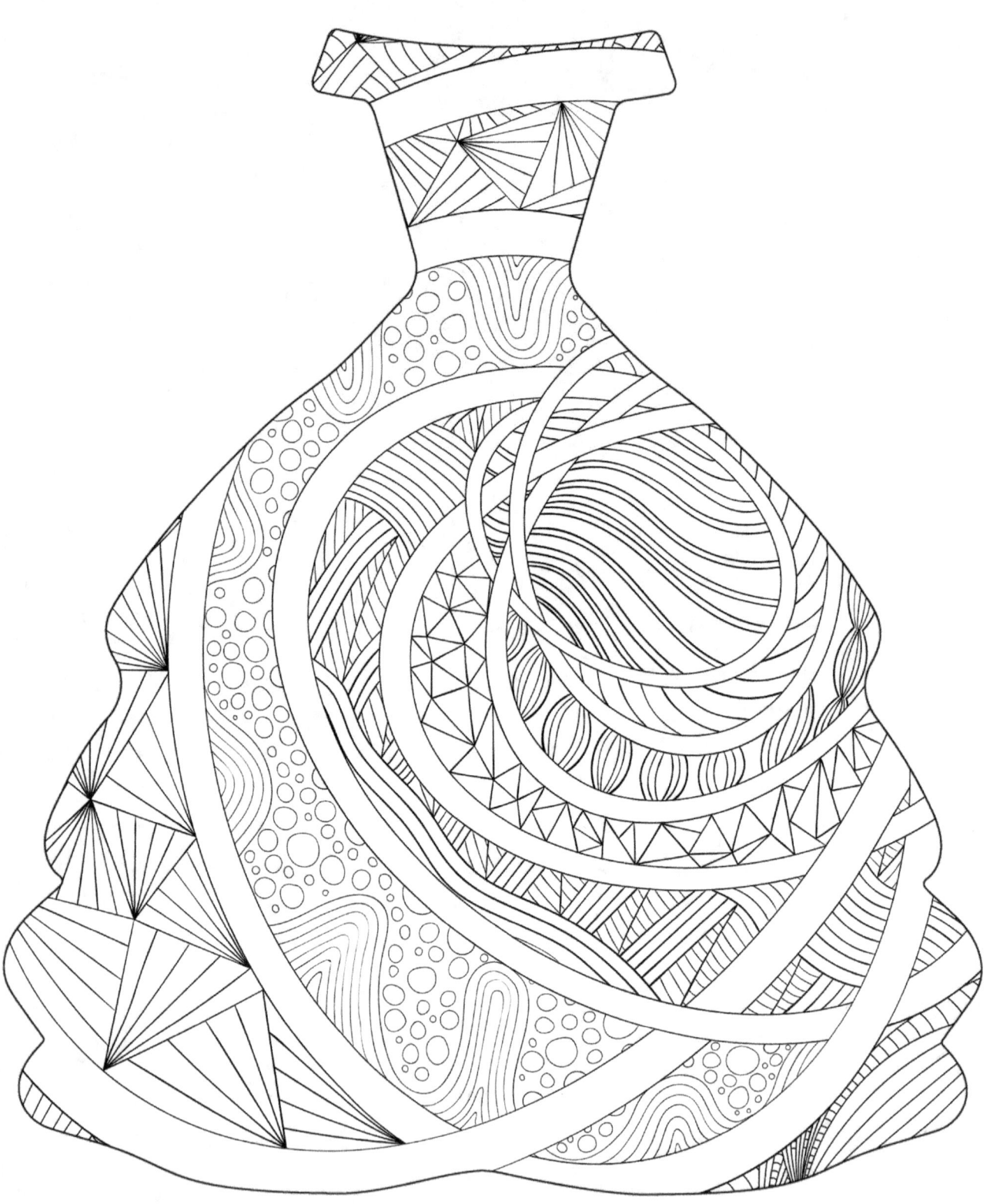

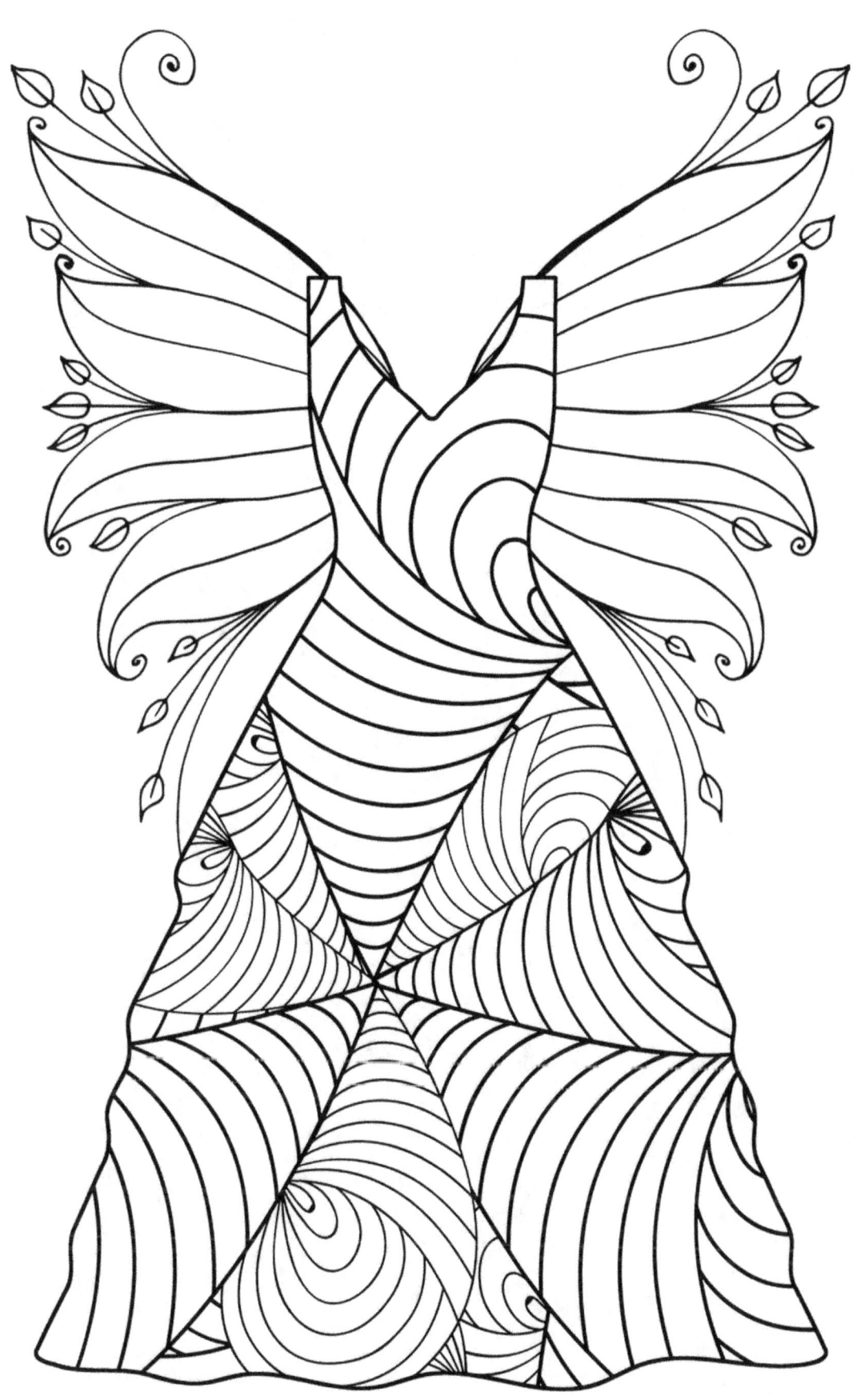

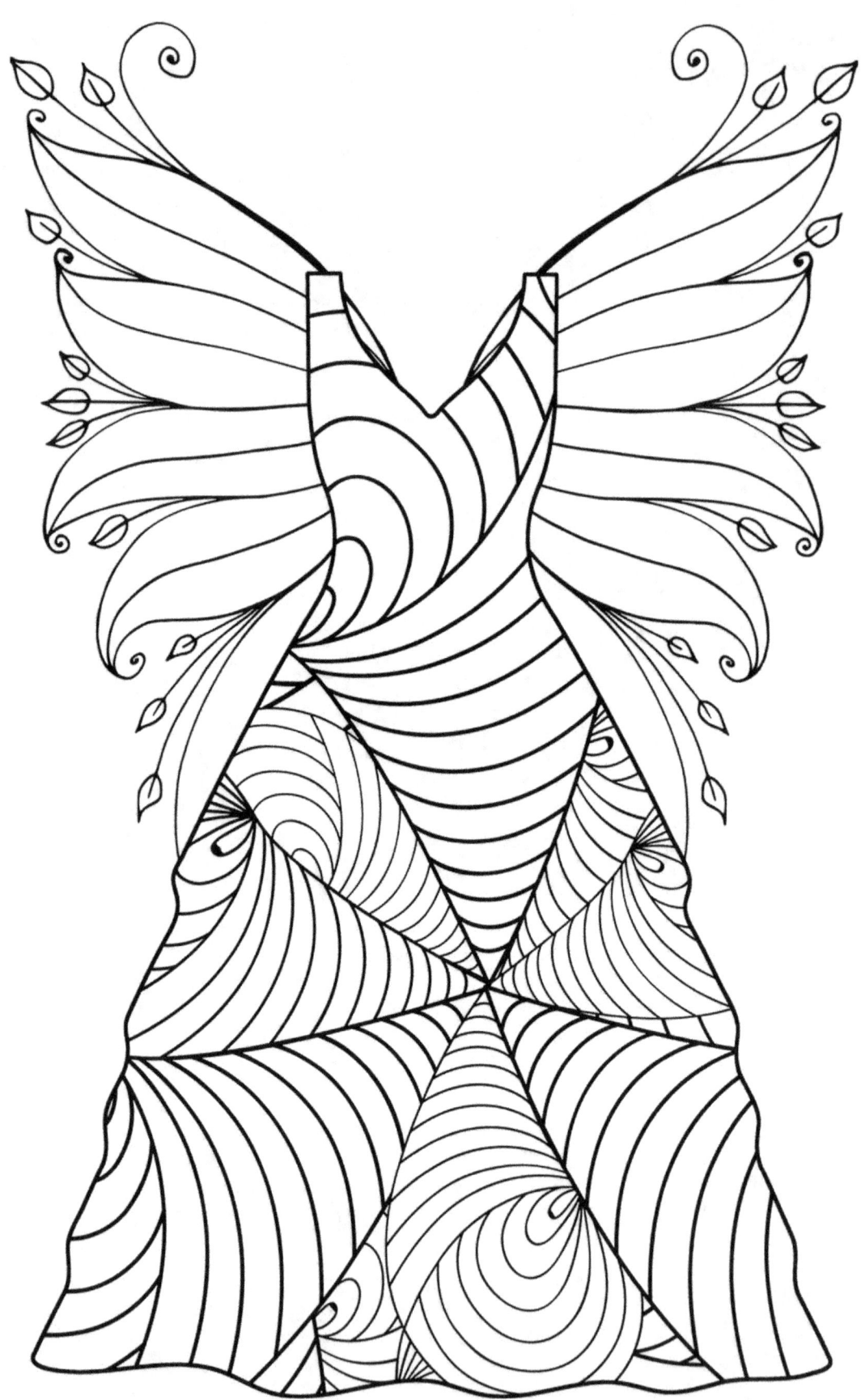

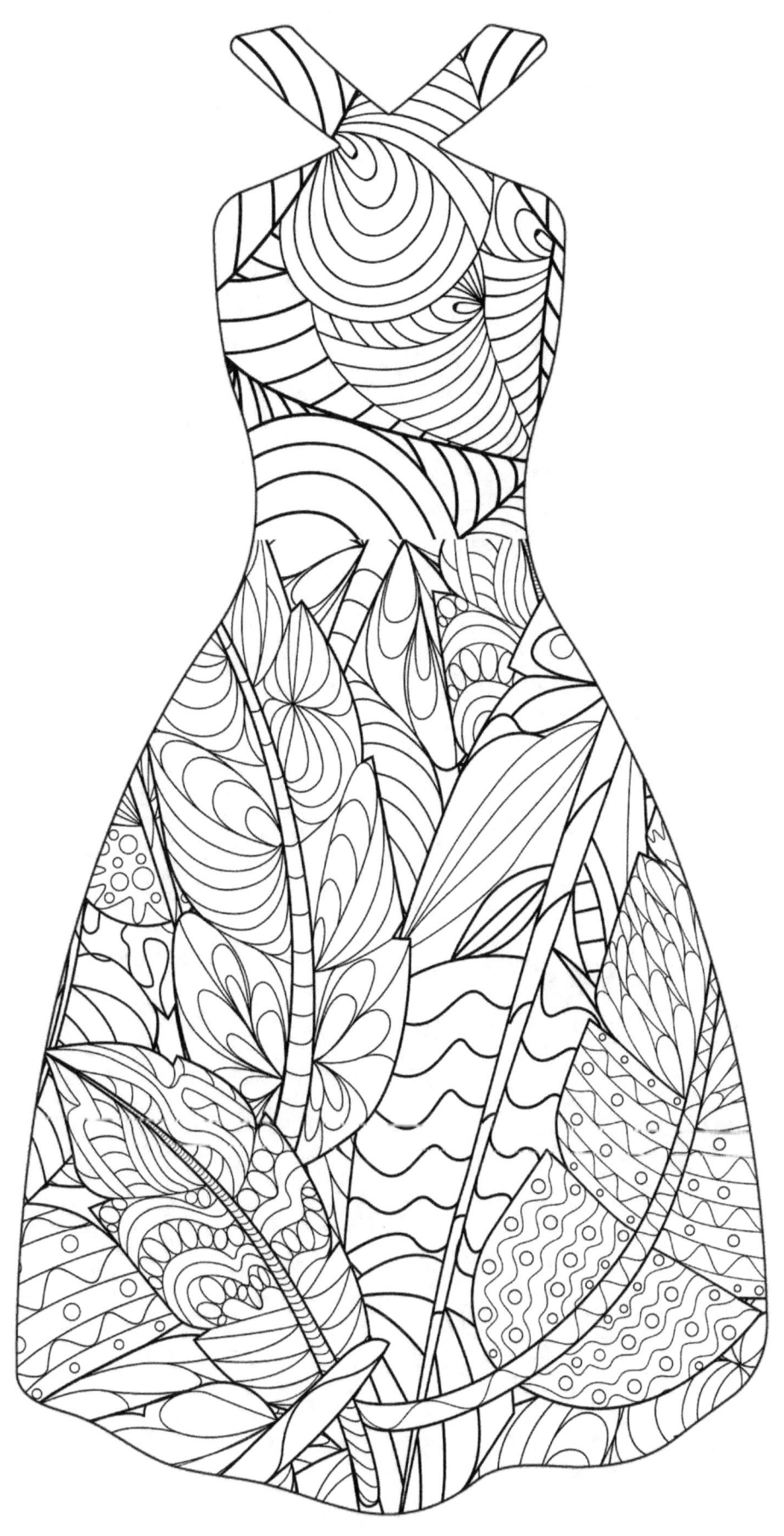

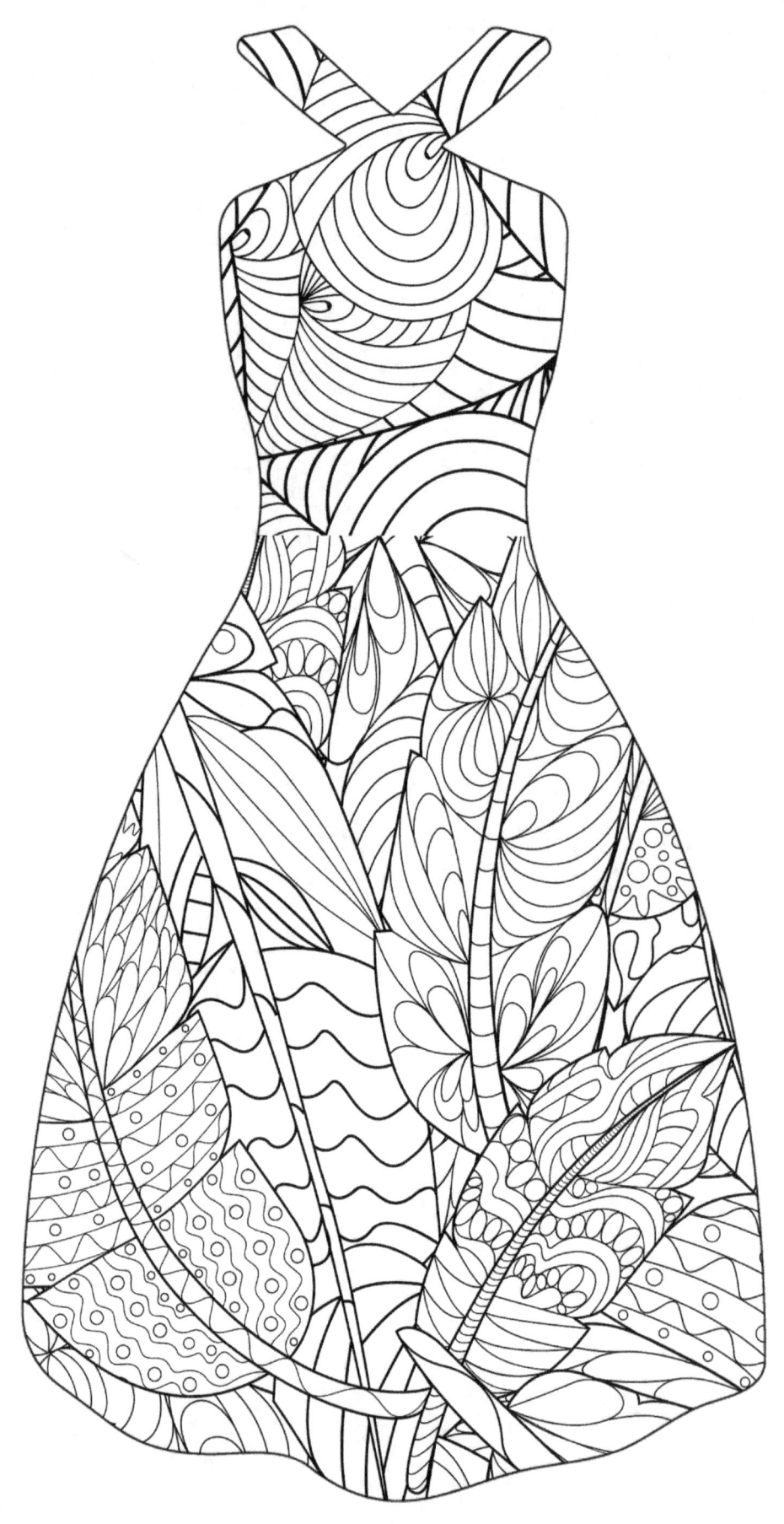

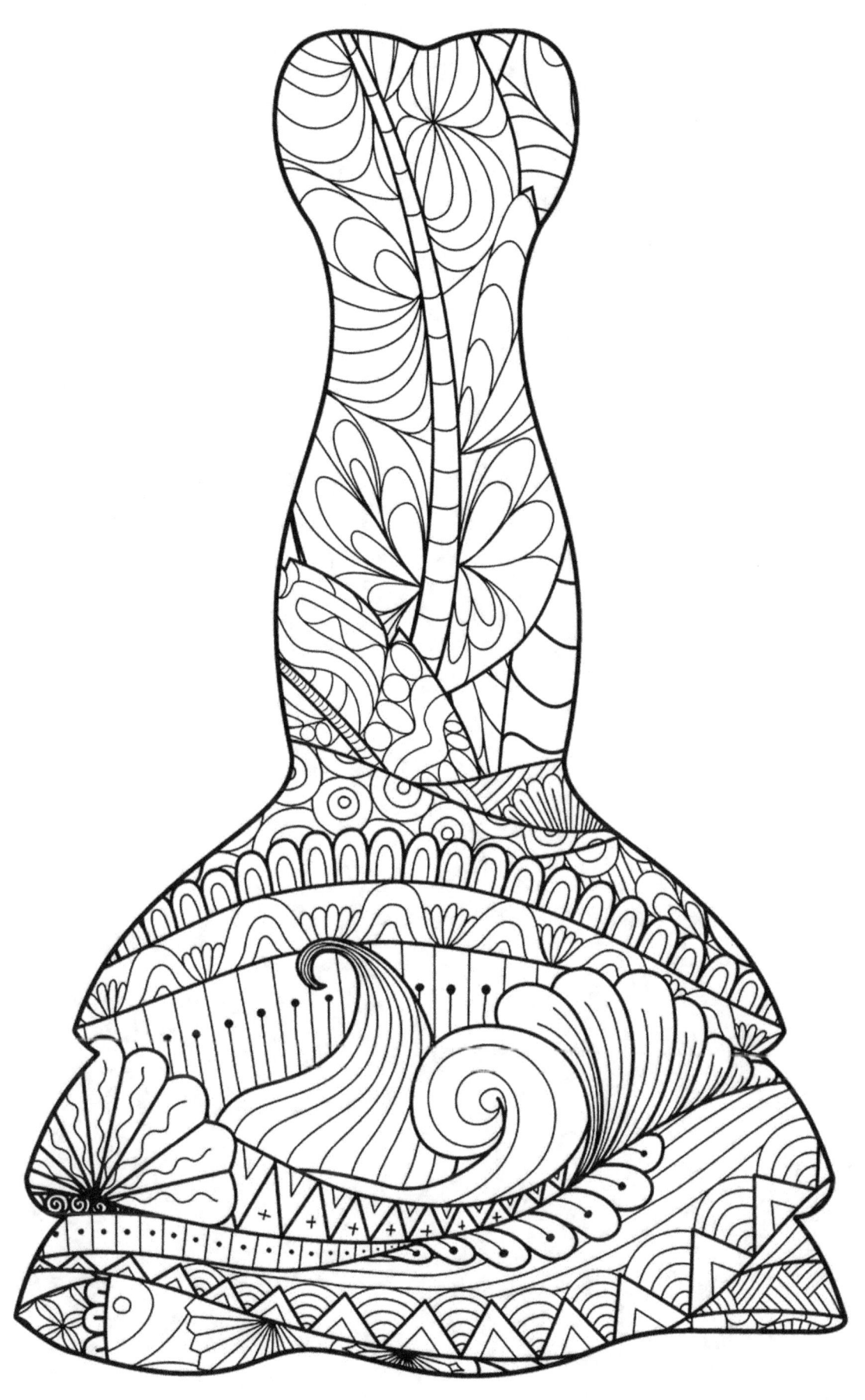

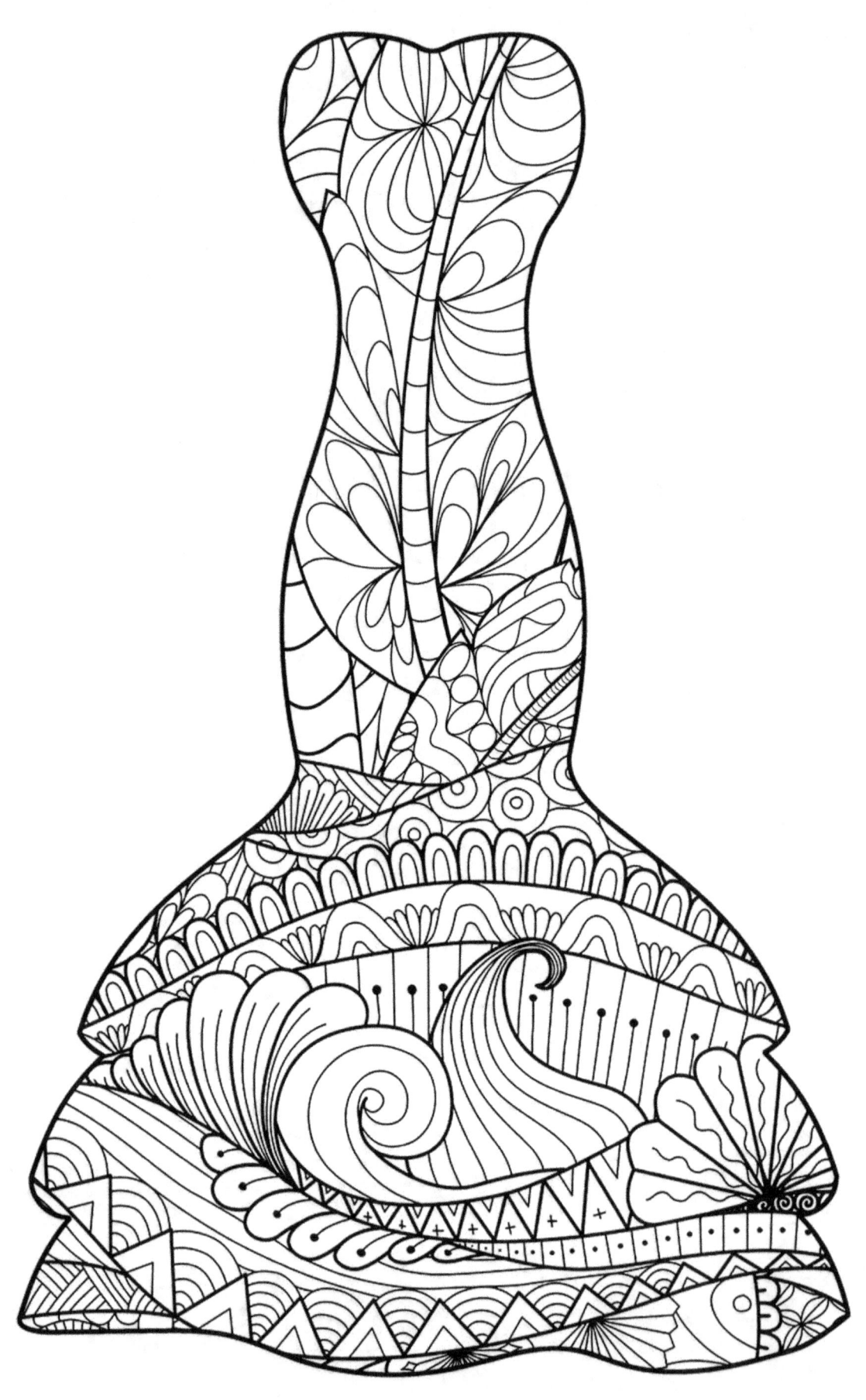

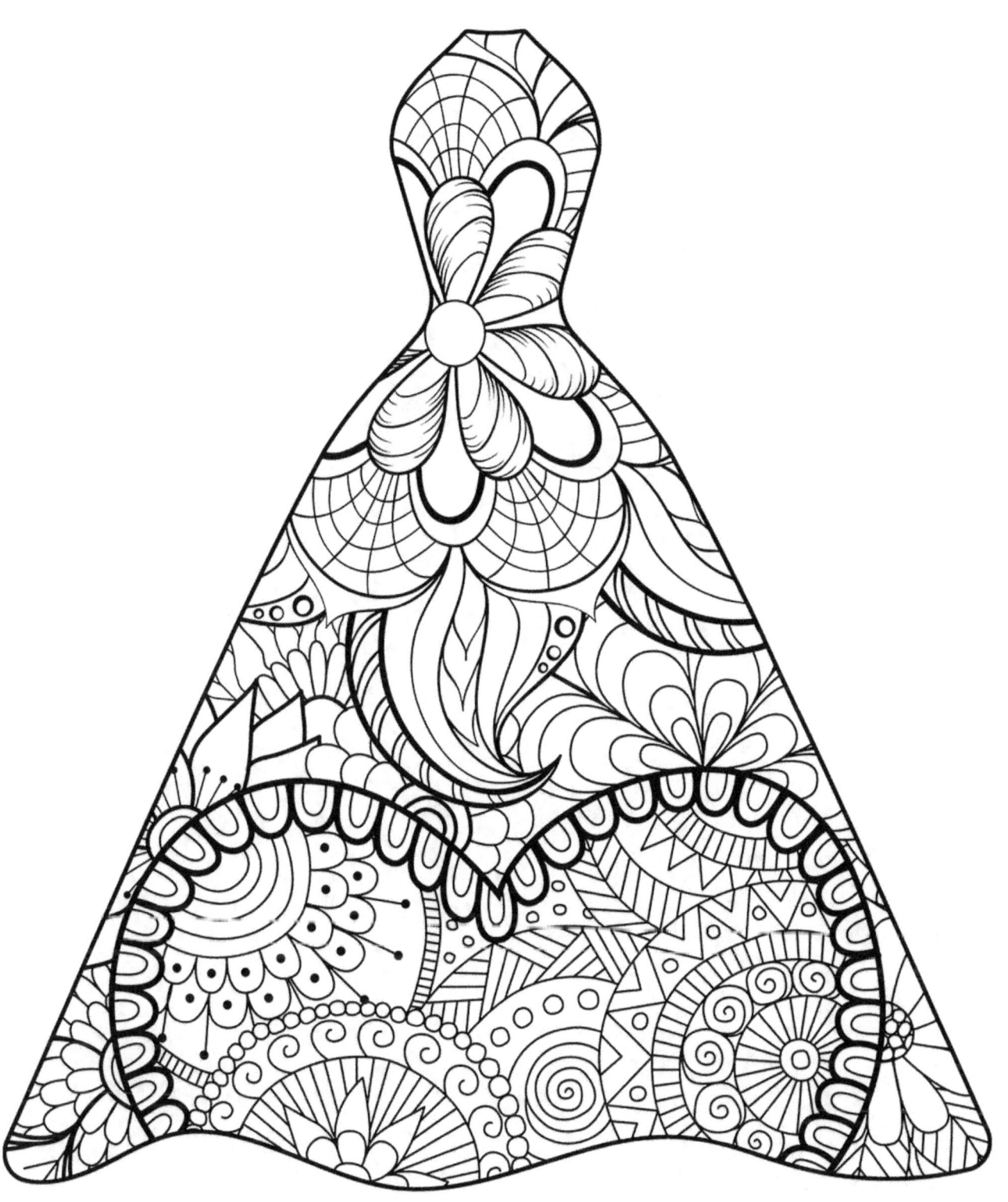

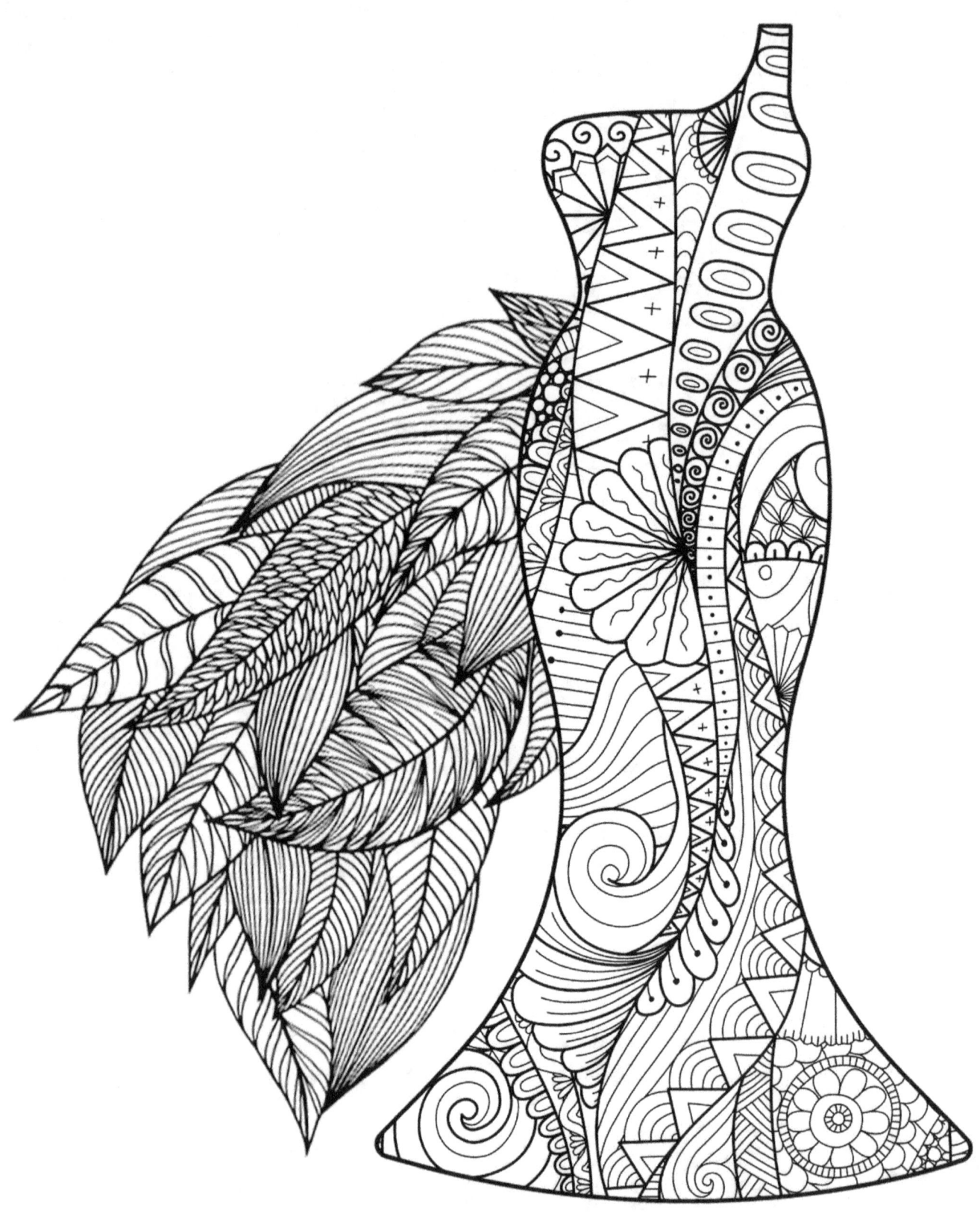

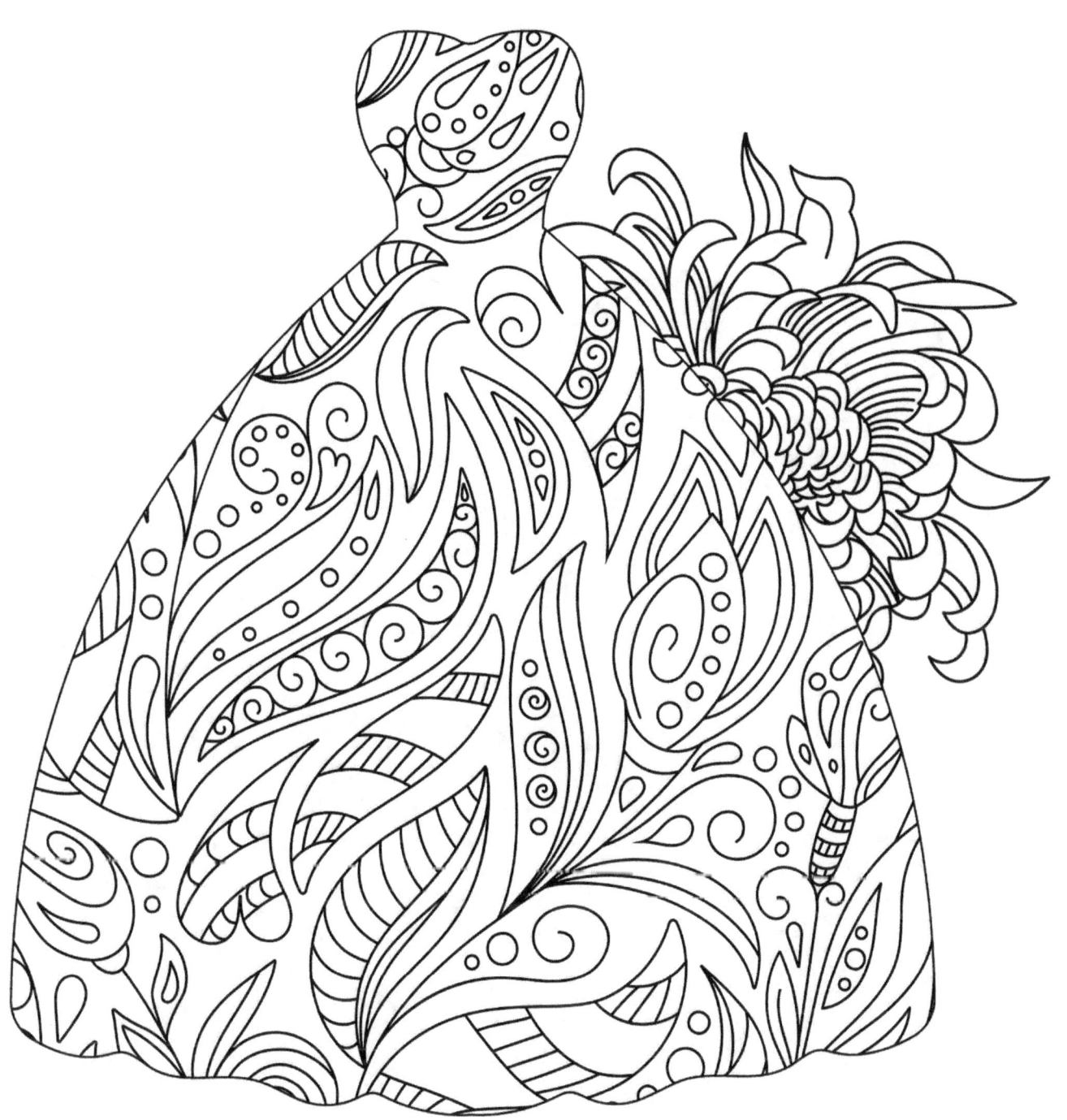

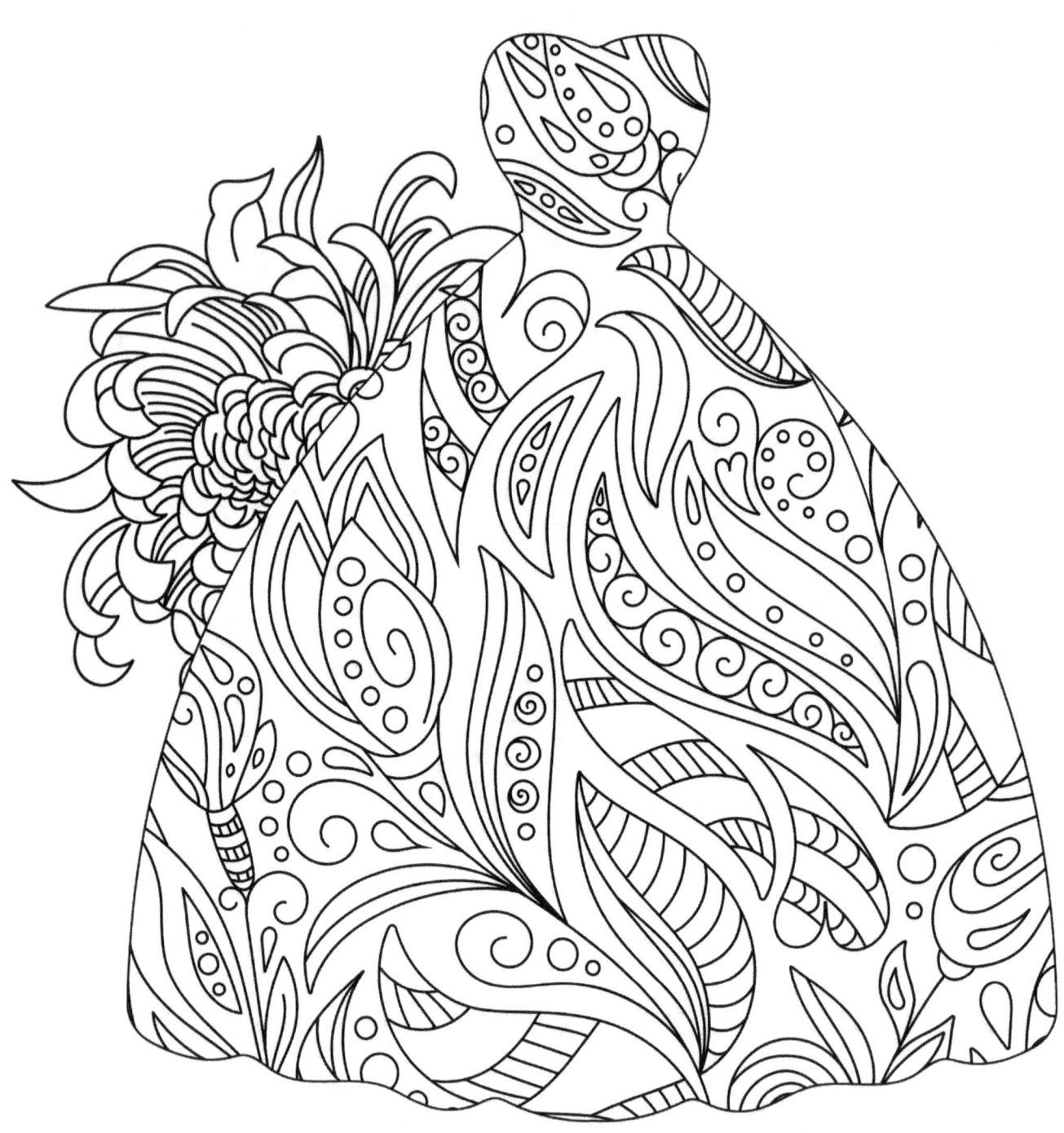

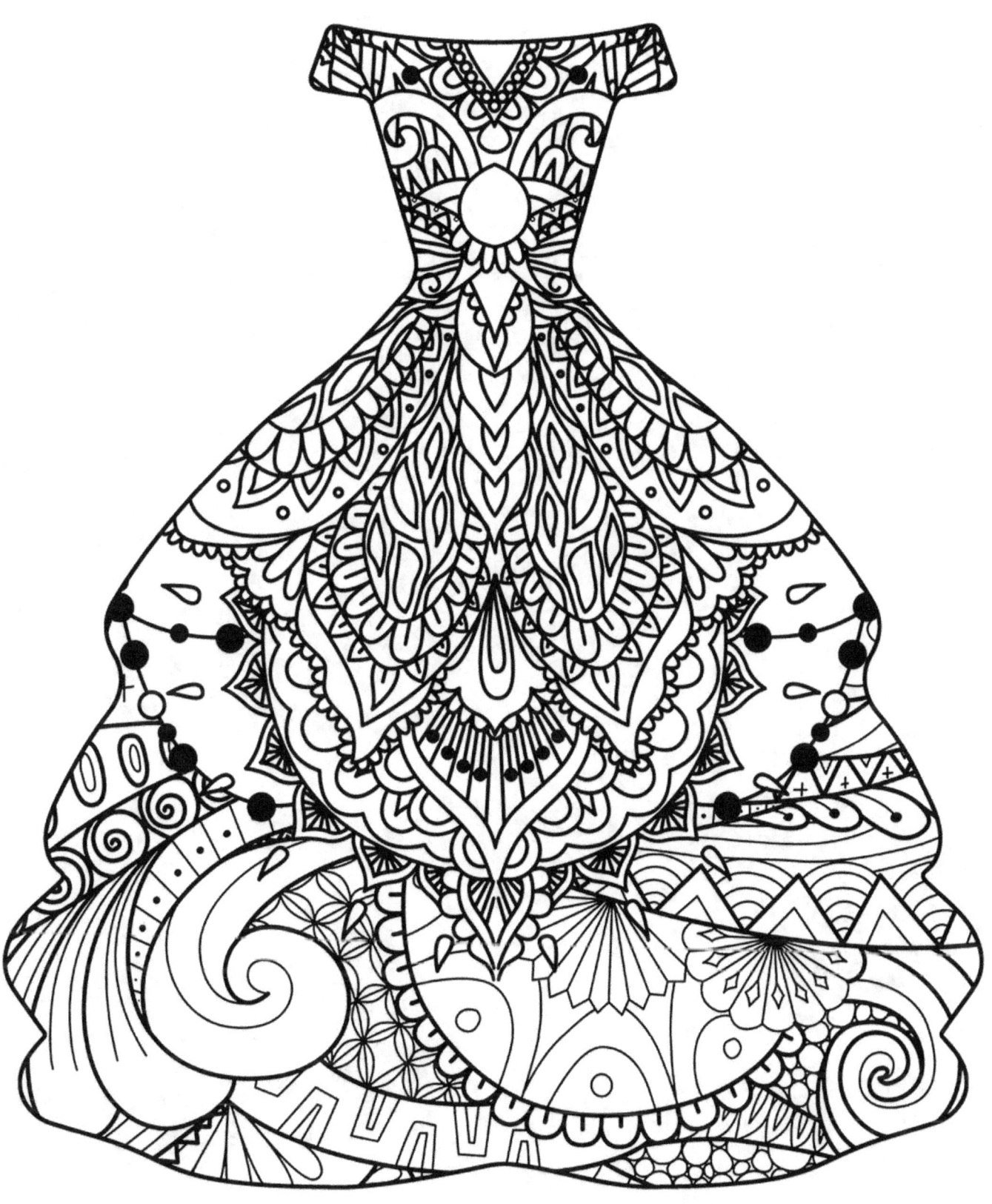

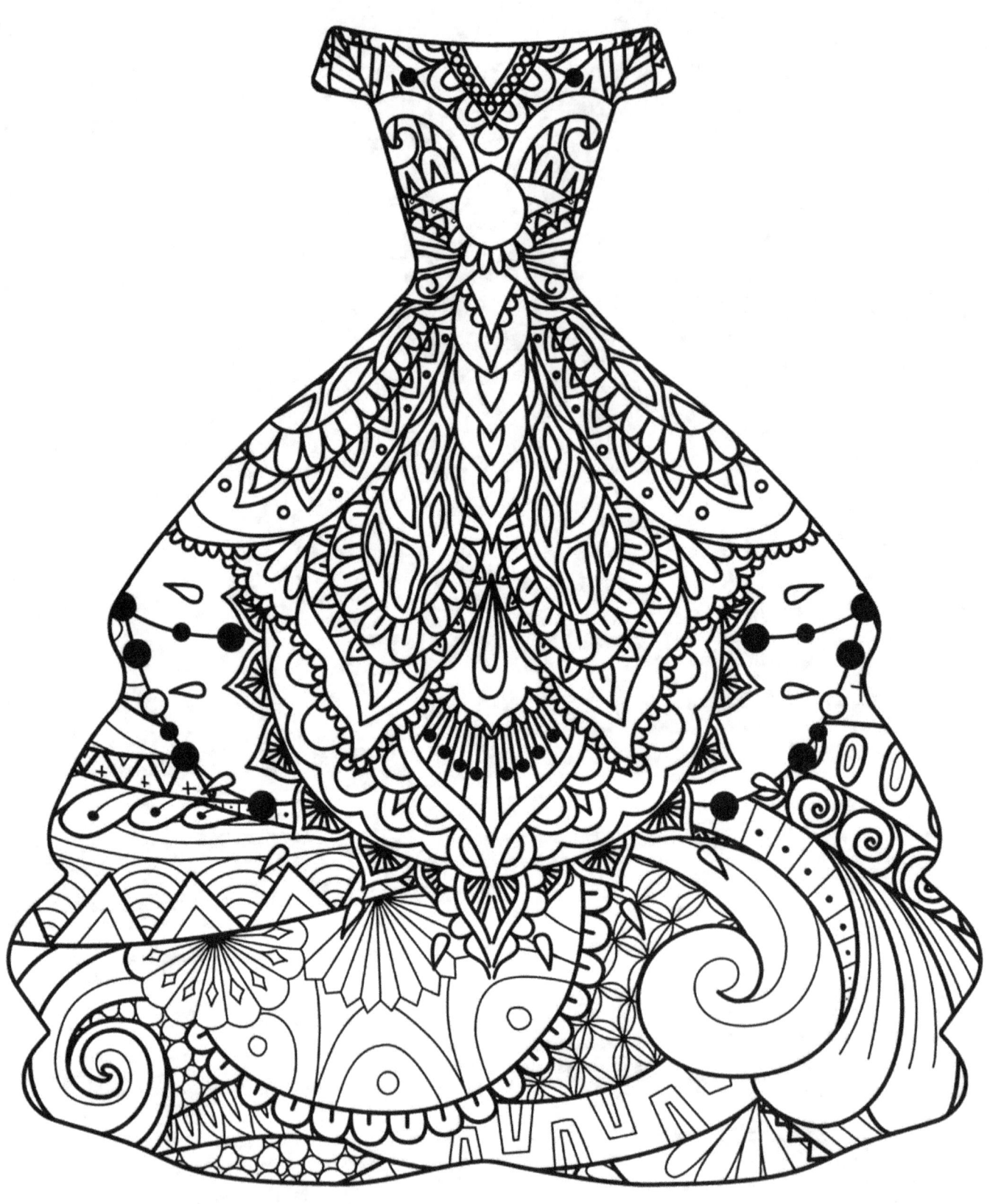

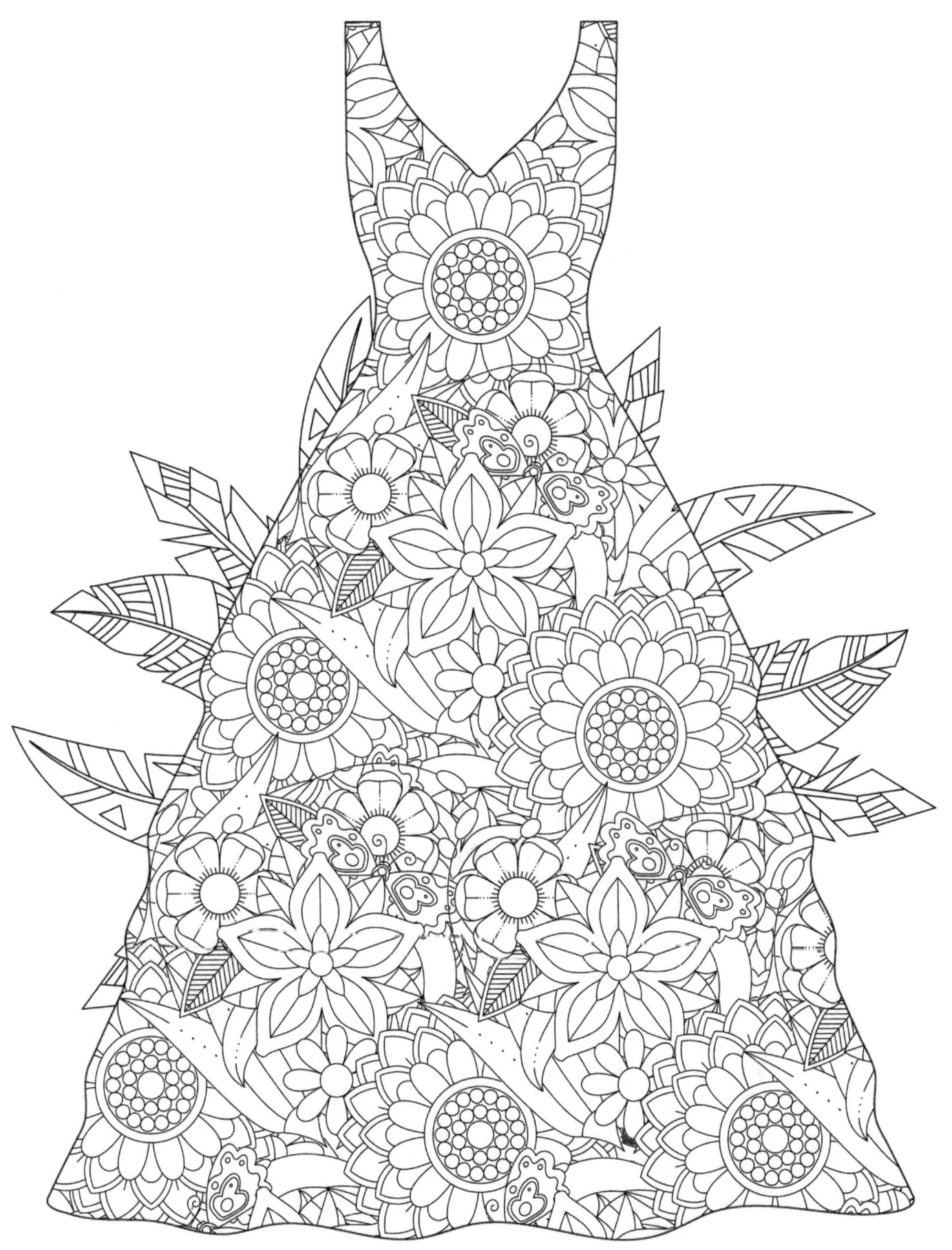

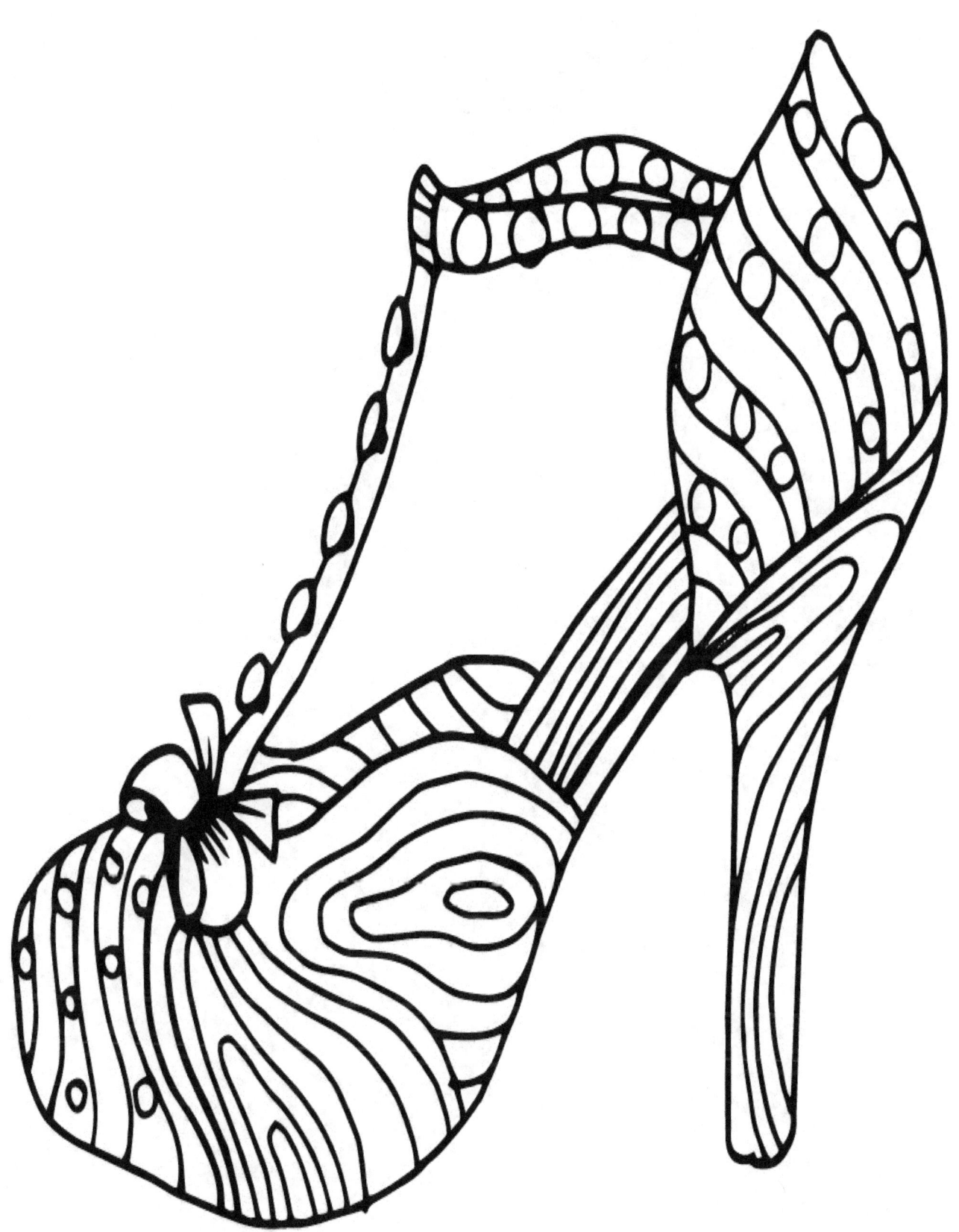

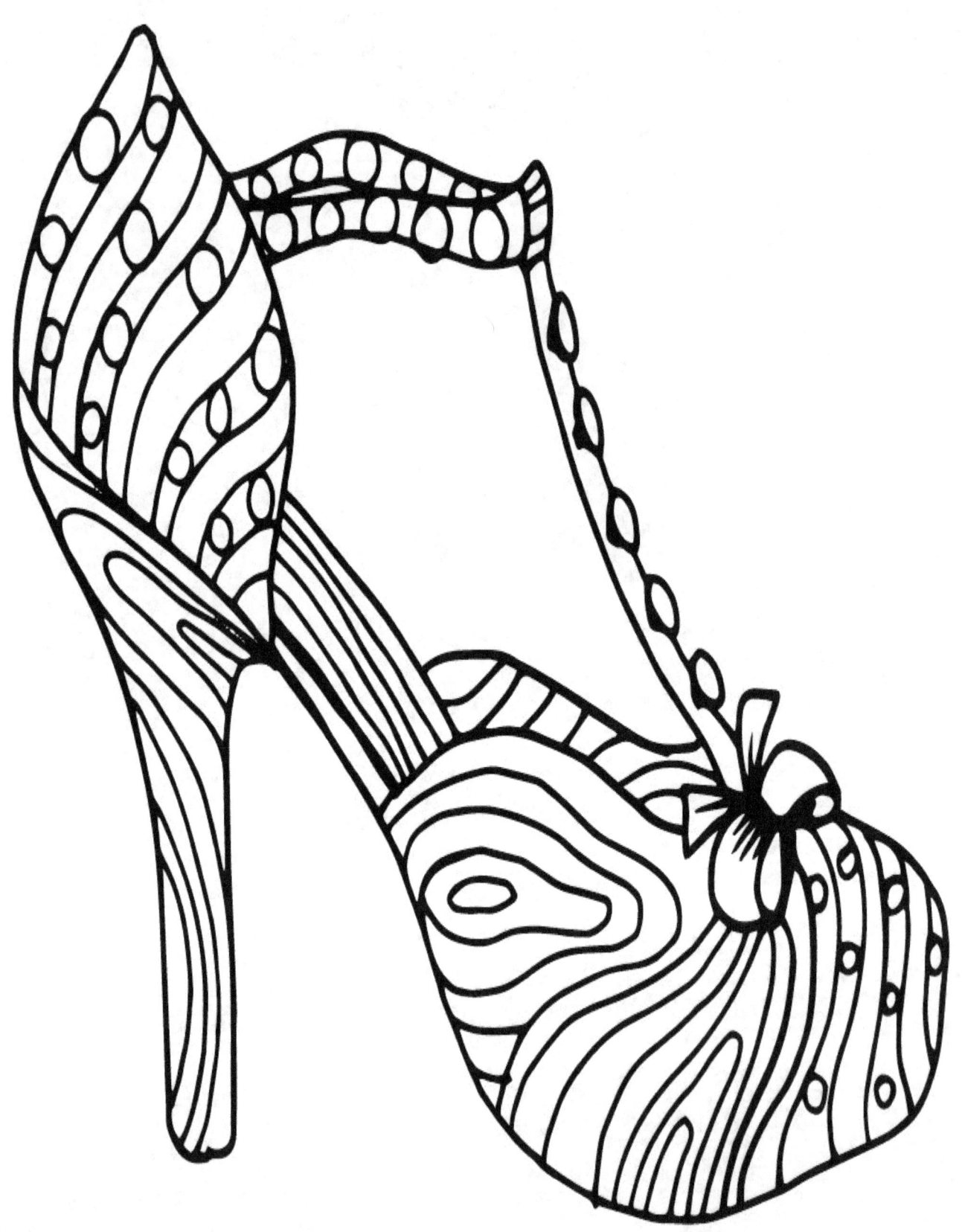

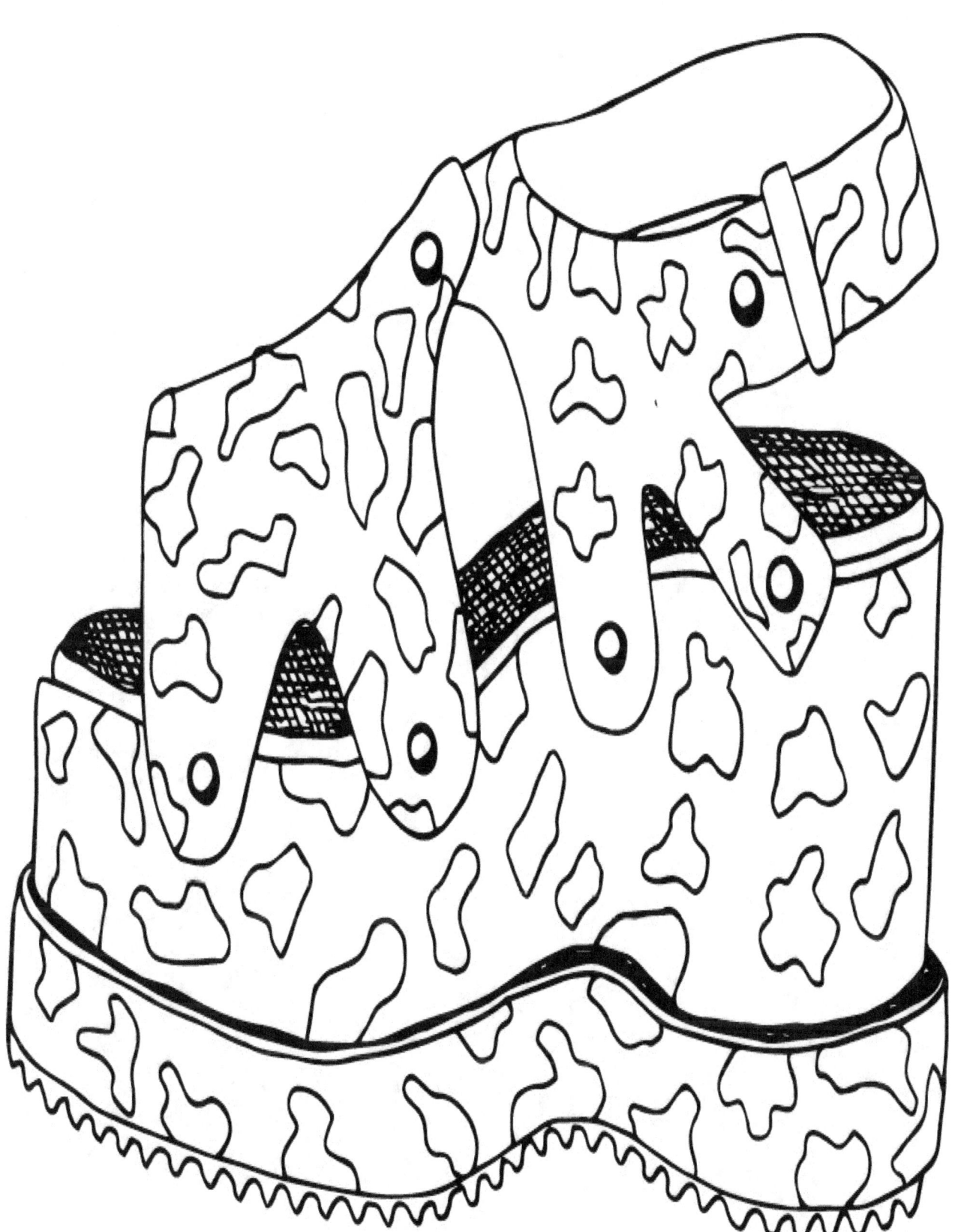

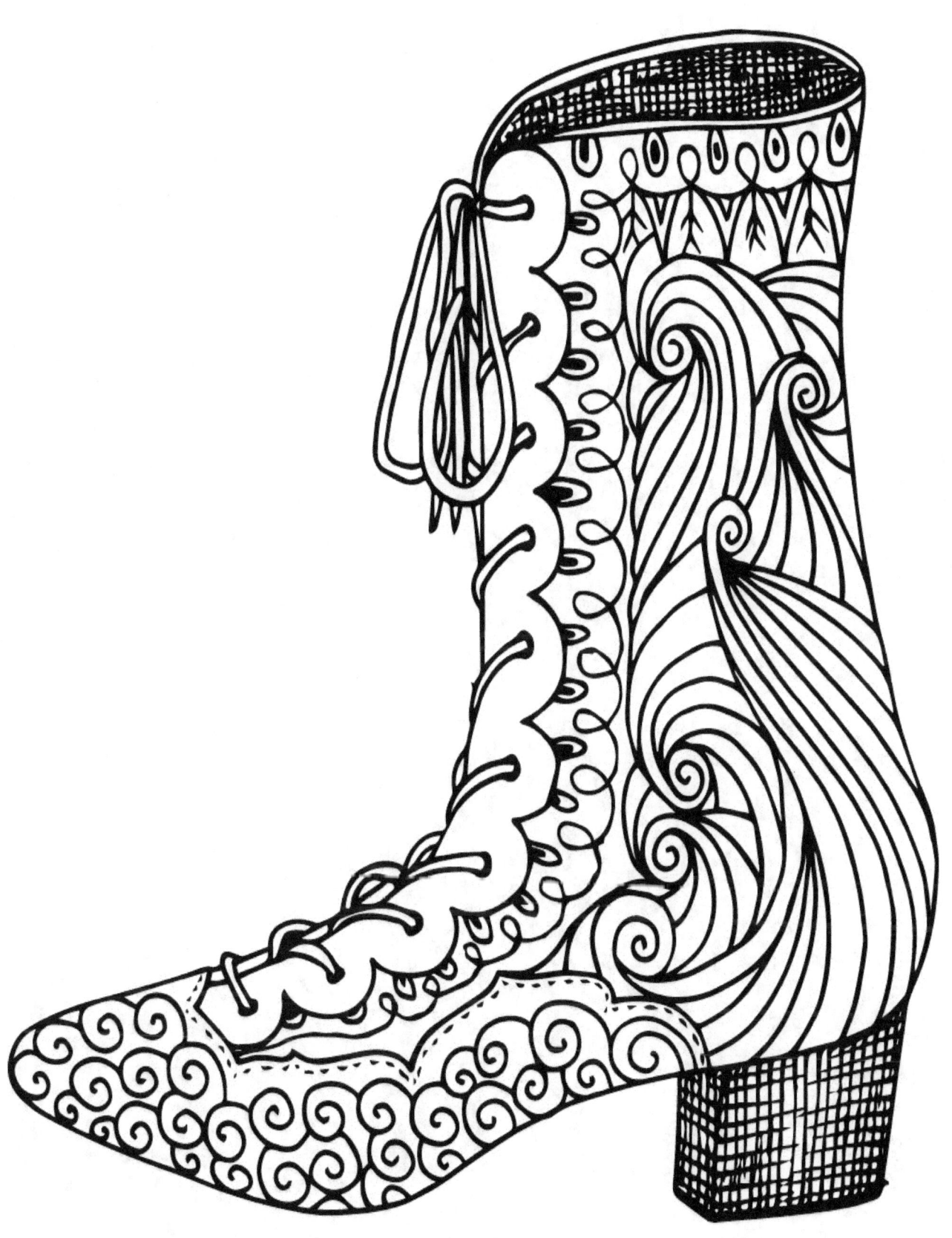

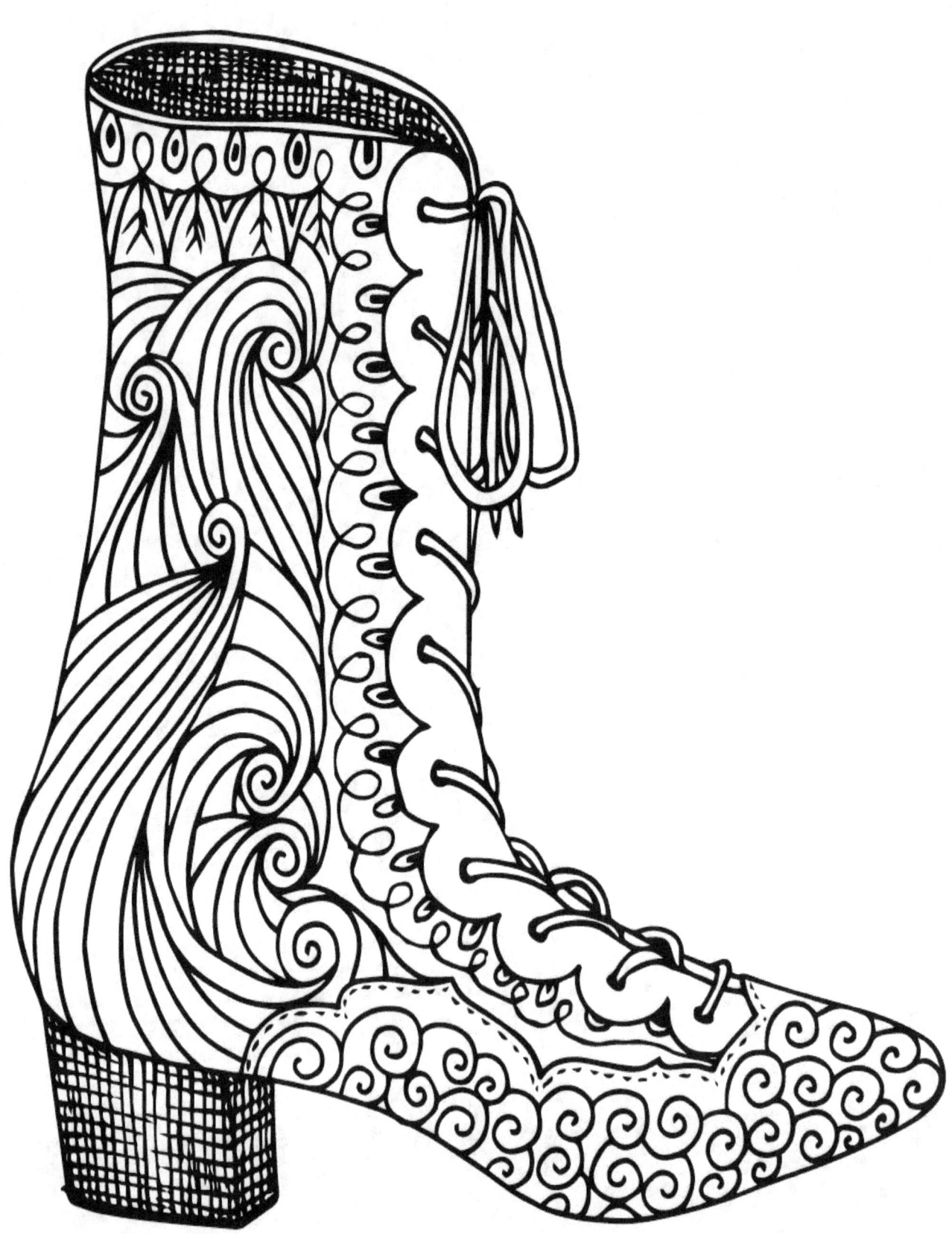

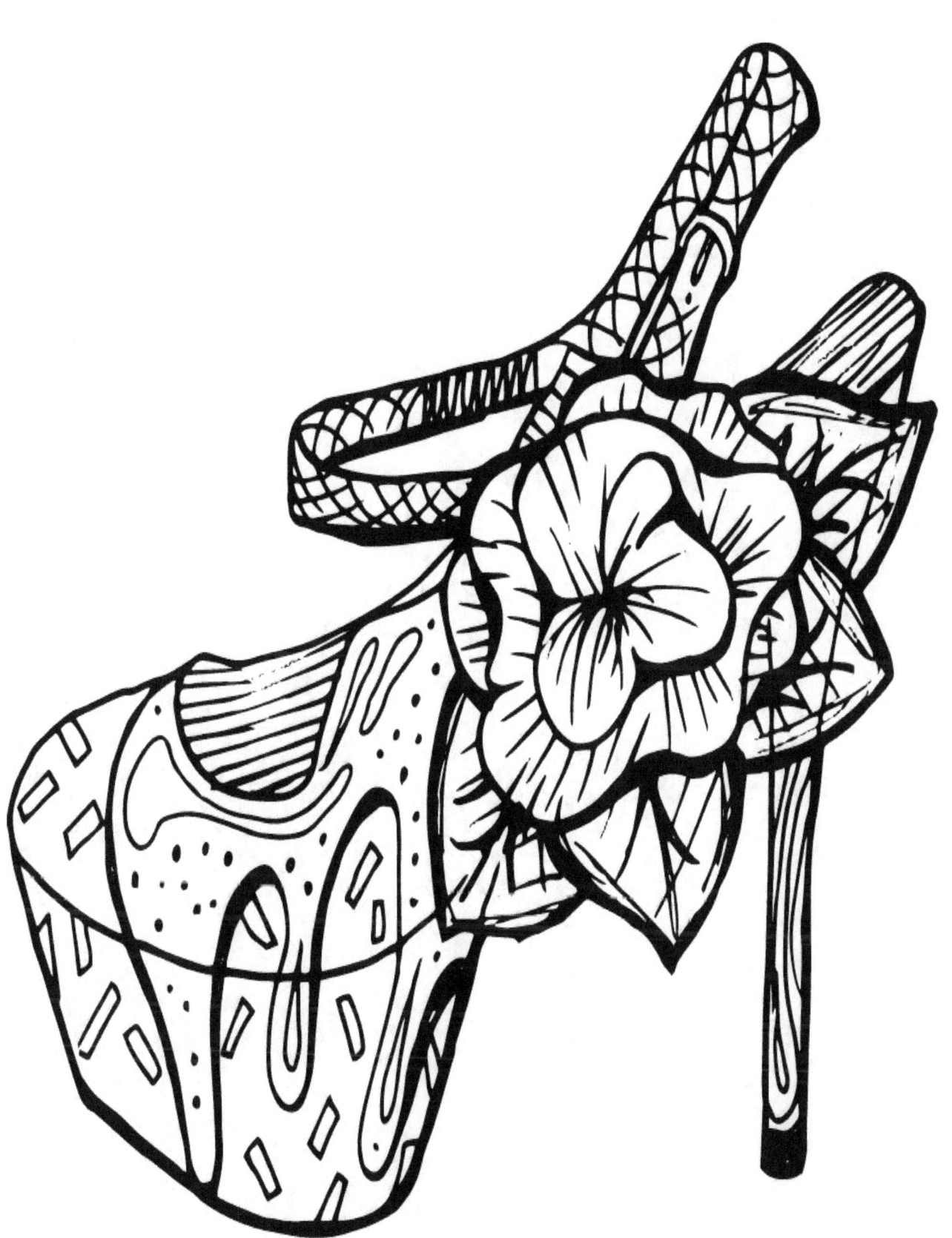

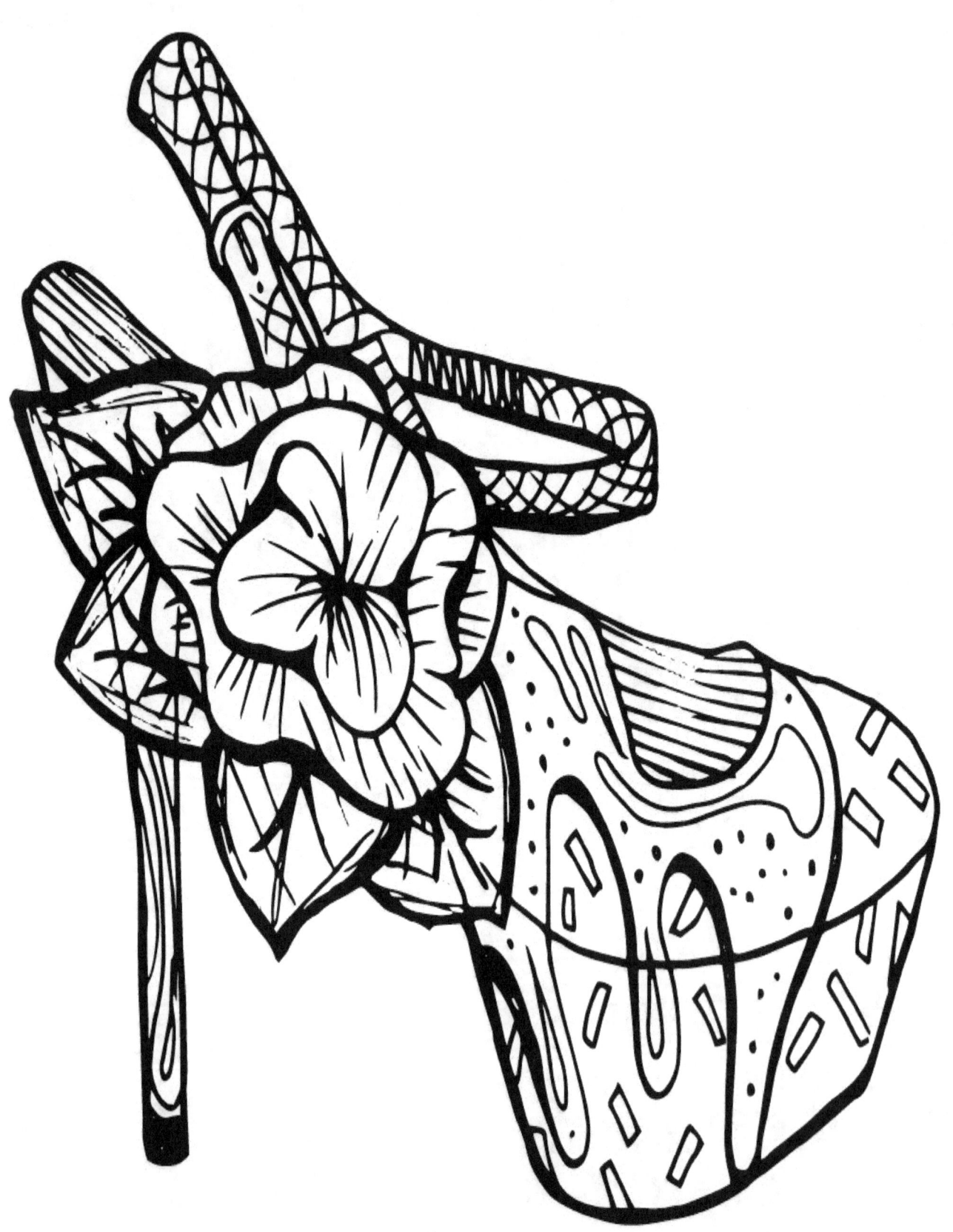

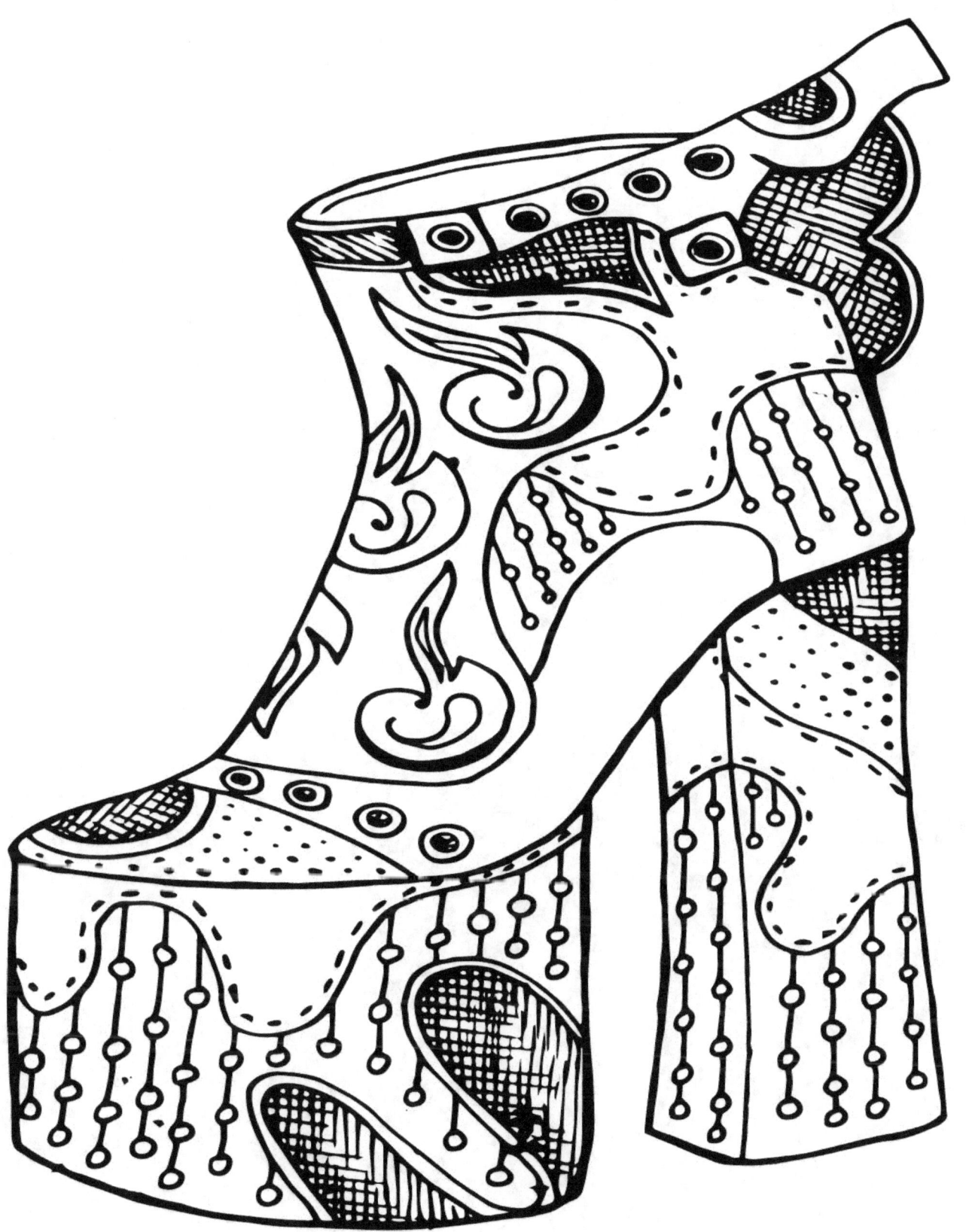

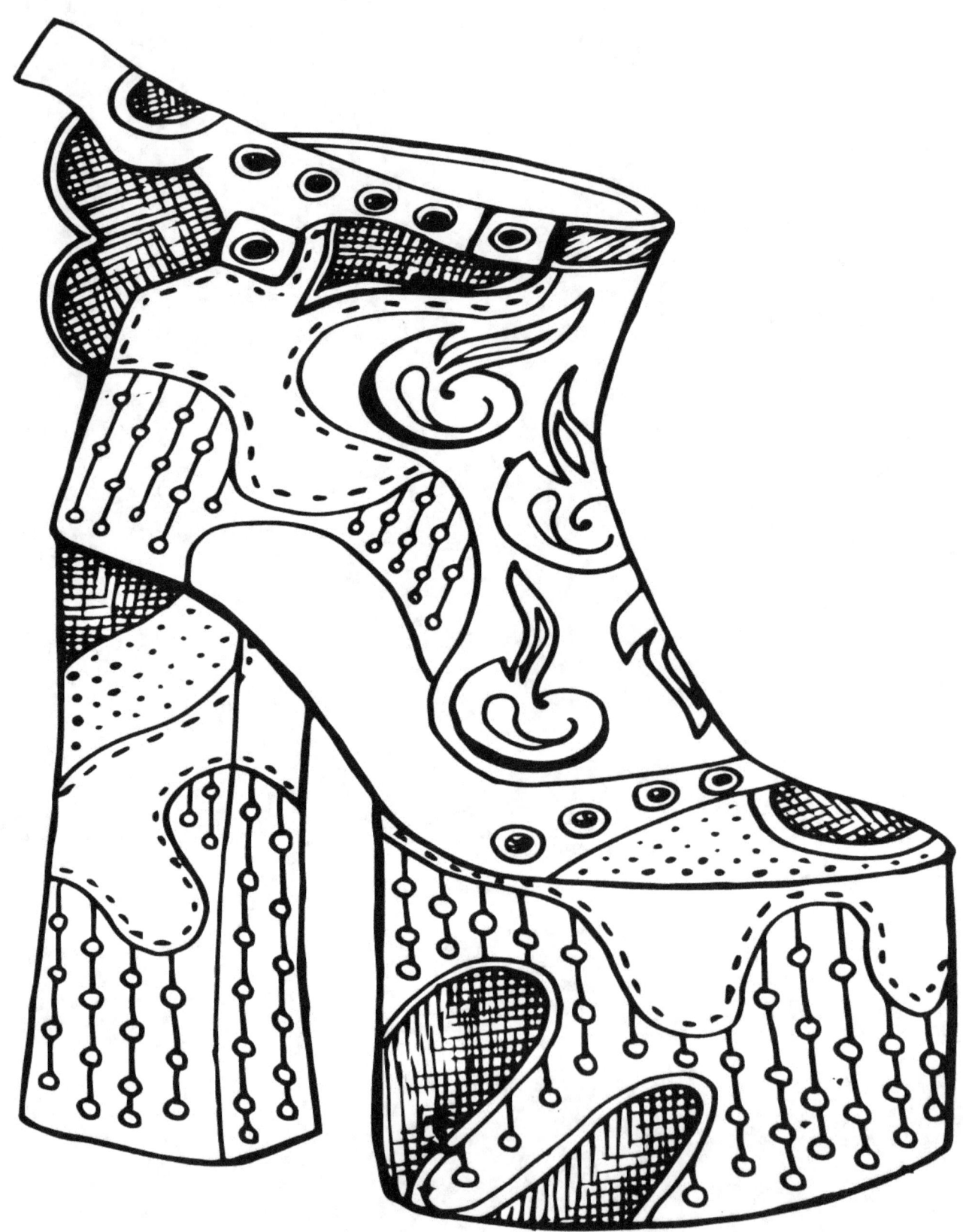

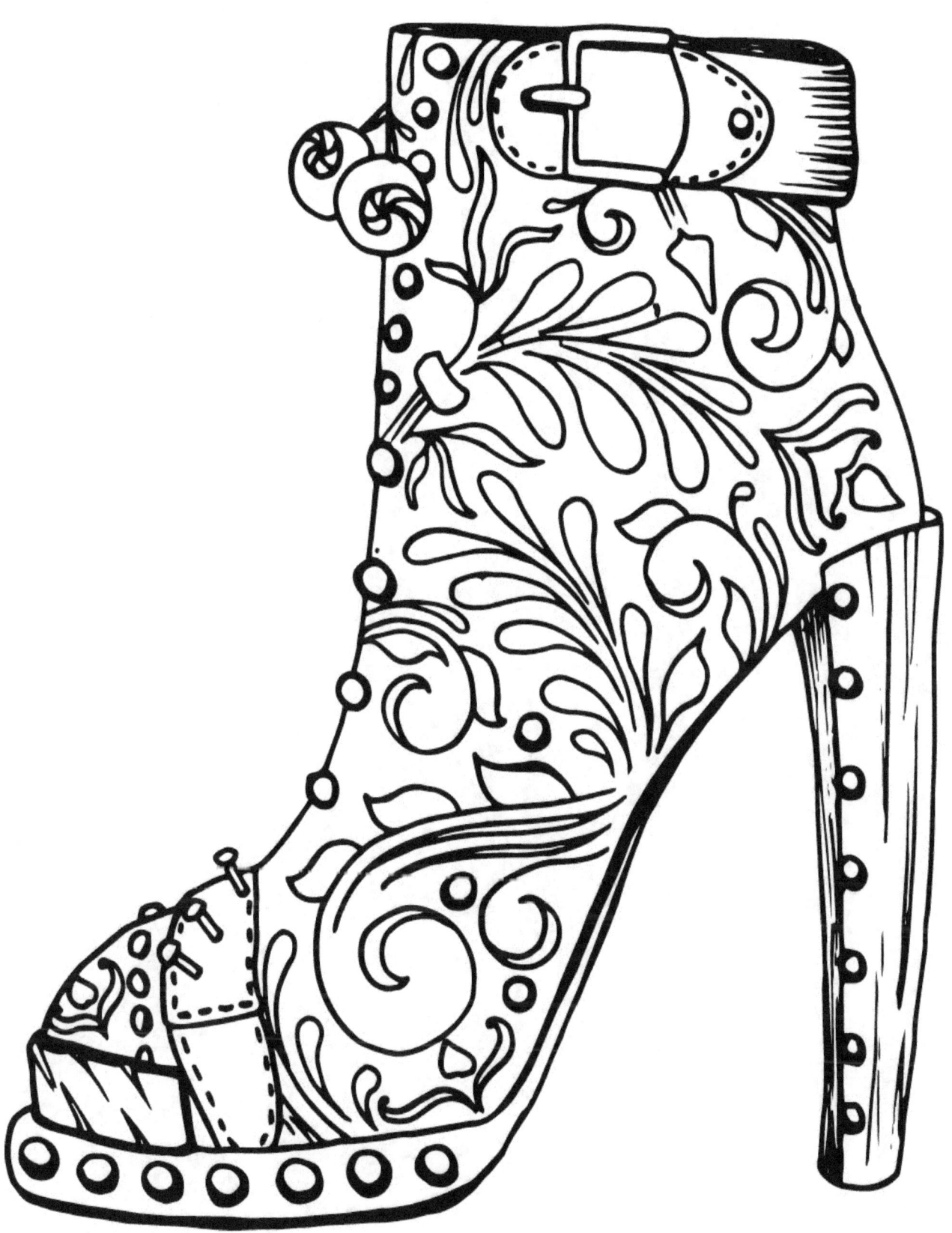

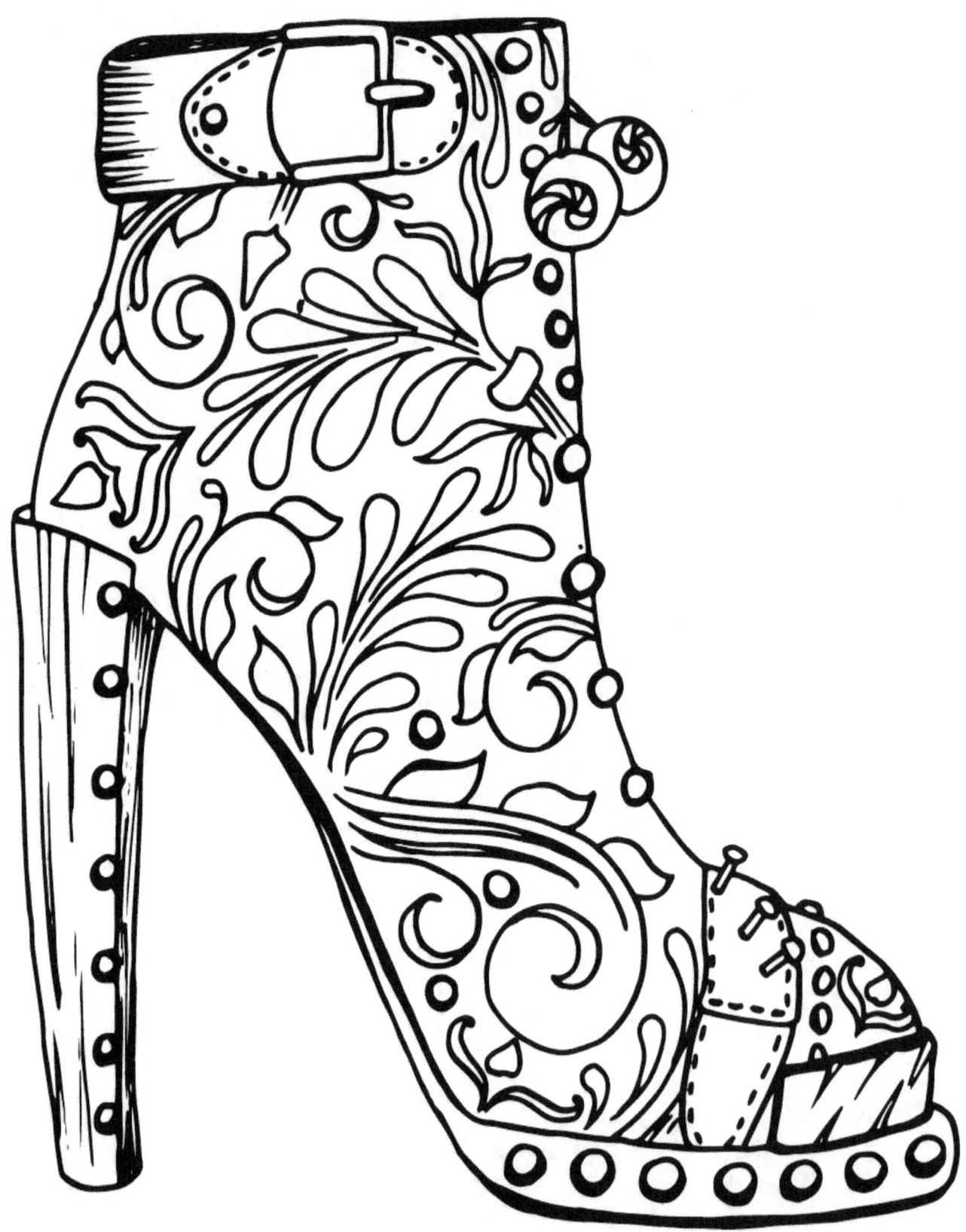

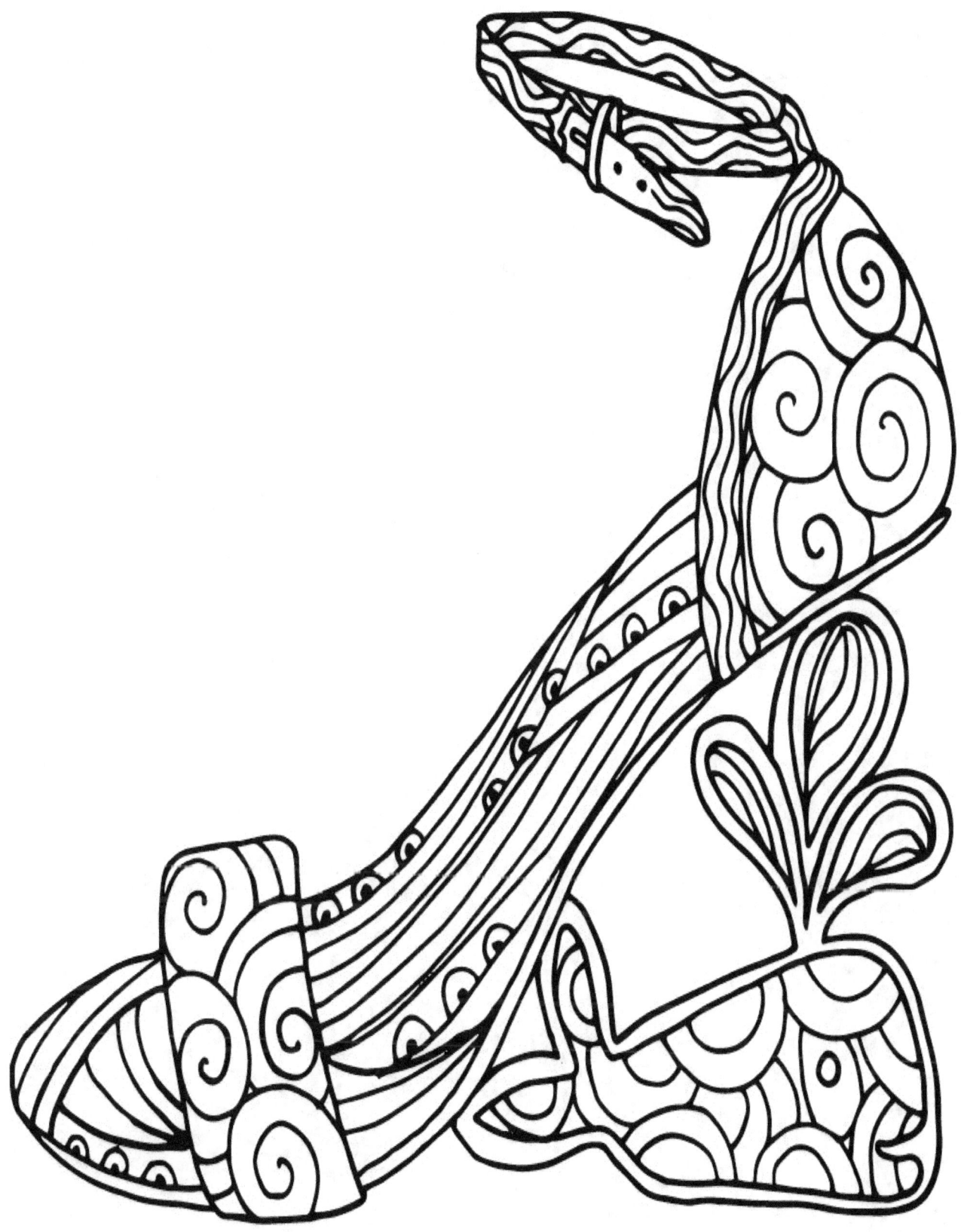

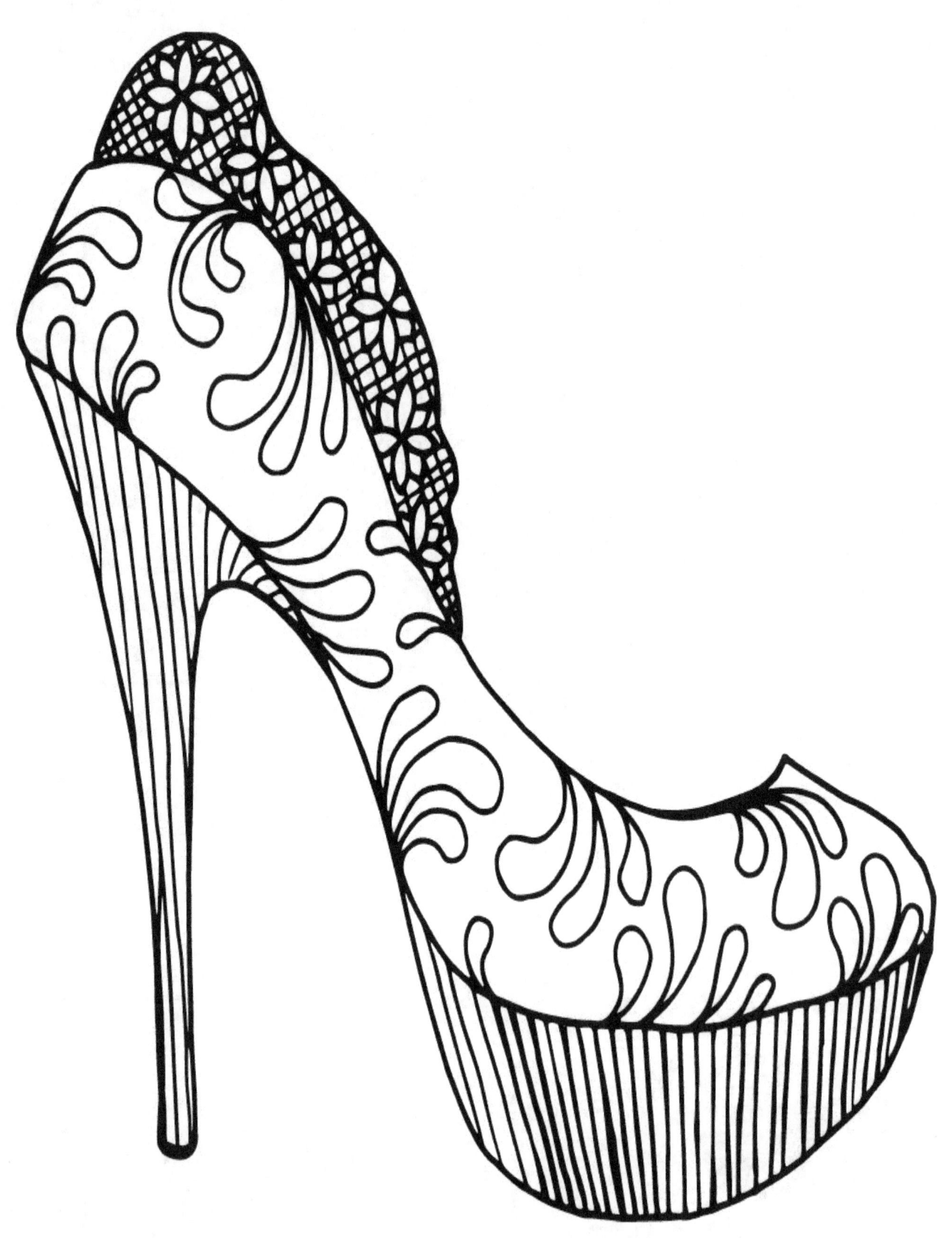

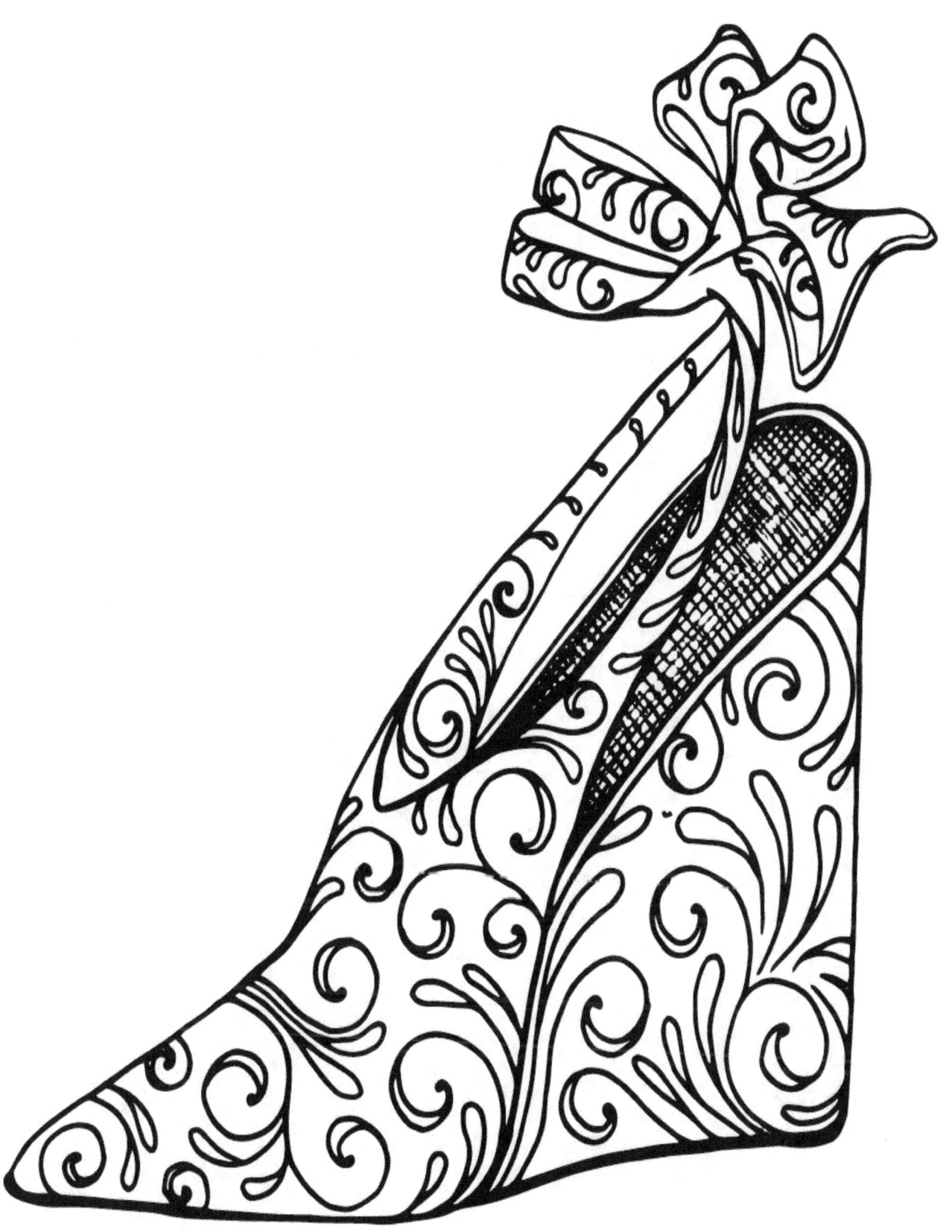

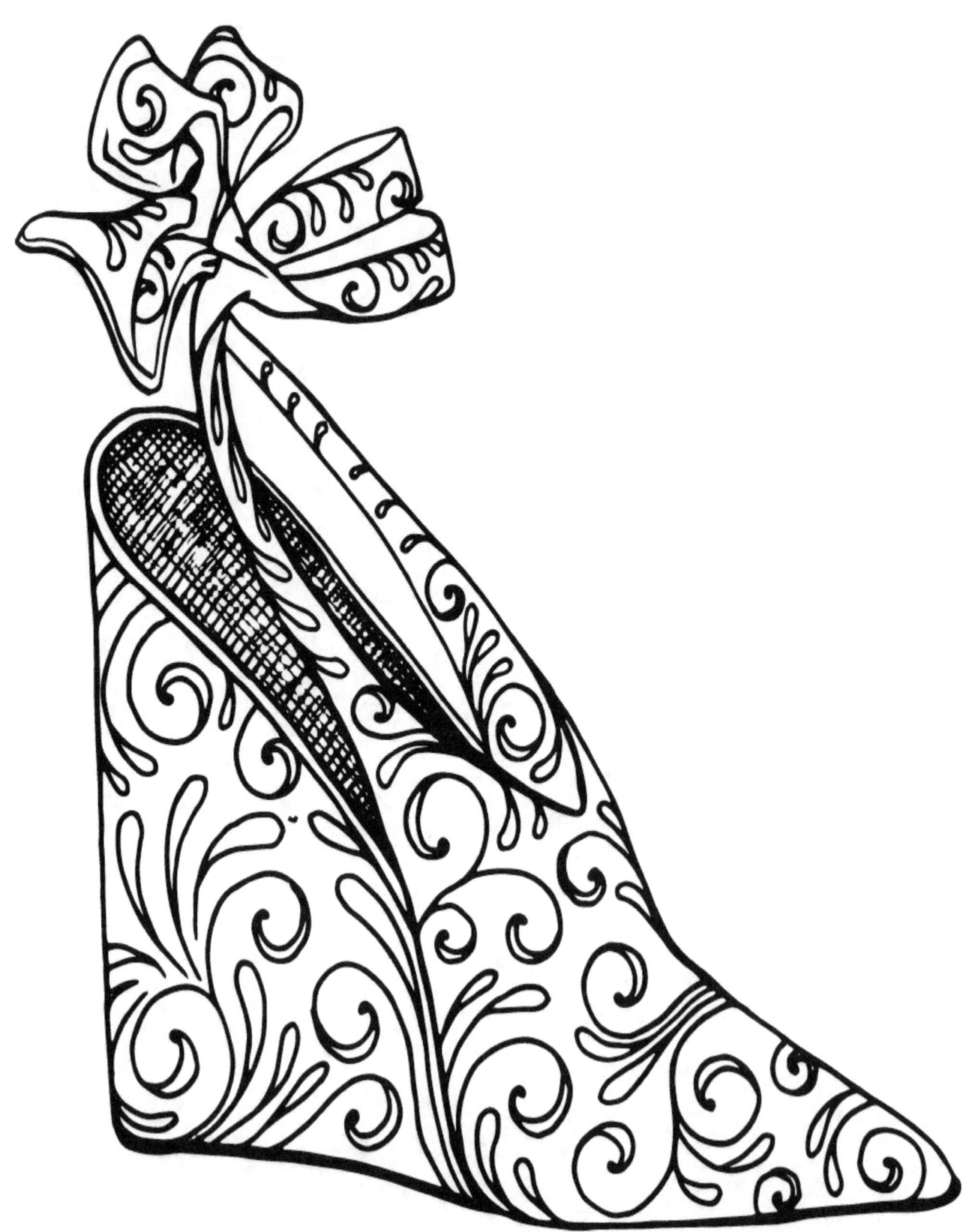

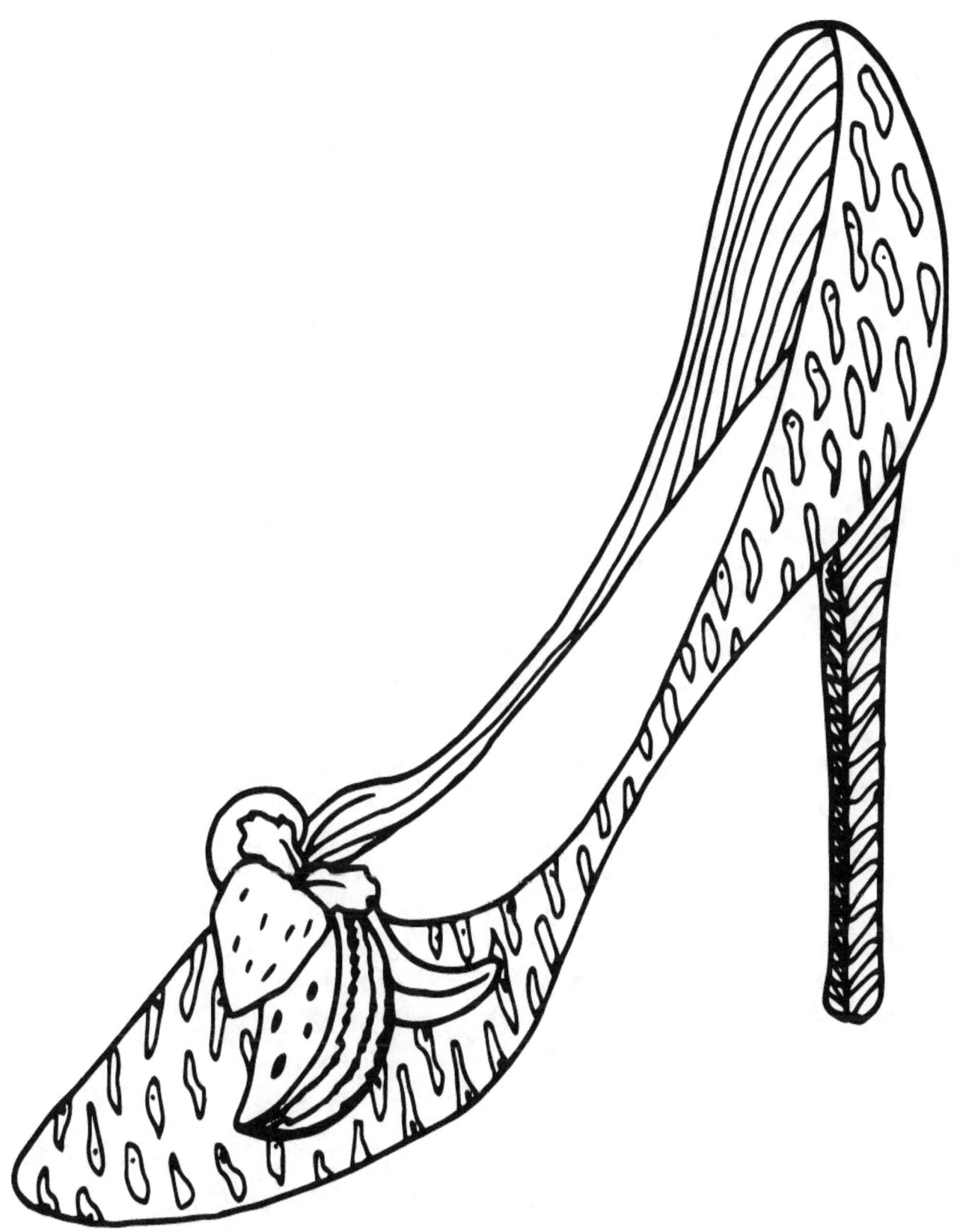